THE
GWYNNS FALLS

THE
GWYNNS FALLS

Baltimore Greenway to the Chesapeake Bay

W. Edward Orser

with contributions by Daniel Bain, Jack Breihan, Guy W. Hager,
Eric Holcomb and David Terry

Charleston London

THE
History
PRESS

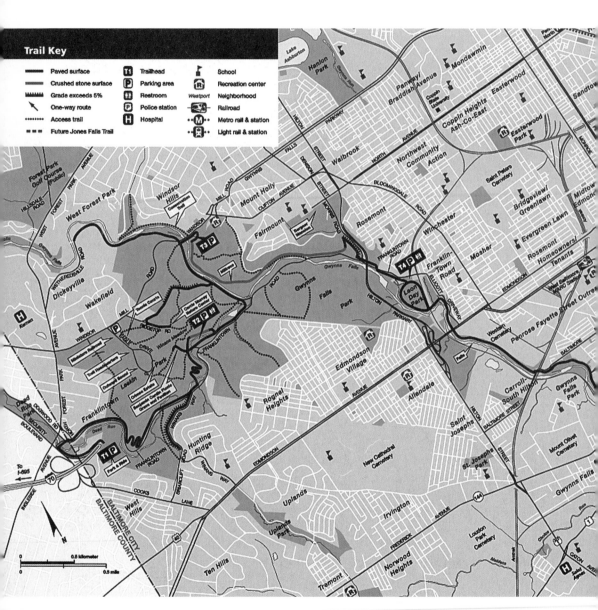

Trail Key

——— Paved surface	**T1** Trailhead	🏴 School
——— Crushed stone surface	**P** Parking area	**R** Recreation center
⋀⋀⋀⋀ Grade exceeds 5%	**H** Restroom	*Westport* Neighborhood
↖ One-way route	**P** Police station	Railroad
········ Access trail	**H** Hospital	**M** Metro rail & station
▪ ▪ ▪ Future Jones Falls Trail		Light rail & station

Map of the Gwynns Falls Trail, indicated by the heavy black line and with trailheads represented by a "T" and a number. *Parks and People Foundation.*

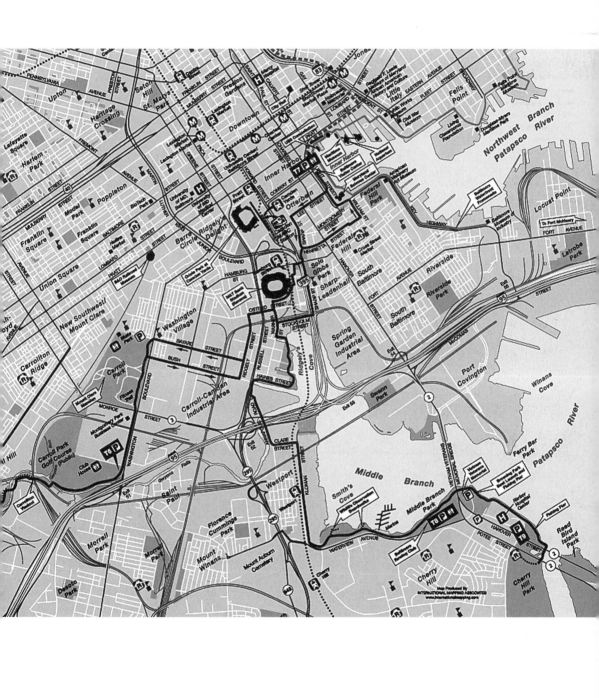

Published by The History Press
Charleston, SC 29403
www.historypress.net

Cover design by Marshall Hudson.

First published 2008

Manufactured in the United Kingdom

ISBN 978.1.59629.476.9

Library of Congress Cataloging-in-Publication Data

Orser, W. Edward.
The Gwynns Falls : Baltimore Greenway to the Chesapeake Bay / W. Edward Orser ; with contributions by Daniel Bain ... [et al.].
p. cm.
ISBN 978-1-59629-476-9
1. Gwynns Falls Watershed (Md.)--History. 2. Baltimore County (Md.)--History. 3. Baltimore (Md.)--History. 4. Natural history--Maryland--Gwynns Falls Watershed 5. Natural history--Maryland--Baltimore County. 6. Natural history--Maryland--Baltimore. I. Bain, Daniel. II. Title.
F187.G89O66 2008
975.2'71--dc22

2008016524

Contents

CONTENTS

Preface

"Stream valleys are the best connectors of all...By linking open spaces we can achieve a whole better than the sum of its parts."
 —*William H. Whyte,* The Last Landscape *(1968)*

Walkers and bikers on Baltimore's Gwynns Falls Trail experience much more than a recreational pathway linking some two thousand acres in a greenway park along the Gwynns Falls and its tributaries. As they access the trail's fifteen miles from its principal gateways—the Inner Harbor, Middle Branch or I-70 trailheads—or, indeed, any portion along the way, they encounter rich layers of natural and human history, some with visible traces, but others not immediately evident to the untrained eye.

The trail is truly something distinctive in American cities. The natural landscape it traverses includes the flat tidal lands of the Chesapeake Bay's coastal plain, as well as the valleys and ridges of the Piedmont uplands. Human encounter dates from Native American presence and the early European explorations of the Virginia Colony's Captain John Smith to Baltimore's growth to become a major American city. Along the way are sites of early mills, the inauguration of American railroading and the port facilities responsible for the city's development, as well as the interstate highways, sports stadiums and commercial services of the modern metropolis. The trail threads through seemingly pristine areas of natural beauty, as well as degraded former industrial sites—some in the process of revitalization; others in need of remediation. Along the route are thirty Baltimore neighborhoods—some of them among the most affluent; some the most economically stressed. Indelibly marking the experience of residents of those communities, past and present, is the history of race relations—traditions of racial segregation and discrimination, as well as the ongoing struggle for equality and opportunity. Over the course of time, the valley was at times treasured as green space and at others it was treated as a neglected backyard.

The Gwynns Falls Trail represents a significant step toward fulfilling a vision of stream valley parks in an urban setting, a vision which builds upon a century and a half

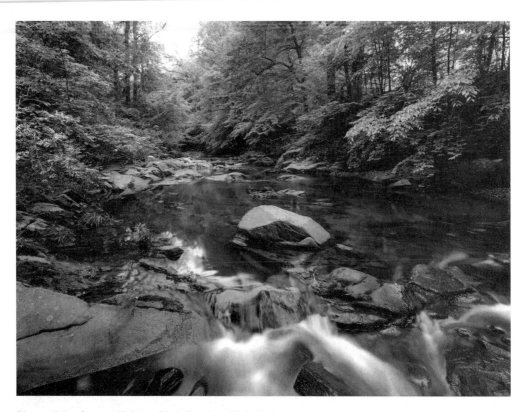

Photo of the Gwynns Falls by Clyde Butcher. *Clyde Butcher.*

in the development of Baltimore's park system and the distinctive recommendations a century ago by America's leading landscape architects—the Olmsteds. Nevertheless, the promise of these earlier efforts was only partially fulfilled, with sections of the Gwynns Falls Valley not secured as contiguous parkland, some west-side urban neighborhoods lacking access to green space and the extensive natural spaces of Gwynns Falls and Leakin Parks' often overlooked resources. Yet, a decade and a half ago, a broad-based partnership coalesced to revive the vision and expand its scope to incorporate community revitalization, as well as environmental stewardship, as essential goals. The group worked against considerable odds to fulfill—and broaden—what many thought an improbable dream. The centerpiece of their concept would be a trail because they believed that it would provide a connective thread, linking neighborhoods to one another and providing multiple points of access. And along the trail, special park spaces would serve the various recreational needs of urban communities, as well as provide opportunities for direct contact with nature—whether in the confined stretches of the lower valley, long impacted by development, or in the more expansive natural areas to the northwest. Environmental responsibility played another key role in the enterprise, which would feature outdoor education, cleanup and remediation projects and scientific research. The result of this expanded vision, they hoped, would be a healthier and more vibrant quality of life for all Baltimoreans.

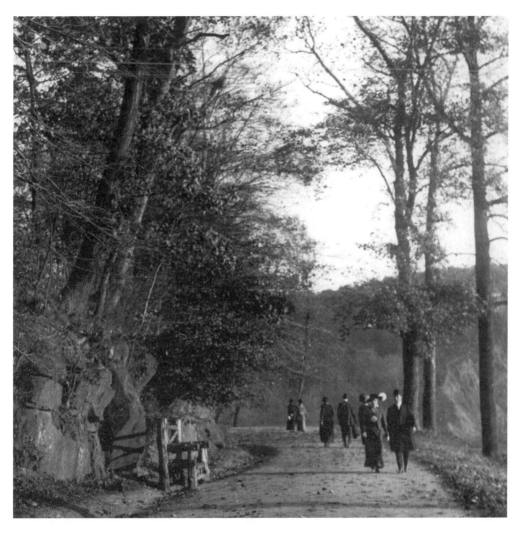

Strollers on the old millrace path, 1915. *Enoch Pratt Free Library.*

In some ways the plan for the Gwynns Falls Trail grew out of distinctive local circumstances, but it is also part of a contemporary national movement to create "linear parks" or "greenways." In an era when space for traditional parks has become scarce, advocates have recognized the opportunities afforded by abandoned railway lines, utility corridors, ridges and stream valleys. In 1968, prominent urban planner William H. Whyte argued that in America's overcrowded society, such spaces might represent the "last landscape." Making the case for linear parks as "linkages," Whyte pointed out that their extensive edges provided maximum opportunities for access for larger numbers of people than often was true with more conventional, compact parks. But more is involved in the linear park or greenway concept than necessity once more proving itself to be the mother of invention. Landscape architect Diana Balmori captured the larger vision of the partnership that championed the Gwynns Falls Trail and its parkland corridor when she wrote:

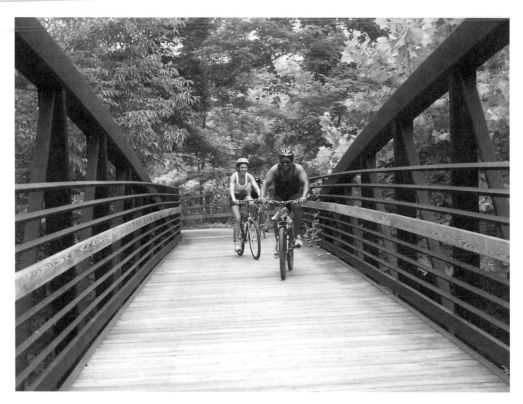

Bikers cross the Gwynns Falls Trail Bridge over Dead Run. *Trust for Public Land.*

The linear park opens pathways to diverse neighborhoods and new recreational experiences of nature; it invites exploration of alternate modes of transport and of cultural resources. It weaves connections between city and suburb, suburb and country, between nature and culture, and among people of different origin, age or sex. It is an answer to the increasing cultural isolation and physical separation in which we often find ourselves.

The chapters that follow make the case that appreciation of the Gwynns Falls and its watershed requires much more than a walk or bicycle ride in a park. Along the route of the fifteen-mile trail are significant stories that tell a great deal about the environmental and human record of a complex landscape. Some of those stories have left indelible marks; others little trace. Some point to accomplishment and promise; others to challenges and obstacles. But to encounter the Gwynns Falls, this greenway to the Chesapeake Bay, is to engage a rich historical record and to become part of an unfolding chronicle so important to the past and present of Baltimore, America's cities and the nation.

Notes at the end of chapters identify sites along the Gwynns Falls Trail related to themes mentioned in the text. They refer to the trailhead number (designated by "T" on the trail map) or to streets and landmarks for sections between the trailheads.

Tributary of the Chesapeake Bay

THE WATER AND THE WATERSHED, PAST TO PRESENT

"The story of a raindrop reminds us of this: every plastic bag, every trace of pesticide, every raindrop that falls anywhere within our watershed, and everything that the water carries, ends up in our streams, our rivers, our Bay, and eventually our own lives."
—*Guy W. Hager and Paul Jahnige,* The Gwynns Falls Watershed Ecological Resource Atlas *(1999)*

The Gwynns Falls flows from its origins in north-central Baltimore County, near Reisterstown, to the Middle Branch of the Patapsco River in Baltimore City (near the present I-95/I-395 interchange). Its watershed drains approximately sixty-five square miles. Today, an estimated one-third of a million people live within the city and county portions of the watershed boundary.

The headwaters of the Gwynns Falls spring from the uplands of Maryland's Piedmont plateau at an altitude of approximately seven hundred feet. Over the course of eighteen miles, the stream descends to the sea level of the Atlantic Coastal Plain and the Chesapeake Estuary. At its outflow into the Middle Branch, the meandering stream in earlier times became an area of shallow wetlands and marshes, though modern development eventually led to the filling and straightening of its course. As the Gwynns Falls made its descent over countless centuries of geologic time, it had to cut its way through sedimentary and igneous rock. Some of the latter was quarried for building purposes in the early period of Baltimore's growth. Places of significant fall over resilient rock outcroppings produced rapids—sites for mills in the era of water power—and in those stretches, the valley walls formed steep gorges.

Prior to European colonial settlement, the upper reaches of the Gwynns Falls were marked by dense forests. Native Americans frequently passed through the area, crossing the stream at a ford in the vicinity of today's Washington Boulevard. In 1608, English Captain John Smith, exploring the Chesapeake Bay region from the Virginia Colony, sailed into the mouth of the Patapsco River, and noted that its several branches afforded fine harbors. Observing that the streams that served as tributaries descended

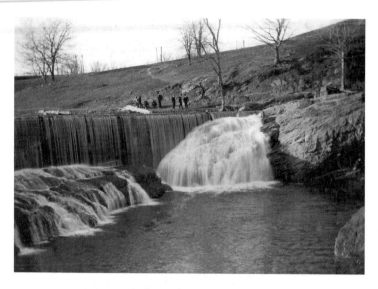

Men gather to observe the waterfall of the Gwynns Falls, below Edmondson Avenue, which some called "Baltimore's Niagara Falls," 1900. Baltimore Sun.

over waterfalls and rapids, he referred to them as "felles" or "fells." Later in the century, early Maryland settler Richard Gwinn established a post near the historic ford to trade with Native Americans in 1669. Over time, the stream came to be known as the Gwynns Falls.

Captain John Smith noted signs of iron ore in the area, and in 1723, an iron furnace and mining operation were established on property belonging to John Moale near the mouth of the Gwynns Falls. Moale vigorously opposed an attempt in the Maryland General Assembly to select his property as the site for Baltimore Town, believing that it was more valuable for iron ore. As a result, the Northwest Branch of the Patapsco—often referred to as the Basin, today's Inner Harbor—was selected as the site for the new settlement in 1729.

Baltimore was established late in the colonial period, and its early growth was related directly to water resources. The branches of the Patapsco Estuary afforded good harbors for trade, and the streams that tumbled into it from the Piedmont provided water power sites for flour mills. Along the Gwynns Falls, a series of mills dotted the banks, and around them small rural settlements grew up. Beyond these villages, the upper reaches of the valley remained a mix of forest and agriculture. The lower portion of the Gwynns Falls, on the edge of the expanding city, became the site of industrial and processing functions—iron and brick operations, stockyards and butchering, railroad facilities and factories. During the nineteenth century, rowhouse neighborhoods provided residences near places of work. Urban development became increasingly dense on the eastern side of the Gwynns Falls, but streetcar transportation enabled it to leapfrog to the western side. Twentieth-century suburbanization, extending into Baltimore County, rapidly transformed the entire Gwynns Falls watershed. Today, it is fully encompassed by the Baltimore metropolitan area—a green space in the midst of dense urban development, both residential and commercial.

It is estimated that in the period of colonial settlement, approximately 20 to 30 percent of the forests in the region already had been cleared for agricultural and

Baltimore City's Four Watersheds and Neighborhood Boundaries

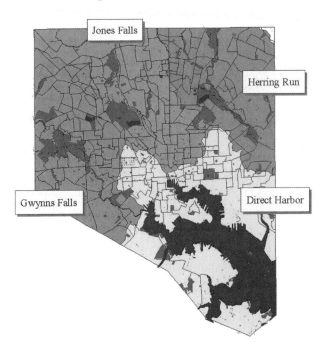

Baltimore's four watersheds and neighborhood boundaries. *Parks and People Foundation.*

industrial purposes; today, only 18 percent of forest cover remains. Development also has sharply increased the amount of land covered by impervious surfaces, calculated to be as much as 40 percent. Lack of plants and trees, combined with hard surfaces, severely limits the ability of the land to absorb rainfall, instead producing rapid runoff and erosion. The result for the Gwynns Falls and its tributaries has been both increased siltation and scouring of the riverbed, neither of which is desirable for healthy streams. The *Gwynns Falls Watershed Ecological Resource Atlas* warns that

> *forested lands within many parts of the Gwynns Falls Watershed currently fall below vital thresholds for maintaining important ecological services and functions, such as water quality, air quality, wildlife habitat, and open spaces for recreation and renewal.*

In the 1830s, the Gwynns Falls was considered as a possible source for Baltimore's drinking water supply. Instead, the decision was made to use the Jones Falls, where a reservoir system was developed in the 1850s. Two decades later, the system drew water from the Gunpowder Falls, farther to the northeast, first retained by the Loch Raven Reservoir (1880s) and later augmented by the Prettyboy Reservoir, both in north-central Baltimore County. With the growing needs of the metropolitan region, Liberty Reservoir was added to tap the Patapsco River in the 1950s, while in the 1960s, the Susquehanna River provided yet another source of water.

In the late nineteenth century, the water quality of the Gwynns Falls was satisfactory enough for the Baltimore Public Baths Commission to maintain a swimming facility in the stream just below Edmondson Avenue. However, by 1915, water there had been determined to be unsafe for bathing, and the commission opened two adjacent swimming pools on the southern end of Gwynns Falls Park to serve the area's growing population. The Board of Park Commissioners, which ran the city's recreation pools after 1917, maintained a policy of racial segregation in those facilities until they were integrated in 1956. Today, only a few public park pools survive in Baltimore.

Baltimore was one of the last major metropolises to develop a separate sanitary sewer system, not doing so until the urban rebuilding effort in the aftermath of the great fire of 1904, which devastated the central business district. Until then, sewage mixed with storm runoff to pollute area streams. Along the Gwynns Falls, early processing and industrial functions dumped animal hair, soap, brewery and butchery wastes directly into the stream. In 1880, a gristmill operator on the lower valley successfully sued upstream meatpackers for fouling his millrace and water wheel. An important obstacle to sewage plans was the danger to the health of oysters in the Chesapeake Bay if waste was not adequately treated prior to discharge.

The upside of Baltimore's slow start was that, when the system was finally implemented in 1905, it separated storm and sanitary functions and provided for modern filtration and treatment of wastewater. It was designed as a gravity system flowing to sea level, with sewage then pumped to east-side Back Bay and west-side Patapsco sewage treatment plants. Though it was clearly an improvement in municipal sanitation, sewer lines were sometimes damaged by floods or poor maintenance—with wastewater from the pipes leaking into streams like the Gwynns Falls—and often it was necessary for signs warning of polluted water to be posted along the banks. Today, Baltimore City is undertaking massive reconstruction of its sanitary sewer pipelines.

In 1903, civic leaders, anticipating the expansion of Baltimore's city boundaries, commissioned the prominent landscape architect firm, the Olmsted Brothers, to develop a comprehensive plan for park development in the coming decades. The Baltimore regional park plan, supervised by Frederick Law Olmsted Jr. and published in 1904, paid particular attention to the stream valleys—the Gwynns Falls, the Jones Falls, Herring Run and the Patapsco River. It recommended that the land along them be secured as parks, principally to remove them from development and to retain them as natural buffers. In succeeding years, Gwynns Falls Park, originally only a small parcel near Edmondson Avenue and Hilton Street, was expanded to the northwest. In 1918, the anticipated annexation occurred, extending Baltimore City's boundary to its current line. The park needs of the new section were addressed in a second report by the Olmsted firm in 1926. In the 1940s, a major portion of the valley of the Dead Run, a tributary of the Gwynns Falls, was secured as parkland to create Leakin Park. Together, the adjoining Leakin and Gwynns Falls Parks constitute an extraordinary park reserve within the limits of an American city.

Historically, floods have impacted Baltimore-area streams. The great 1868 flood had catastrophic consequences for the Patapsco River Valley and produced major damage

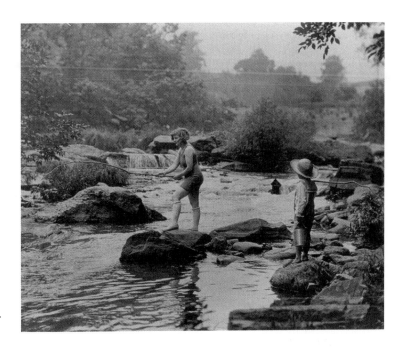

Girl and boy fishing in
the Gwynns Falls, 1925.
Baltimore Sun.

in the Gwynns Falls, washing away the dam that formerly produced a dramatic cascade
in the valley below Edmondson Avenue and destroying the Frederick Avenue Bridge.
In 1972, flooding from Hurricane Agnes had devastating effects on both watersheds,
severely damaging Ellicott City on the Patapsco and washing out Wetheredsville Road,
where the Dead Run flows into the Gwynns Falls.

Today, the ecology of the Gwynns Falls stream and its watershed is the focus of a
number of major initiatives combining research and citizen activism. The Gwynns
Falls Watershed Association is a volunteer organization that seeks to improve water
quality and to promote the value of the stream and its tributaries "as a recreational,
aesthetic, educational and natural resource." The U.S. Geologic Survey operates four
continuous record stream-flow gauging stations for research along the Gwynns Falls.
The Baltimore Ecosystem Study (BES, part of the National Science Foundation's Long
Term Ecological Research Network) brings to bear the expertise of researchers from the
biological, physical and social sciences to collect and synthesize data on the ecological
and engineering systems of the metropolitan area. The program, one of only two of its
kind in the nation, seeks to understand the urban water cycle and its relation to patterns
of urban development.

In a partnership complementing the research activities of BES, Baltimore's Parks
and People Foundation has engaged in neighborhood tree inventory projects, fostered
neighborhood greening projects and developed youth forestry training and summer
employment programs. Closely tied to the objectives of BES is the Center for Urban
Environmental Research and Education (CUERE) at the University of Maryland,
Baltimore County, which seeks to advance understanding of the environmental, social
and economic aspects of the urban landscape through research and educational

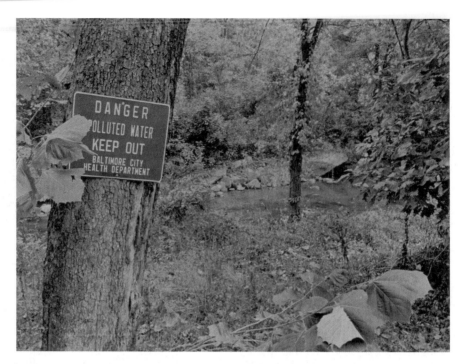

A sign warning of water pollution along the Gwynns Falls, 1971. *Martha Armstrong, UMBC Community Studies Project.*

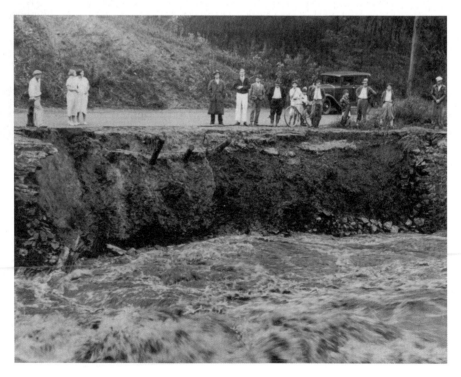

Flooding along the Gwynns Falls at Ellicott Driveway, 1934. Baltimore Sun.

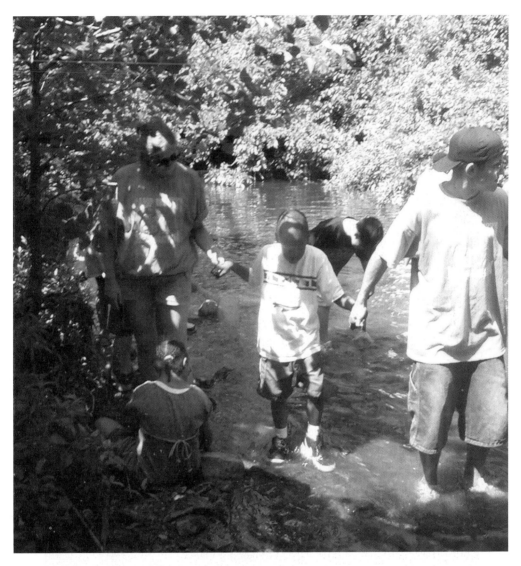

Kids doing a recent stream study. *Parks and People Foundation.*

programs. BES and CUERE have joined with Parks and People and federal and local governmental agencies in the Watershed 263 project, which focuses upon the ecology of the urban district drained by the storm sewer system in Southwest Baltimore. The Gwynns Falls Trail traverses lower portions of Watershed 263 in the Carroll-Camden Industrial District near its discharge into the Middle Branch.

Trailhead 6: a BES stream-flow gauging station is located near the trail. The interpretive panel at this site contrasts the environments of unhealthy and healthy streams.

Four Hundred Years Ago

CAPTAIN JOHN SMITH EXPLORES BALTIMORE'S WATERWAYS, 1608

"Whether the river on which you plant doth spring out of mountains or out of lakes. If it be out of any lake, the passage to the other sea will be more easy, and [it] is like enough that out of the same lake you shall find some spring which run[s] to the contrary way towards the East India Sea."
 —*Instructions of the Virginia Company of London to the Jamestown settlers, 1607*

"The Westerne shore [of the Chesapeake Bay] *by which we sayled we found all along well watered, but very mountanous and barren, the vallies very fertill, but extreame thicke of small wood so well as trees, and much frequented with Wolves, Beares, Deere and other wild beasts. We passed many shallow creekes, but the first we found Navigable for a ship, we called Bolus, for that the clay in many places under the clifts by the high water marke, did grow up in red and white knots as gum out of trees; and in some places so participated together as though they were all of one nature, excepting the colour, the rest of the earth on both sides being hard sandy gravell, which made us thinke it Bole-Armoniack and Terra sigillata."*
 —*Captain John Smith,* The General Historie of Virginia *(1624)*

While Native Americans had been crossing the Gwynns Falls for centuries, the first European to map and record his observations about the region was Captain John Smith, who in the summer of 1608 led two expeditions from the English settlement at Jamestown in Virginia to explore the Chesapeake Bay.

The Virginia Company of London, representing the English investors in an entrepreneurial colonizing enterprise, instructed the first Jamestown settlers to explore the various waterways of the Chesapeake Bay system in the hope of discovering a western passage to "the East India Sea." The company was also eager to determine the presence of gold or other precious metals, as well as to gain knowledge of the various "Indian" tribes in the area. The entrance of the English into North America represented a foray into regions already staked out by early Spanish explorers, and Spanish ships represented a potential threat to attempts at exploration or settlement.

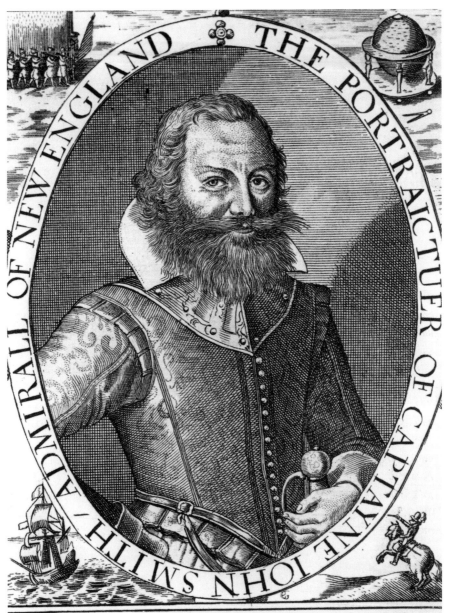

THE PORTRAICTUER OF CAPTAYNE IOHN SMITH ADMIRALL OF NEW ENGLAND

These are the Lines that shew thy Face but those
That shew thy Grace and Glory, brighter bee,
Thy Faire-Discoueries and Fowle-Overthrowes
Of Salvages, much Civilliz'd by thee
Best shew thy Spirit and to it Glory Wyn,
So, thou art Brasse without but Golde within.

Portrait of Captain John Smith, admiral of New England, on a 1616 map of New England, early engraving. *The Association for the Preservation of Virginia Antiquities.*

The Virginia Colony at Jamestown, established in 1607, became the first permanent English settlement in the New World and the basis for an extensive English empire abroad, but it had a very tenuous early existence. John Smith (circa 1580–1631), whose title "captain" came from earlier adventures in Europe, was designated as one of the seven original council members charged with governing the colony. Following the 1608 voyages, he also served as council president during a difficult period in the colony's struggle for existence. His strong personality made his leadership controversial, and in 1609 he left Virginia for England, never to return to the Chesapeake.

For Smith's two explorations of the bay, he used a barge, or shallop—a large (perhaps forty feet long), open wooden boat that could be rowed or sailed. On the initial journey, the party consisted of fifteen men; on the second, twelve. Leaving Jamestown on June 2, 1608, Smith's first expedition traveled along the bay side of the eastern shore, crossed to the western shore, went as far north as the Patapsco River basin, explored the Potomac River to its falls (west of Georgetown) and then returned to the colony on July 21. The second party, launched on July 24, explored the upper headwaters of the bay and the mouth of the Susquehanna River and then sailed up both the Patuxent and the Rappahannock Rivers to their falls. The combined journeys established rather conclusively that the various tributaries of the bay offered no outlets to a waterway to the Far East, though the hope for such a passage died slowly. But the expeditions did produce Smith's valuable "Map of Virginia," first published in England in 1612, with detailed and relatively accurate delineation of the Chesapeake Bay region—its shorelines, inlets and rivers—as well as the names and locations of Native American tribes.

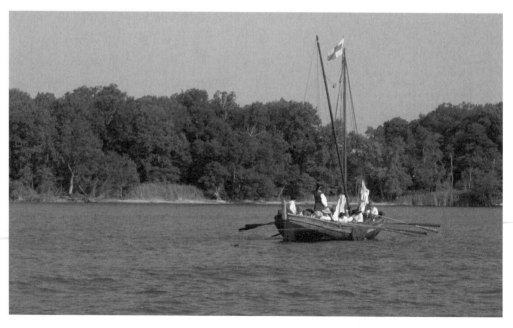

A reenactment of Captain John Smith's exploratory party aboard a replica of their shallop during observance of the 400th anniversary of the expedition. *Drew Mullins, Sultana Projects.*

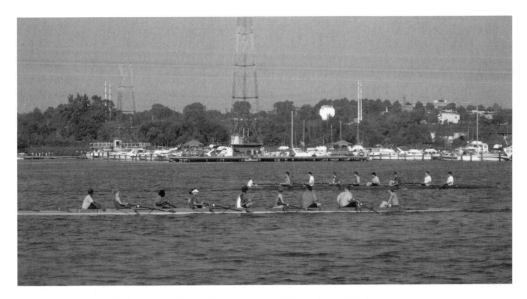

Rowers on the Middle Branch. *Baltimore City Department of Recreation and Parks.*

On the first voyage, Smith and his party found the western shore of the Chesapeake to be

> *well watered, but very mountanous and barren, the vallies very fertill, but extreame thicke of small wood so well as trees, and much frequented with Wolves, Beares, Deere, and other wild beasts* [the spelling is Smith's].

They moored near the mouth of the Patapsco River, and then, on June 13, 1608, they traveled across the Middle Branch, the basin for both the Gwynns Falls and the main stem of the Patapsco River. They found the Patapsco to be navigable by boat as far as the falls at Elkridge (a place Smith called "Downs Dale"), and then they proceeded on foot to the heights above, placing a brass cross to claim the valley for England. On his map, Smith designated the Patapsco River by the name "Bolus," a reference to the clay outcroppings that caught his attention in the vicinity of the Middle and Northwest Branches, represented by today's Federal Hill and Cherry Hill. Bolus referred to *bole armoniac*, a reddish brown, yellow clay that Europeans believed to have medicinal value. It also could be a marker for iron in the soil, as early settlers discovered.

The second exploratory journey departed from Jamestown on July 24, 1608, only three days after the return of the first. On the twenty-ninth, Smith's party again anchored at the mouth of the Patapsco River and then proceeded north to the headwaters of the bay. There, the expedition arranged to meet representatives of the Susquehannocks. The second party returned to Jamestown on September 7.

Trailhead 9: Captain John Smith and his party sailed in these waters and continued up the Patapsco River, just to the east.

Native Peoples of the Chesapeake

ALGONQUIANS AND SUSQUEHANNOCKS

"A highway of the Seneca Indians passed through the western part, at least, of what is now Baltimore City, and crossed Gwynns Falls near the mouth of that stream."
—*William Marye, "The Old Indian Road,"* Maryland Historical Magazine *(1920)*

Long before colonial-era European contact, Native Americans traversed the Gwynns Falls Valley. There is no evidence of permanent settlements, but there is strong indication of ongoing presence. The valley lay between lands occupied by the Algonquian-speaking Indians, who populated the coastal waters of Maryland and Virginia, and the Susquehannocks, Iroquois-speaking Indians who lived along the upper Chesapeake Bay in northern areas of Maryland and in Pennsylvania. The latter, from whom the Susquehanna River took its name, were nomadic, and they frequently attacked the more settled, agricultural Algonquians.

The Algonquians, like many other Native American groups, divided labor along gender lines, with the men responsible for hunting and fishing and the women responsible for cooking and agriculture, such as tending the corn crop and fertilizing it with fish. Warfare was also the duty of adult males. The Algonquian-speaking tribes were organized with chiefs, like the Powhatans of tidewater Virginia.

Susquehannocks predominated in the upper Chesapeake Bay region, though they were rather recent arrivals there at the time of first European contact. They established some six permanent settlements in today's Maryland–Pennsylvania area, but they also traveled through the Chesapeake region for hunting, and frequently, for warfare aimed at contesting the territory that was historically the domain of the Algonquians. When Captain John Smith encountered the Susquehannocks in his explorations of the upper Chesapeake Bay in 1608, he described them as fierce and warlike, a nation whose warriors seemed like giants:

Such great and well proportioned men, are seldome seene, for they seemed like Giants to the English, yea and to the neighbors, yet seemed of an honest and simple disposition, with much adoe restrained from adoring the discoverers as Gods.

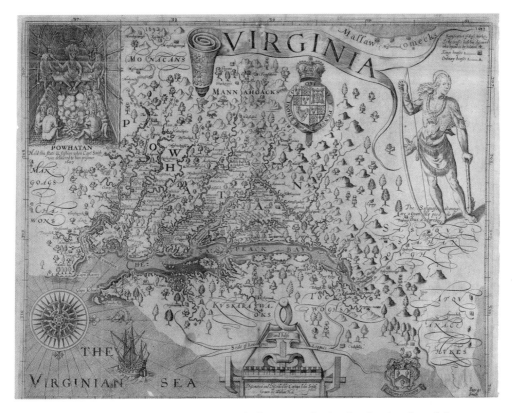

Captain John Smith's "Map of Virginia" was relatively accurate in charting the shoreline of the Chesapeake Bay region. It depicts a Susquehannock warrior. *Maryland State Archives.*

Smith was equally struck by their ferocious and elaborate appearance:

> *Their attire is the skinnes of Beares, and Wolves, some have Cassacks made of Beares heades and skinnes that a mans necke goes through the skins nec, and the eares of the beare fastned to his shoulders behind, the nose and teeth hanging downe his breast, and at the end of the nose hung a Beares Pawe, the halfe sleeves comming to the elbowes were the neckes of Beares and the armes through the mout with pawes hanging as their noses.*

There is strong evidence that an important trail used by the Susquehannocks traveling from Pennsylvania to the Chesapeake region crossed the Gwynns Falls at two fords, where the stream meets the coastal plain, between today's Wilkens Avenue and Washington Boulevard. Both became the routes of early colonial-period wagon roads. The upper crossing later was used by colonial militias as a "Garrison Road" (extending northward to a fort near present-day Garrison in Baltimore County) in their mission to protect early settlements from Native American attack. Downstream, the second Native American ford became the route of the important colonial wagon and post road connecting Philadelphia and Alexandria, through Baltimore, along a route roughly the same as the current Washington Boulevard.

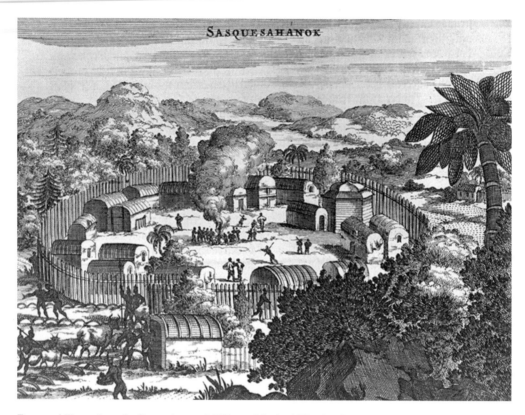

Engraved illustration of a Susquehannock Village. *Maryland Historical Society.*

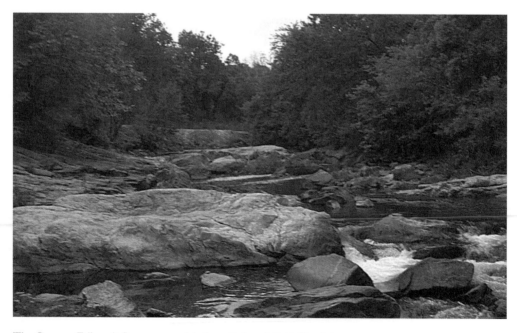

The Gwynns Falls as it flows over rock ledges. *Parks and People Foundation.*

In 1634, Cecil Calvert, the second Lord Baltimore, fulfilled the wishes of his father by establishing Maryland as a proprietary colony of the English Crown. Its first settlement and capital, St. Mary's City, was situated in southern Maryland, near the confluence of the Potomac River and the Chesapeake Bay. Three decades later, in 1669, Richard Gwinn established a post to trade with Native Americans on the colony's northern frontier. The stream-side location near the last set of falls was likely chosen because of its proximity to the fords used by Native Americans as traditional routes through the area. Gwinn's name (the spelling changed over time to Gwynns) became attached to the stream: the Gwynns Falls. He also laid out plans for "Gwinn's Town" and built an early stone fort—the foundations of the latter were still visible in the early 1900s, though no trace remains today.

The arrival of Europeans in the Virginia and Maryland colonies created a demand for animal furs for trade, intensifying conflict between Native American tribes in the Chesapeake area. Maryland Native Americans—weakened by war, decimated by disease and pushed off traditional lands—migrated northward or removed to scattered sites within the state.

Trailheads 5 and 6: Native Americans forded the Gwynns Falls in this vicinity on historic trails.

Colonial Plantation Economy Along the Gwynns Falls

The Carrolls

"At the Point you have a full view of the elegant, splendid Seat of Mr. [Charles] Carroll, Barrister. It is a large and elegant House. It stands fronting looking [sic] down the River, into the Harbour. It is one mile from the water. There is a most beautiful walk from the house down to the water."
—*Diary of John Adams (1777), Massachusetts Delegate to the Continental Congress, and later second president of the United States*

From the early settlement of Maryland as a proprietary colony, tobacco dominated the agricultural economy of the tidewater region, taking firm hold in the relatively flat lands of the eastern and western shores. In the vicinity of modern Baltimore, the coastal plain became much narrower, limiting opportunities for this principal cash crop. Throughout the Chesapeake region, port towns of any significance were slow to develop because plantations located along the many waterways could establish their own pier facilities and ship goods back and forth to Europe without the necessity of intermediaries. Direct shipment meant that plantation owners often were better connected to tradesmen and merchants in the mother country than to those in the colony.

As in the neighboring Virginia Colony, the status of laborers was somewhat ambiguous at first. Whites often worked as indentured servants, and some early arrivals of African descent may have had a similar status. However, during the first decades of both colonies, African identity routinely became linked with slave status. By the 1660s, this condition was codified in law. Moreover, both custom and ordinance made it clear that European settlers regarded Africans as racially inferior. As long as there was a stream of white laborers, African slave labor did not predominate in the colonial economy. But from the 1690s onward, the premium placed upon tobacco encouraged increased cultivation, and slave traders supplied their human cargo.

One of the largest plantations in the Gwynns Falls region during the colonial period was the domain of the Carroll family, who early on established themselves as among the most prominent members of early Maryland society. In 1732, Dr. Charles Carroll of

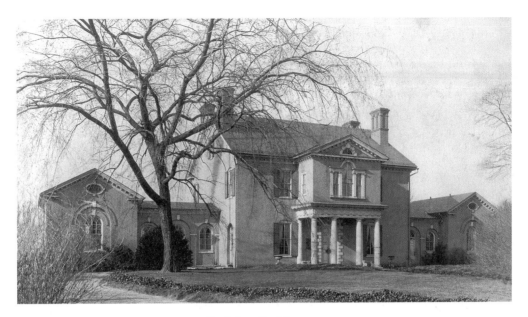

The Mount Clare Mansion, circa 1908. *Enoch Pratt Free Library.*

Annapolis obtained the land patent "Georgia" along the lower Gwynns Falls. Dr. Carroll sold a large portion of the holdings to the Baltimore Company, an ironworks enterprise in which he was an investor, and began a working plantation on the remainder. He also established two of the earliest gristmills along the Gwynns Falls.

In 1760, Dr. Carroll's son, Charles Carroll, the Barrister, completed the Mount Clare mansion in classical Georgian style, and the structure was expanded substantially in 1768. Mount Clare's grounds featured terraced gardens, which sloped from the hillside mansion down toward the river, as well as an orangery and extensive orchard. Tobacco and wheat were the plantation's cash crops, likely cultivated by slaves. In the early period, goods transported to and from the Georgia Plantation were shipped from piers extending into the shallow waters of the Middle Branch near the mouth of the Gwynns Falls.

The Baltimore Company became a significant early industrial enterprise. In 1733, it established a forge on the west bank of the Gwynns Falls to produce crude pig iron. A 1755 map of Virginia and Maryland showed the company and its location, while failing to correctly label the nearby newly established Baltimore Town. Like other iron forges of the era, the operation apparently made use of a variety of labor—free and indentured laborers, but also slaves. As an indication of the scale of the work force, a 1785 notice listed the plant as employing "more than 200 Negroes," almost certainly slaves. The company also acquired vast tracts of land in the area, extending from east of the Gwynns Falls to a point westward as far as Catonsville.

In 1829, James Maccubbin Carroll, the Barrister's nephew and heir, played an important role in the origins of the Baltimore and Ohio Railroad, donating land for its first railway station—named Mount Clare—and for the original rail line right of way across the Gywnns Falls.

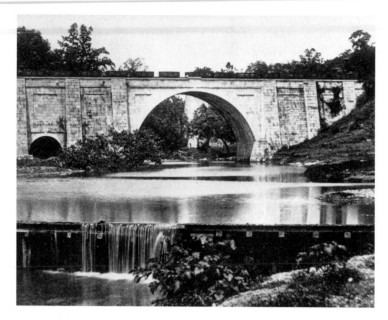

The Carrollton Viaduct, built for the B&O Railroad, spans the Gwynns Falls near the early sites of the Carroll family's gristmills and the Baltimore Company's ironworks. The Gwynns Falls Trail now uses the small arch originally used by a wagon road. *Enoch Pratt Free Library.*

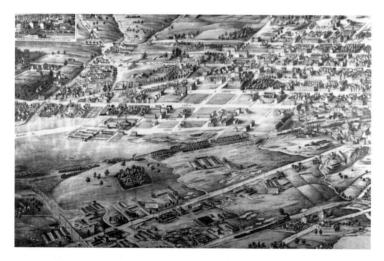

Mount Clare, set on a hillside, surrounded by clay pits, brickyards and other industrial uses, in a Sachse bird's-eye view, 1869. *Enoch Pratt Public Library.*

Members of the Carroll family continued to live at Mount Clare until 1851. During the Civil War, the estate was the site of Federal troop camps. Afterward, brickmaking and other industrial uses dominated the surrounding landscape. Between 1870 and 1889, the German-American Schuetzen Association leased a portion of the land for a shooting range and recreational park. (In recent years, Carroll Park has been the site of Ocktoberfests, continuing to celebrate the city's German-American heritage.) In the period from 1890 to 1907, Baltimore's Park Commission purchased portions of the Mount Clare grounds to provide a large landscape park and playing fields to serve the recreational needs of the

southwestern section of the city, by then an urbanized, working-class district. Since 1917, the Mount Clare mansion has been leased by the National Society of the Colonial Dames of America in the State of Maryland, who keep it open to the public. Mount Clare was placed on the National Register of Historic Places in 1970.

Trailhead 6: the Carroll Park Golf Course and Carroll Park were parts of Mount Clare, the former Carroll estate. The Mount Clare mansion is located on the elevation in Carroll Park.

LAND RECORDS AND EARLY LANDSCAPES IN THE LOWER GWYNNS FALLS WATERSHED
By Daniel J. Bain

Our access to landscape information is unprecedented. First, air travel, then satellite imagery available through Internet outlets, has provided rapid, comprehensive information on land cover. But, for the more distant past, we must depend upon property records to give us a window into the early colonial history of an area like the lower Gwynns Falls watershed.

The Settlement of the Lower Gwynns Falls

As far as we can tell, the first piece of land purchased from British authorities within the Gwynns Falls watershed, Walnut Neck, was surveyed in 1664 for Hugh Kinsey. This property later was incorporated into the land grant called Georgia, surveyed in 1731 for Dr. Charles Carroll, father of Charles Carroll, Barrister. Figure 1 shows a time series of land surveys (property boundaries prepared for purchase) in the lower Gwynns Falls.

Though there is some imprecision due to the loss of original boundary markers, the maps do provide important evidence. For example, though some properties in what would become Baltimore City had been claimed by the late seventeenth century, some areas on the western side remained unclaimed after lands for Baltimore Town were charted (1731). English movement onto the Piedmont uplands was slow, as soils there were not especially well suited to tobacco cultivation. The records also suggest that ridge-top properties seemed to be more desirable than valley-bottom properties, since it is difficult to farm a hillside. As late as the 1730s, portions of the Gwynns Falls basin remained unclaimed, likely due to the rough terrain that is preserved today in valley areas like those in Leakin and Gwynns Falls Parks.

In the late seventeenth and early eighteenth century, a number of influential figures purchased land in western Baltimore, and their grants continue to influence the area's cultural landscape. Among them (shown in Figure 2) were Georgia, the Carroll estate; Ridgely's Delight, the estate of Charles Ridgley; Pemblicoe, the tract surveyed for John Oldton; Maiden's Choice, Thomas Cole's tract and the name given to a tributary of the Gwynns Falls; and Chatsworth, the land of George Walker.

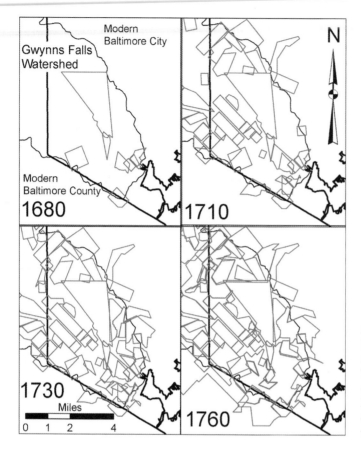

Figure 1: The grey lines show boundaries for properties surveyed in the years indicated. The thick dark lines are contemporary Baltimore city limits and the thin dark line outlines the Gwynns Falls watershed. *Daniel Bain.*

Early Landscape Changes in the Lower Gwynns Falls

Surprisingly, there were likely more trees in the lower Gwynns Falls watershed at the turn of the twenty-first century than there were at the turn of the nineteenth century. By 1733, a group of prominent figures in colonial Maryland, organized as the Baltimore Company, had built an iron furnace near the mouth of the Gwynns Falls. This furnace—the first financed solely through colonial capital funds—had special consequences for the early Gwynns Falls landscape.

One of the ingredients essential to the manufacture of pig iron, in addition to iron ore and flux (usually limestone), is fuel. Early iron refining processes commonly used fuel, flux and ore layered in the furnace. In this arrangement, any fuel that creates explosive gas during combustion disrupts layering and lowers the efficiency of the refining process. Modern iron and steel manufacture uses coke or coal that has been baked to remove volatile substances. However, during the 1700s, fuel for iron refining was traditionally charcoal, or wood that had been partially combusted to remove volatile materials. Therefore, iron production required many trees to provide this charcoal.

Baltimore Company iron was largely exported as pig or bar iron (raw material). Based on the best compilation of production records for its iron furnace (for a four-year period

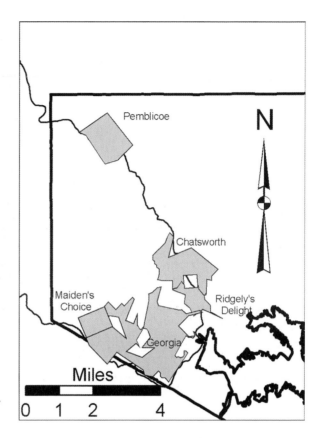

Figure 2: The location of prominent early Baltimore-area land grants. *Daniel Bain*.

between 1734 and 1737, as compiled by Keach Johnson), the company was exporting an average of five hundred tons of pig iron to England each year. Using this number, we can estimate rates of deforestation necessary to sustain this production of pig iron. We know a ton of pig iron required, on average, one and a half "loads" of charcoal (a "load" is equivalent to 120 bushels of charcoal). For one load of charcoal, it took 2.5 cords of wood. So a typical year of production required 1,250 cords of wood. An acre of forest generally yields between 10 to 30 cords of wood, depending on the tree species and local soil and water status. Therefore, the Baltimore Company was clearing between 40 and 120 acres of land every year during this period. As furnaces were added by the company, it is likely that production in the mid- and late 1700s was sustained, if not increased. Moreover, this estimate only accounts for wood devoted to charcoaling, much less to heating or building. To put it in another perspective, every year the Baltimore Company cut 0.2 to 1.0 percent of the 14,000 acres of the Gwynns Falls watershed lying within present-day Baltimore city limits simply for charcoal. At the upper end of this estimated rate, the lower Gwynns Falls could have been completely cleared by 1833 from charcoaling alone!

Land records also provide additional lines of evidence for significant clearing in the lower Gwynns Falls watershed before the turn of the eighteenth century. Figure 3a shows properties the Baltimore Company or its co-owners purchased in the lower Gwynns Falls watershed according to account books and certificates of survey. These properties cover

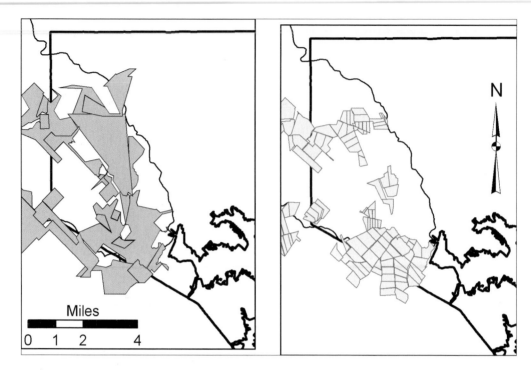

Figure 3: Map a indicates properties owned by the Baltimore (Iron) Company in the lower Gwynns Falls. Map b shows the lands auctioned off upon liquidation of the company in the early 1800s. *Daniel Bain.*

a substantial portion of the lower watershed. The estates of the early Baltimore gentry were not located in the middle of the watershed, likely due to the presence of Baltimore Company lands, which dominated landholdings in the lower Gwynns Falls. Figure 3b shows the actual locations of lots auctioned off during dissolution of the Baltimore Company (circa 1810), revealing that its lands covered at least 40 percent of the lower Gwynns Falls watershed at that time.

Descriptions of the lots auctioned off in 1810 (depicted in Figure 3b) provide an additional piece of evidence indicating how extensively forests were cleared in the lower Gwynns Falls. Roughly 10 percent of the lots contain descriptions of the property contents (for example, "thriving young woods, thin soil" [Lot 34] or "20 a[cre] old field, the remainder gravelly soil indifferently wooded" [Lot 27]). It is likely that lots so described had been almost completely cleared. In contrast, even with its long history as an urban center, the contemporary lower Gwynns Falls contains roughly 12 percent forest. There is no doubt that iron production and the charcoal it required radically altered the lower Gwynns Falls before the turn of the eighteenth century.

Remarkably, these early land grants and the ways that early property owners made use of the land still impact the shape, character and natural environment of the area today.

Port of Baltimore

"QUEEN CITY OF THE CHESAPEAKE"

"Whether the city of Baltimore was located by accident or design, her citizens have cause for congratulation that they enjoy a location the best of any Atlantic cities for residence, commerce, trade, and manufacture."
 —*J. Thomas Scharf,* History of Baltimore City and County *(1881)*

"Baltimore was the place of possibilities she remembered from her childhood. When she was a girl in Virginia, Baltimore had always been the great city at the end of the steamboat trips."
—*Lucy Baker, remembering a journey with her father on a Chesapeake Bay steamship from tidewater Virginia, early twentieth century (from Russell Baker's autobiography,* Growing Up *[1982])*

Baltimore was a late bloomer in colonial America, not chartered until 1729, nearly a century after Maryland's first settlement at St. Mary's City. But its potential as a port was key to its establishment, and by 1800—only seventy-one years later—it had grown rapidly to become the new nation's third largest city (behind New York and Philadelphia, surpassing Boston). The cultivation of grain by settlers in the hills of central Maryland was transforming an economy previously dominated by tobacco, grown in the flatter lands of the tidewater. The Northwest Branch (including the Inner Harbor and Fells Point) became the principal location for shipping, shipbuilding and ship maintenance, but similar operations also lined the shores of the Middle Branch, near the mouths of the Patapsco River and the Gwynns Falls.

The strategic location of the port received a major boost with the construction of the new nation's first railroad, the Baltimore and Ohio (B&O), on which work began in 1828. Afraid that major canals connecting other Eastern cities to developing Western lands would give them competitive advantages, Baltimore leaders gambled on the risky new technology of rails and steam-powered trains. By the 1850s, the B&O had reached the Ohio River Valley, connecting the markets of the Midwest with the port at Baltimore.

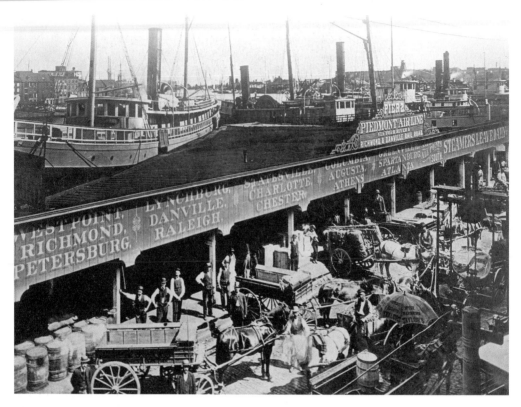

Horse-drawn wagons line up at the Light Street Wharf where steamships await, 1900. *Enoch Pratt Free Library.*

For the next century, the city could claim a unique advantage as the westernmost of major Atlantic ports, with excellent rail connections to the interior.

Competition for these markets, especially for the coal and steel of the Appalachian region, led in the early twentieth century to the extension of the Western Maryland Railway (WMR) into the mountains of Pennsylvania. To connect to the harbor, the WMR ran its tracks down the lower portion of the Gwynns Falls Valley (paralleling parts of the route of today's Gwynns Falls Trail), crossed the Middle Branch on a bridge (still extant, with its turntable at the center of the channel) and built major port facilities for grain and coal export and for iron ore import on the north side of the Middle Branch at Port Covington. The railroad's pier operations at Port Covington ceased in 1973, but today the north shore features a cable ship terminal and containership berths at the South Locust Point Marine Terminal.

From Baltimore's earliest days, shipbuilding represented an important port-related activity. Maritime enterprises at Fells Point on the Northwest Branch centered on ship construction and repair. In the first half of the nineteenth century, laborers—white and black, the latter both free and slave (including the young Frederick Douglass)—caulked ships there. Competition for scarce jobs led Isaac Myers in 1866 to establish the Chesapeake Marine Railway and Dry Dock Company, one of the first African

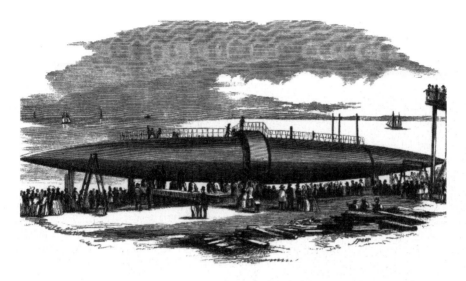

Winans's first of four "cigar-shaped" iron boats constructed between 1857 and 1866. This one was built at Winans Cove (Port Covington), Baltimore, 1858. Scientific American, *November 6, 1858, New York*.

American–controlled enterprises of its kind. Baltimore earned a reputation for building "Baltimore Clippers," fast sailing ships with spacious cargo capacities. The era of steamships was ushered in as early as 1813, with the locally built *Chesapeake*, and by the 1840s and 1850s, area shipbuilders were turning out bay "steamers."

In the mid-nineteenth century, pioneer railroad designers and builders Ross Winans and his son Thomas established a pier and shipyard on the north shore of the Middle Branch at Ferry Point (near the present Hanover Street Vietnam Veteran's Memorial Bridge). Their operations included experimental ship design; the most notable—though ultimately a failure—was the series of "cigar ships," with streamlined features resembling later submarines. Baltimore shipbuilding had a major resurgence during World War II, when the U.S. Navy's Liberty ships were constructed rapidly at Bethlehem Steel's facilities in Fairfield on the southeast side of the Patapsco's Middle Branch.

In the nineteenth century, steamships made Baltimore "the Queen City of the Chesapeake," as a network of shallow-bottomed vessels plied the waters of the bay and its tributaries, linking the city with smaller towns and cities throughout the tidewater area of Maryland and Virginia. When rural residents of Virginia's tidewater, like Lucy Baker and her father, went to the city, it was to Baltimore by steamship, not overland to Richmond. Baltimore ships not only dominated the Chesapeake, but they carried on a lively trade with South American and European ports. Both Liverpool and Bremen became major connections for transatlantic commerce. B&O Railroad arrangements with the North German Lloyd Line from the 1860s onward brought thousands of European immigrants to passenger terminal facilities on the north side of Locust Point, and at one time, the Point was second only to New York's Ellis Island in its volume of newcomers. Arriving from Germany, Eastern Europe, England and Scandinavia, some immigrants settled in Baltimore, but many took the railroad to points west.

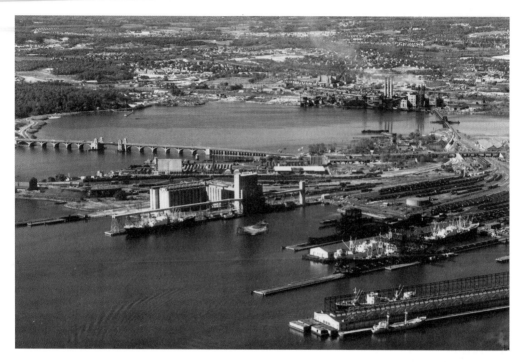

Aerial view of the Middle Branch, with the Western Maryland Railway's Port Covington terminals in the foreground, the rail bridge to the industries of Westport in the upper right and the Hanover Street Bridge across the Middle Branch to the left, center, 1959. *B&O Railroad Museum.*

Following World War II, shipbuilding declined and port volume stagnated. If Baltimore had a competitive advantage in the era of the railroad, it lost that edge in the era of the truck. However, new highways—especially the interstates—accompanied by the construction of the Harbor Tunnel in the 1950s and the Fort McHenry Tunnel for I-95 in the 1980s, eased traffic bottlenecks for the port. The establishment of the Maryland Port Authority (MPA) in 1956 provided the leadership of a state agency to help the Port of Baltimore respond to changing times, especially the revolution in cargo transport ushered in by container shipping. The MPA, which became the Maryland Port Administration in 1971, also facilitated the growth of auto import and export facilities. Today, terminals in the vicinity of the former Fairfield shipyards (near the Harbor Tunnel crossing), together with those across the water at Dundalk, make Baltimore one of the leading United States ports for auto shipment.

On the occasion of the celebration of the 300th anniversary of the port, it was credited with directly providing sixteen thousand jobs, as well as another seventeen thousand indirectly. Increasingly, in recent years, the port's shipping and waterfront industrial operations have migrated to Outer Harbor areas as residential and commercial redevelopment has come to predominate in the Inner Harbor and other historic waterfront locations.

Trailhead 7: Baltimore's Inner Harbor.
Trailheads 8 and 9: views of port activity across the Middle Branch on Locust Point.

Harborside
Neighborhoods
FROM EARLY URBAN SETTLEMENT TO URBAN HOMESTEADING

"Otterbein is best known as one of America's most successful attempts at urban homesteading."
—*Baltimore Commission for Historical and Architectural Preservation (2004)*

Two of the city's oldest neighborhoods—Federal Hill and Otterbein—had their starts as urban settlements beside the growing port of Baltimore. Their location near the water has always been the key determinant for these two adjacent communities, even as their social and economic circumstances have changed over the years. The two flourished in the heyday of shipping and the industrial activities that grew up nearby. This was the era of the walking city, when the proximity of work and residency was a priority for citizens of all income levels, except the most wealthy. However, the area experienced economic decline a century ago, when urban congestion and new transportation modes enabled outward migration and the Inner Harbor location was no longer deemed prime, either for shipping or for other industrial uses. The aging neighborhoods were held in such low regard that they were targeted for displacement by highway expressway planners, a threat a coalition of activists fought and eventually won. In recent decades, Federal Hill and Otterbein have been rediscovered by those attracted to their historic character and easy access to the waterfront, the amenities of the Inner Harbor and downtown. Today, they are prime examples of historic preservation, and both are registered historic districts.

The high ground of Federal Hill was noted in 1608 by Captain John Smith as one of several distinctive clay hills standing above the tidal areas at the mouth of the Patapsco River. It took its present name as the site of celebrations for Maryland's ratification of the federal constitution in 1788. For many years, an observatory for spotting ships arriving at Baltimore's harbor was located there. The hill was also mined, with tunnels carved out of its interior to tap deposits of iron ore and sand. In the 1870s, the promontory, offering some of the best views of the Inner Harbor and the Northwest Branch, was purchased for a city park. The oldest surviving rowhouses (both frame and brick) date to the early

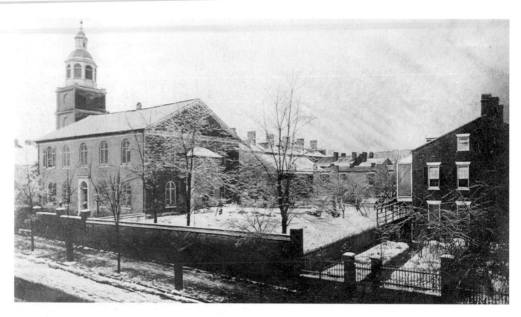

Otterbein Church, built in 1785, Baltimore's oldest religious structure in continuous use, 1932. *Enoch Pratt Free Library.*

nineteenth century and were built in the Federal style, with gabled roofs and dormer windows. By mid-century, popular architectural tastes embraced Italianate styles; the flat façades of two- and three-story rowhouses featuring ornamented window and door lintels, as well as decorative cornices.

The area known today as Otterbein, situated on the flatter land immediately west of the Inner Harbor, had a similar history of development. In an era when the primary mode of transportation was walking, urban neighborhoods like these housed residents of varied social and economic statuses and contained residential, industrial and commercial functions. Otterbein is a particularly good example of this mix. Its major streets (West Lee Street, for example)—feature large two- and three-story rowhouses, which originally housed the economically more advantaged, like merchants, professionals and (in this waterside location) sea captains and others with leading roles in the shipping industry. Side streets typically housed those of more modest means—artisans, lesser merchants, clerks—in smaller rowhouses. Alleys (like Welcome Alley) consisted of small, narrow rowhouses, which were the dwellings of servants and laborers (both black and white).

The compact urban area also contained multiple industries. To its immediate east were the bustling wharves of steamship companies; to the west (from the 1850s) were the tracks and terminals of the B&O Railroad; and scattered amidst the rowhouses were major city markets, tobacco and chair manufacturers, breweries, bakeries, boiler and wagon works and oyster packinghouses. (These examples are evident in city directories and maps from the period from 1850 to 1910.) The social mix of the area was manifest as well—Protestant and Catholic churches and a Jewish synagogue testified to religious variety, while the distinction between schools designated as "primary" and "colored," as

A Federal-style rowhouse on Montgomery Street, with gabled roof and dormers, 1936. *Enoch Pratt Free Library.*

well as the presence of several nearby African American churches, provided evidence not only of an interracial population, but also of racial segregation.

By the latter part of the nineteenth century, Federal Hill and Otterbein had become predominantly working-class neighborhoods. Street railways, which crisscrossed the area, enabled the more economically advantaged to seek residence in the developing urban periphery, from which they could commute to center city employment and shopping. Aging housing, crowded urban conditions, traffic congestion and proximity to commercial and industrial functions all fostered the exodus. Those who remained typically worked in less skilled industrial and laboring occupations. The larger residences, once the homes of an elite, now often housed large families and boarders. When the Great Depression of the 1930s heightened economic adversity in inner city locations, many of the properties were held by absentee landlords and some had become vacant.

When highway planners began to develop proposals for modernized roadways to serve the needs of the area in the post–World War II period, the routes they chose converged on the oldest sections of the city, their logic governed both by transportation efficiency and by a conviction that highways could also serve as agents of "slum removal." With the advent of the federal interstate highway program in 1956, these considerations led to plans for a Baltimore expressway system in which the routes eventually designated I-95, I-70 and I-83 would have converged in downtown Baltimore, spanned the Inner Harbor on a multilane bridge and demolished substantial portions of Otterbein, Federal Hill and Fells Point. To protect those areas, opponents formed the Society for the Preservation of Federal Hill and Fells Point in 1967 and joined together with other citywide opponents in the coalition they called MAD (the Movement Against Destruction). Hoping that protection could be enhanced through the National Register of Historic Places, the society succeeded

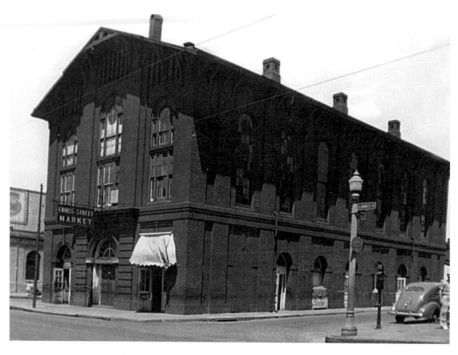

The Cross Street Market, which served South Baltimore residents, housed merchant stalls on the first floor and a meeting room on the second. This structure burned in 1951 and was replaced by the current building in 1952. *Enoch Pratt Free Library.*

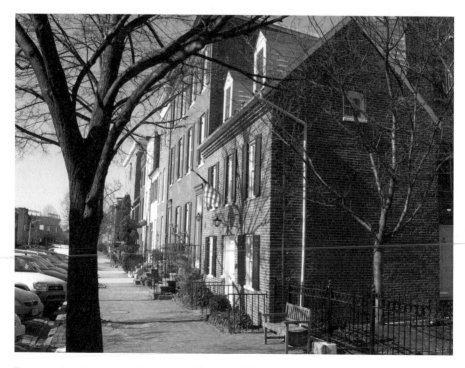

Renovated rowhouses on Montgomery Street in Federal Hill today. *Guy Hager.*

in gaining historic district status for Fells Point in 1969 and Federal Hill in 1970—these were among the first such designations for districts nationally. Snowballing opposition in the 1970s led highway planners to make substantial alterations; I-95 was rerouted to the southern edge of South Baltimore, sparing both Federal Hill and Otterbein, and I-83 ended as a boulevard near the Inner Harbor, leaving Fells Point intact.

By the 1960s, Federal Hill had indeed become a distressed community, and in Otterbein, where properties had been acquired by the city for the highway route, houses stood forlorn and vacant, enclosed by chain-link fences. However, at that same time, a small number of new residents, attracted to the area by the combination of low prices, historic character and convenient location, had grasped the potential of the rehabilitation and preservation of the historic structures and began renovation efforts on portions of Montgomery Street and Warren Avenue in Federal Hill.

Baltimore housing officials, wanting to encourage the renewal of properties held by the city, developed the innovative Urban Homesteading Program. Sometimes referred to as the "Dollar House" plan, it provided for the purchase of distressed housing for one dollar, with the important provisions that the houses be restored according to code and the homesteader reside there for at least five years. First employed on Sterling Street on a small scale, Urban Homesteading was applied to the Otterbein section in 1975. Not knowing what kind of response to expect for structures that, in many cases, were little more than shells, housing officials were surprised by the volume of requests for Otterbein houses and had to resort to a lottery to equitably accommodate the demand. Adding to the attraction of both the Federal Hill and Otterbein neighborhoods was the major redevelopment of the Inner Harbor waterfront, in which aged commercial, industrial and shipping facilities were demolished and replaced with a waterside promenade, a park, the Rouse Company's Harborplace festival marketplace, the Maryland Science Center, the National Aquarium and other amenities that helped to turn the harbor area from a neglected backwater into a lively entertainment center, tourist attraction and open space.

Today Federal Hill and Otterbein are success stories of the renovation and preservation of historic neighborhoods. Housing values are high, and renovation, as well as new construction, has spread far beyond their immediate limits. One irony has been that most renovators were newcomers without prior ties to the area, so that architectural preservation has not necessarily assured continuity with earlier generations of residents. Indeed, in the case of Otterbein, the entire section had been vacated prior to resettlement. As a further irony, the name Otterbein was not the historic designation of the homesteading district. Instead, city housing officials took it from the Otterbein Church (originally United Brethren and now United Methodist), itself one of the oldest structures in this part of the city. The church is now surrounded on three sides by the modern Baltimore Convention Center—its survival a fitting reminder of a much earlier and very different period in the city's saga.

Trailhead 7: Inner Harbor. The trail's route passes through the Federal Hill neighborhood on Henrietta and Williams Streets and the Otterbein neighborhood on Lee and Sharp Streets.

African American Heritage in Sharp-Leadenhall

By Eric Holcomb

"What, to the American slave, is your 4ᵗʰ of July? I answer: a day that reveals to him, more than all other days in the year, the gross injustice and cruelty to which he is the constant victim."

—Frederick Douglass, address in Rochester, New York, July 5, 1852

Today, the neighborhood of Sharp-Leadenhall is surrounded by Otterbein, Federal Hill, South Federal Hill and the Stadium Area. Extensive city planning activities of the 1960s through the 1980s created and named these neighborhoods, but the historic African American community that took roots in this vicinity contributed greatly to Baltimore, as well as to the causes of abolition and civil rights. Many historic houses, churches and other structures in the vicinity are lasting reminders of an African American community that challenged slavery and segregation.

In the pre–Civil War era, South Baltimore became home to many free African Americans. They lived alongside Baltimore's white working class in jobs as coopers, caulkers, laborers, draymen, bootblacks, waiters, oystermen, sawyers and laundresses, among others. Many owned their homes. By 1851, fifteen hundred African Americans lived in the area bounded by Hill, Hanover, Cross and Eutaw Streets.

Although African Americans resided in every part of the city, several significant early African American institutions were located on or near Sharp Street. One of the first, the African Academy, formed out of a partnership between free African Americans and the Quaker-led Maryland Society for Promoting the Abolition of Slavery and the Relief of Free Negroes, and Others, Unlawfully Held in Bondage (also known as the Maryland Society), the first abolitionist organization in the South. The society appointed a committee to raise subscriptions for a permanent school for African Americans, established in the 1790s.

In the same building, African American scholar Daniel Coker (1780–circa 1846) opened the Sharp Street School in 1807. Born into slavery, Coker escaped to New York, converted to Methodism and then moved to Baltimore, where he remained a fugitive

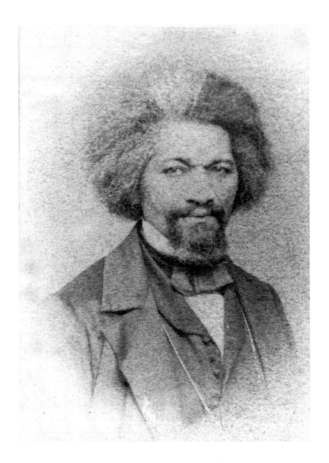

As a slave in Baltimore, Frederick Douglass attended Sharp Street Church. In 1838, he escaped to freedom and became a noted leader of the abolitionist movement. *National Park Service, Museum Management Program and Frederick Douglass National Historic Site.*

slave until several prominent free black residents bought his freedom. Under Coker, the school grew to national prominence. At the time, Coker also wrote *A Dialogue Between a Virginian and an African Minister*, one of the earliest abolitionist tracts by an African American. In 1816, he helped found the African Methodist Episcopal Church, the first denomination to separate from its parent church because of race, not theological differences.

William Watkins, who succeeded Coker as schoolmaster from 1820 to 1852, also became a leading abolitionist. He was a contributor to *The Liberator*, William Lloyd Garrison's paper, directly influencing Garrison. He also was a co-founder of the Literary Society, which taught debating techniques and discussed current affairs and philosophical movements. Another figure associated with the Sharp Street School who proved influential was Lewis G. Wells, Baltimore's first known African American physician. Frederick Douglass, who escaped from slavery in Baltimore to become a leading abolitionist, credited Wells with inspiring him to realize that "a black man...[could] display so much learning" and providing him with "a higher opinion of the possibilities for and capacity of his race than he ever had before." William Watkins Jr. coedited the *North Star* with Frederick Douglass, and Frances Ellen Watkins Harper became a famous abolitionist poet.

The Sharp Street Methodist Church, the city's oldest African American United Methodist congregation, now located in West Baltimore, formally began in 1797, when several African Americans began worshiping at the African Academy. As early as 1807, the congregation owned the church, a parsonage and several houses. The congregation grew quickly, and by the 1860s it provided the community with an "intelligence bureau" (employment agency) and Sabbath school, and it also sponsored several fraternities and societies.

Like the Sharp Street church, Ebenezer African Methodist Episcopal (AME) Church became an important institution. In the mid-1830s, African Americans in South Baltimore organized a prayer group and purchased the current church site at 18–30 West Montgomery Street, converting a two-story frame structure used as a carpenter's shop into a meetinghouse. In 1848, the congregation erected a new building. A *Baltimore Sun* article in that year reported that it

> *constitutes quite an ornament to the neighborhood. It is constructed in a very credible manner containing side and front galleries, the former reserved for a flourishing Sabbath school attached to the station and the latter used by the choir. The church is provided with very neat lamps and the pulpit forms one of the most prominent ornaments of the interior whilst seats are so arranged as to seat, very conveniently, about 600 persons.*

From 1839 to 1849, Ebenezer also operated a day school, which continued under different auspices for a number of years. Today, Ebenezer thrives as the oldest standing African American church in Baltimore.

By the time of the Civil War, South Baltimore harbored three African American churches, including John Wesley Methodist Chapel (circa 1838), a police station, two private African American schools and the Cross Street Market. But during this time, the city's free black population was under siege. In 1841, for example, Maryland made it illegal for free African Americans to "knowingly call for, receive, or demand abolitionist literature from the Post Office." In 1845, the state outlawed any meetings held by African Americans, except at regular houses of worship. One source of increased tension was the fact that African Americans increasingly competed for jobs with European immigrants, producing intense rivalries. The new arrivals took skilled jobs away from African Americans, especially those associated with shipbuilding and railroading. Pressure on housing also intensified for African Americans in the Sharp-Leadenhall area when the B&O Railroad acquired a swath of land between Howard and Eutaw Streets for its future Camden railroad yards, displacing hundreds of African Americans in the area.

Closely connected with the African American community in the pre–Civil War years was the strong Quaker presence in this vicinity. In 1808, at least twenty-three influential Quakers resided on or near Sharp Street and built a meetinghouse on Lombard Street. Many of them were active in the Maryland Society. During its short existence, the society succeeded in gaining revision of Maryland's manumission law to allow the freeing of slaves in one's last will and testament, helped organize the African Academy, sponsored

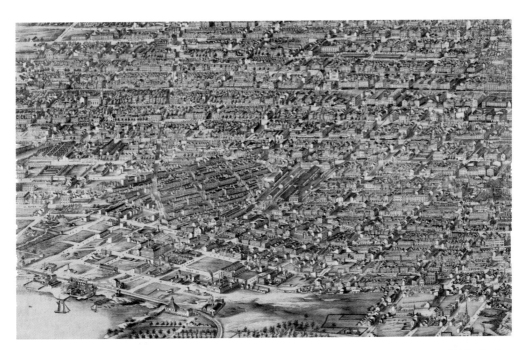

A Sachse bird's-eye view depicts the residential and industrial density of South Baltimore in 1869. *Enoch Pratt Free Library.*

many petitions of freedom (known as freedom suits), helped Benjamin Banneker prepare and print his first almanac and advocated for the end of slavery.

Elisha Tyson, the most famous Quaker abolitionist within this community, came to Baltimore from Philadelphia and, sometime in the late 1790s, moved to Sharp Street, directly across from the African Academy near Sharp and Pratt Streets. In the early 1800s, he retired from business and devoted the rest of his life to abolitionism, forming the Baltimore Protection Society, a group that actively intervened to prevent the kidnapping of free Baltimore African Americans by slave traders. When he died in 1824, over two-thirds of Baltimore's African Americans attended his funeral.

Other significant abolitionist activity took place along the Sharp Street corridor. In 1824, Benjamin Lundy, editor of the *Genius of Universal Emancipation*, the first antislavery newspaper in America, moved to Baltimore and continued to produce the publication here. In 1828, he asked William Lloyd Garrison to come to Baltimore and serve as editor. During his short stay, Garrison became acquainted with leading free African Americans, including William Watkins, who became a frequent contributor to *The Liberator*, and Hezekiah Grice, who organized in Baltimore a "Legal Rights Association" and initiated the first free colored persons' convention.

Area churches actually served both free blacks and slaves. They also provided meeting places to discuss and solicit funds to purchase slaves' freedom, as when members of Ebenezer freed a lay minister who had been jailed by a slave trader. The underground railroad—a clandestine network that aided runaway slaves—had South Baltimore

connections. Records document how Elisha Tyson helped fugitive slaves in their flight to reach sympathizers in Chester, Pennsylvania. The role of South Baltimore residents in underground railroad activities is also illustrated by the following case:

> *I was sold by him* [Mr. Mayland] *to a slave trader to be shipped to Georgia; I was brought to Baltimore, and was jailed in a small house on Paca near Lombard. The trader was buying other slaves to make a load. I escaped through the aid of a German shoemaker, who sold shoes to owners for slaves. The German shoe man had a covered wagon; I was put in the wagon covered by boxes, taken to* [a] *house on South Sharp Street and there kept until a Mr. George Stone took me to Frederick City where I stayed until 1863, when Mr. Stone, a member of the Lutheran church, had me christened giving me the name of James Wiggins.*

By the end of the Civil War, most of the area of Sharp-Leadenhall was densely developed, with close to sixty houses to an acre. The occupations of many of the African American residents varied greatly: soldiers, lumber workers, boardinghouse operators, teachers, rope makers, coal workers, woodworkers, herb doctors, engineers, plasterers, farmers, boatmen, seamen, carpenters, fishermen, oyster shuckers, stevedores and wheelmen. After the Civil War, South Baltimore's African American community continued to increase in numbers, in part because of massive migration from the South.

During this period of increased activity, Sharp Street Methodist Church opened Mount Auburn Cemetery. It also helped to establish a citywide ministerial alliance, organize the first African American YMCA and form the Centenary Biblical Institute (the institution that eventually became Morgan State University). During this period, African Americans, many of them new migrants from the South, founded the Leadenhall Baptist Church, which opened in 1872. The church structure at 1021–23 Leadenhall Street was placed on the National Register of Historic Places in 1979.

Throughout the first half of the twentieth century, South Baltimore again became a victim of the ever-changing urban landscape. The B&O increased its Camden tracks and railroad yards, and many industrial buildings expanded or moved to the area, further decreasing the number of residential properties. However, during both world wars, rural African Americans and whites continued to migrate to Baltimore, placing pressure on South Baltimore's neighborhoods. A new threat emerged after World War II, when highway engineers began drawing plans to build expressways into and through Baltimore. In anticipation, the city government, in 1966, demolished 360 houses and relocated 3,000 residents. In the course of the following eight years, approximately 620 additional families were relocated, over 80 percent of them African Americans.

During this period of extraordinary change, several positive activities occurred. Local resident Mildred Mae Moon (1924–92), as part of a citywide coalition, squelched the east–west highway proposal, forcing the main route of Interstate 95 to the south—though the I-395 connector to downtown eventually did infringe upon the neighborhood. And in 1980, she convinced government officials to reallocate some of the highway funds to

Mildred Mae Moon led the fight to spare the Sharp-Leadenhall community from a threatened urban expressway and later fought for affordable housing. *Guy Hager.*

build a seventy-seven-unit senior housing mid-rise project and one hundred townhomes. In recognition of her efforts on behalf of the Sharp-Leadenhall neighborhood, in April 1993, the Hamburg Street Bridge was dedicated to Mildred Mae Moon.

Today, the neighborhood is much changed from its pre– and post–Civil War history, surrounded as it is by new elements like the Convention Center, the Camden Yards baseball and football stadiums and principal rail and roadway arteries. Long gone are some of the early institutions—like the Sharp Street Church and the Friends Meetinghouse, both of which relocated a century ago to follow their members to locations in North and West Baltimore. However, there are still such reminders of the past as the Leadenhall Baptist Church and the rowhouses of the residential neighborhood south of Hill Street.

West of Trailhead 7, the Gwynns Falls Trail follows Sharp Street, the historic center of the community, and passes through Solo Gibbs Park, named to honor a neighborhood leader. The Leadenhall Baptist Church and the remaining historic residential areas are just to the east of the trail.

Baltimore's First Economic Boom

FLOUR MILLING

Of the Ellicott Brothers: "Their operations produced such great changes in the manufacture of flour that they are justly entitled to the proud distinction of being the real progenitors of modern milling in Maryland."
—*Thomas Scharf,* History of Baltimore City and County *(1881)*

It is hard to recognize today, but flour mills along the Gwynns Falls, Jones Falls and Patapsco River contributed to Baltimore's first economic boom. Though it was little more than a waterside village when it was established late in the colonial period (1729), by 1800 Baltimore had become the third largest city in the new nation, and flour milling was largely responsible for its dramatic early growth. Tobacco, raised on the coastal plains of the eastern and western shores, dominated the economy of the early Maryland Colony, but the uplands of central Maryland, settled later, were more suited to the cultivation of grain, which replaced tobacco as the principal cash crop. The natural fall of the streams as they tumbled from the hills of the Piedmont to the coastal plains of the Chesapeake provided water power. Energy from the falling water could be maximized by diverting the flow along a millrace that followed the contour of the hillside to a point where it sent water cascading down from the heights to turn the wheels below.

In the colonial period, gristmills served the needs of larger landowners—like the Carrolls—or of nearby farmers. However, by the late 1700s and early 1800s, newer and larger merchant mills were capitalist enterprises, purchasing grain from a number of sources, employing large-scale grinding operations and selling flour products to local or distant markets. In the first quarter of the nineteenth century, Baltimore-area flour was being shipped to the West Indies, South America and Europe, and in the 1820s, Baltimore overtook Philadelphia as the leading producer in the United States. Following the Civil War, extensive grain cultivation in the recently settled mid-continent shifted flour production westward, and in the late nineteenth century, massive mills like those in Minneapolis made Baltimore-area operations obsolete. By 1900, most mills along the Gwynns Falls and its neighboring valleys had become idle, and many lay in ruins from floods and neglect.

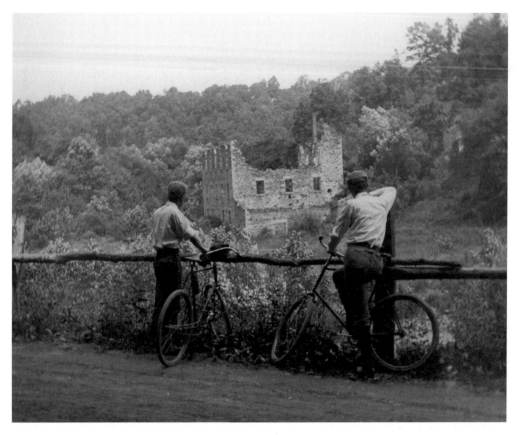

Bicyclists view the ruins of an old mill on the Gwynns Falls, 1899. *Enoch Pratt Free Library.*

The Ellicott brothers—Joseph, John and Andrew—played a major role in the transformation of the Baltimore region's new grain-based economy, establishing a network of operations that ushered in the era of merchant millers. Originally from Pennsylvania, the Ellicotts migrated to Maryland in the 1770s and established a major flour mill complex near Ellicott City. They selected the site because the fall of the Patapsco River in that vicinity could provide strong water power to turn their mill wheels. In the 1790s, the Ellicotts also built a complex known as Three Mills along the Gwynns Falls at Frederick Avenue, with the millrace extending from a dam just below Edmondson Avenue.

The Ellicotts encouraged farmers in the hills of central Maryland to shift to wheat cultivation and to use lime to make their fields more fertile. The brothers, along with inventor Oliver Evans, were pioneers in the introduction of new automated, labor-saving mill technology. Recognizing the need for suitable transportation, they helped establish the Frederick Turnpike for wagons, which carried their products from the Patapsco River and Gwynns Falls mills to the port of Baltimore. At the Inner Harbor, they built a warehouse for storage and a wharf for the shipment of their flour. The merchant mill empire of the Ellicotts flourished into the first decades of the nineteenth century.

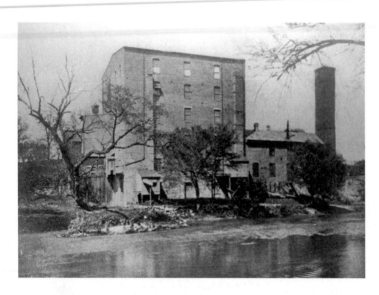

A flour mill on the lower Gwynns Falls, 1895. *Enoch Pratt Free Library.*

However, financial hard times reduced their fortunes soon thereafter. While milling continues at Ellicott City to this day (though no longer associated with the Ellicotts), only one of the Three Mills buildings on the Gwynns Falls still stood by 1900—a monument to an earlier era. Today, there is no remnant of any of the Three Mills structures. The falls and dam at the head of the millrace were devastated by major floods in 1866 and 1868, and in 1917, Ellicott Driveway had been completed along the route where water to power their mills once flowed.

Upstream along the Gwynns Falls, where the valley widens just north of Edmondson Avenue, five flour mills, known collectively as the Calverton Mills, were established in 1813 in close proximity to one another along Calverton Road (later known as Franklintown Road). To power the mill wheels, an impressive millrace diverted water from the Gwynns Falls some three miles upstream and then conveyed it along the contour of the steep eastern walls of the valley to the point where its descent could produce considerable energy. Ellicott family members were among those involved in the ownership of these operations, and Calverton Mill owners participated in the establishment of the Frederick Turnpike downstream. Prominent among the proprietors were members of the Vickers family—Joel and George—who built Mount Alto as their estate home on the uplands near Garrison Avenue. The mills suffered major damage from flooding in 1866 and from a fire in 1888. By that time, flour milling was on the decline in Baltimore. In 1913, only a few remnants of the mill structures survived as picturesque reminders of an earlier era, and the millrace course had been filled in to become a popular strolling path in the newly established Gwynns Falls Park. Today, recreational users of the Gwynns Falls Trail travel along the tree-lined upper portions of the old millrace in the section between Windsor Mill Road and Hilton Parkway; they also cross the outlet of the old watercourse where it empties into the Gwynns Falls at the southern edge of Leon Day Park near the railroad bridge.

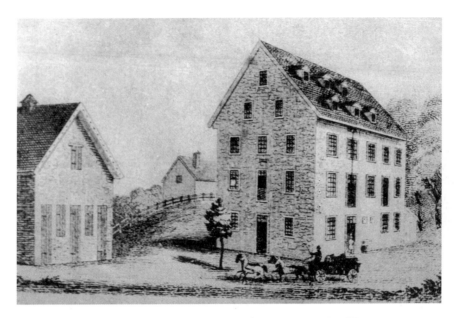

A mill at Calverton, from a newspaper print, undated. *Enoch Pratt Free Library.*

Young volunteers at work near the Gwynns Falls Trail. *Heide Grundmann.*

Trailheads 3, 4 and 5: from Trailhead 3 to Morris Road, the trail follows the path formed when the Calverton millrace was filled in. The Calverton Mill complex was located to the east of Leon Day Park (Trailhead 4). Between Trailheads 4 and 5, the trail makes use of Ellicott Driveway for its route between Edmondson and Frederick Avenues.

A Gristmill Village

FRANKLINTOWN

"The scenery along it [the Franklin Turnpike] is romantic and picturesque, and well repays the drive which the stranger may take to visit it. The road is Macadamised, and is, of course, decidedly the best turnpike in Baltimore."
—*John. H.B. Latrobe,* Picture of Baltimore *(1832)*

Franklintown is one of several communities along the Gwynns Falls that retain reminders of their origins as rural villages, even though they became part of Baltimore City in the annexation of 1918 and long have been surrounded by modern metropolitan Baltimore. The settlement grew up around an early gristmill, and the Franklin(town) Turnpike connected rural areas of western Baltimore County with city markets. Franklintown was also one of the area's earliest suburban communities, planned in the 1830s as a residential settlement some five miles from the city center.

Franklintown, on the northwest tributary of the Gwynns Falls known as Dead Run, was the site of an early gristmill, which likely served the needs of local farmers. A mill may have existed there in the late colonial period, but mill historian John McGrain says that the earliest clear evidence dates to the 1830s. In 1827, a group of investors—some of them local landowners, one of whom was William H. Freeman—sought a charter for the Franklin Turnpike. The road would run from what was then the western boundary of the city near West Franklin Street through the Gwynns Falls and Dead Run Valleys to connect with Liberty Road in northwestern Baltimore County. Turnpike historian William Hollifield quotes the act of incorporation on the need for the road as follows:

> The inhabitants of Baltimore County, who reside upon Gwynn's falls [sic], Dead run and the country adjacent thereto...suffer great inconvenience from the want of a good and direct road leading to the city of Baltimore.

The statement, explaining that the potential users were primarily engaged in agriculture and manufacturing, described the landscape as "rough and uneven" and the existing

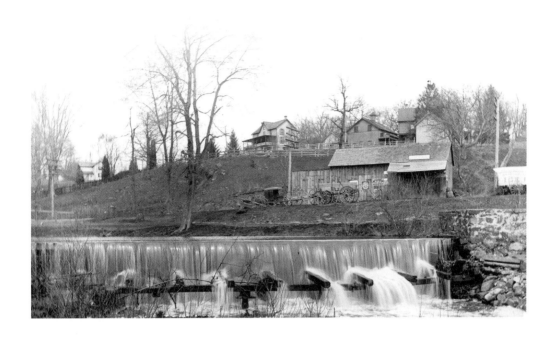

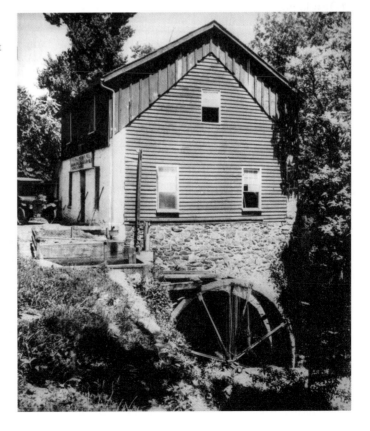

Above: The old mill dam on Dead Run at Franklintown, with the shop of a wheelwright on the opposite bank, 1901. *William Eberhardt.*

Left: The old gristmill in Franklintown, 1936, now a private residence. *Fred Worthington.*

Kids pose for a photograph on Franklintown Road, 1901. *Maryland Historical Society.*

roads as "wretched and almost impassable." As the turnpike left the built-up city, it traversed the steep valleys of the Gwynns Falls and Dead Run, affording the views of natural scenery that John Latrobe found so "romantic and picturesque." Over the following decades, the turnpike company maintained the road and a tollgate keeper collected tolls. In the early 1900s, dissatisfaction with the ability of the turnpike companies to provide adequate conditions for roads in the new era of motor transport mounted, leading to local and state takeover of the earlier private operations.

William H. Freeman had other plans for the area. Prominent in state political circles, Freeman also was associated with Maryland horse-racing interests, which established the Central Racetrack nearby on land he donated. For a number of years, the track proved a major site in national horse-racing circles. To accommodate visitors to the races, Freeman built the Franklin House, known later as the Franklintown Inn (on Franklintown Road, near Forest Park Avenue). In 1832, he launched a plan to build a new community, Franklin Towne. Joining him as investors were John Glenn, owner of a large estate in Catonsville (now the site of the Catonsville Campus of Baltimore County Community College) and Reverdy Johnson, whose Lyndhurst estate was located on the heights above the Gwynns Falls Valley southeast of Franklintown. All three partners were also directors of the Bank of Maryland. Freeman laid out the plan for this new "suburban" community with an elliptical park in the center surrounded by residential lots located on the hillside above the mill village. The plans suffered a major setback in 1834 when the Bank of Maryland failed, angering its many small investors. In 1835 the investors rioted, targeting Glenn, Johnson and Freeman as those responsible for their losses. Franklin Towne experienced only modest development as a residential

A group at the Ben Cardin Pavilion in Winans Meadow, near Trailhead 2. *Guy Hager.*

community, but nineteenth-century "Victorian cottage" dwellings are reminders of this historic episode, as are the distinctive patterns of property lines and streets on the hillside. Freeman died during the Civil War—his grand plans not fulfilled, but having left his mark on the village of Franklintown.

During the nineteenth century, owners of the gristmill built a warehouse and several related stone structures across from it on the north side of the road. The old mill along the Dead Run continued to function until 1934; it subsequently was converted to serve as a private residence.

In the second half of the twentieth century, the historic character of Franklintown attracted residents interested in the restoration and preservation of the historic structures remaining from an earlier era. They frequently have had to fend off threats to the integrity of the village and the surrounding green space—always such an important part of the community's identity. Baltimore City's purchase of the adjacent Winans estate as Leakin Park in the 1940s seemed to ensure conservation of the area's natural quality. In the 1960s and 1970s, when highway planners proposed to route the east–west expressway through the eastern edge of the community and the heart of Leakin Park, not surprisingly Franklintown citizens played an active role in the successful fight to "stop the road." In 2001, Franklintown was placed on the National Register of Historic Places.

Trailhead 1: the trail proceeds east from the end of I-70 (a reminder of the controversy over the expressway route) and follows Franklintown Road through historic Franklintown, passing the former gristmill (for many years a residence) and other early stone structures.

From Flour Mills to Textile Mills

DICKEYVILLE

"Wetheredsville [Dickeyville] *is a thriving village situated on the Gwynn's Falls,… surrounded by bold and romantic scenery, through which the stream rushes with impetuous force."*

—*Thomas Scharf,* History of Baltimore City and County *(1881)*

The fact that this secluded community along the Gwynns Falls has had six names over the course of its nearly three hundred years of existence provides a clue to its distinctive history and identity. For about a century it was a mill village of textile workers, but since the 1930s it has stood out as an early and successful model of historic preservation and renovation.

The water power that the Gwynns Falls could provide for mill sites determined the establishment of Dickeyville. The first sites were gristmills, serving farms in the local area. As early as 1719, Peter Bond, the son-in-law of Richard Gwinn (from whom the Gwynns Falls took its name), started a mill in this vicinity, and in 1762, Swiss-born William Tschudi built both a mill and a house, using stone native to the area. Operations on a larger scale began when a group of investors established the Franklin Paper Mill, located on the west bank of the stream. The community at the time was called Franklinville.

In 1829, the purchase of the paper mill by the Wethered family ushered in a new era of textile production. The Wethereds, for whom the village came to be known as Wetheredville (or Wetheredsville), converted to the weaving of woolen textiles. They added mills downstream on the east bank, naming the entire operation Ashland Mills. The second generation of Wethereds—brothers Samuel, John and Charles—like many entrepreneurs of the era, turned their attention to technological challenges; in their case, the effort to improve the efficiency of steam engines. Historian William C. Shultheis credits them as "innovators in steam navigation" because of their role in developing a process to superheat steam, a breakthrough that won them recognition in the United States and Europe. However, the Wetheredsville enterprises fell upon hard times. Fires

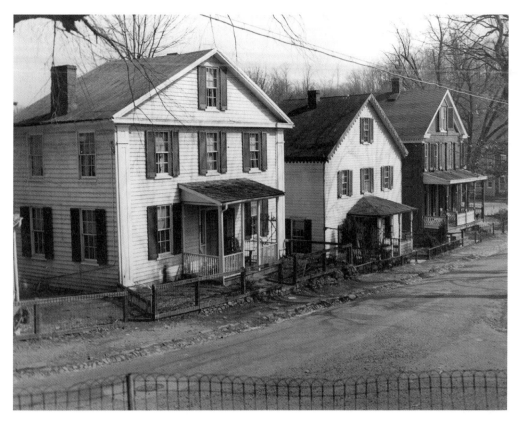

Detached former houses of textile millworkers in Dickeyville on the eve of restoration efforts, 1936. *Enoch Pratt Free Library.*

and floods inflicted misfortunes in the 1850s and 1860s, but the greatest challenge came during the Civil War. In 1863, the mills were confiscated by Union troops when it was discovered that they were not only producing material for military uniforms of "Union Blue," but also for those of "Confederate Gray."

In 1871, the mills were purchased by William J. Dickey. An immigrant who came with his family from Ballymena, Northern Ireland, when he was six, Dickey had gotten his start in his father's woolen business in Baltimore, which hired weavers on a piecework basis to produce cloth in their homes. At the mills he acquired on the Gwynns Falls, he added cotton fabric to the products produced there. Thomas Scharf reported in 1881 that the company employed 210 hands. In 1887, Dickey bought the Union Manufacturing Company mills in Oella (on the Patapsco River in western Baltimore County, near Ellicott City). By the turn of the century, his textile manufacturing company, with the combined operations, was considered among the largest in Baltimore County (under its jurisdiction until the city's annexation in 1918). When William died in 1896, his sons named the village Dickeyville in his memory.

In the early twentieth century, textile producers faced competition from plants with newer machinery, economies of scale and cheaper labor costs. In 1909, the complex

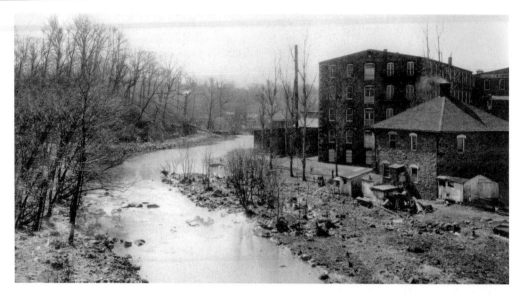

The Franklin Mills, just below the Forest Park Avenue Bridge, was the site of early paper production. It was later converted to woolen and cotton textile manufacturing, 1920s. *Mildred Tyssowski.*

at Dickeyville was sold to Glasgow Mills, which experienced two decades of decline until the termination of production in the early 1930s. By that time, the economically depressed community had developed such a negative image that, in 1917, it changed its name to Hillsdale in a vain attempt to refurbish its reputation.

Both the Wethereds and the Dickeys patterned their textile production complexes on the basis of company paternalism—a practice prevalent in the early textile industry. Under the model, the company provided housing and other amenities for workers; in return, it sought a labor force that was stable, loyal and willing to accept low wages. The Wethereds built early stone houses, and the Dickeys added frame residences, many of them duplexes—both types of structures survive today. In addition, during the nineteenth century, the paternal owners provided for churches (structures for Methodist and Presbyterian congregations were built by the owners), a school (though children often went to work in textile mills at an early age), a company store and a recreation and social hall. Like other area company mill towns, the community boasted a musical group, the "Silver Cornet Long Distance Walking Band." In short, in the original Wetheredsville and Dickeyville eras as a company town, the community was very much a closed social world for its workers.

Interestingly, the collapse of the mill operation gave birth to a new incarnation for Dickeyville—which reclaimed its earlier name—as a pioneer in the national historic preservation movement. In 1934, the entire complex, consisting of two mills and eighty-one houses, was sold at auction for $42,000. A development company, with Harold A. Stilwell serving as architect and agent, began a restoration effort designed to make the most of the historic texture afforded by the earlier stone, brick and frame mill structures to re-create a residential community in a village-like setting. In the economically hard-

Frame "double houses" in Dickeyville, 1920s. *Mildred Tyssowski.*

Heide Grundmann with a cleanup crew on the Gwynns Falls Trail. *Guy Hager.*

pressed years of the Great Depression, Americans harked back to earlier models in their collective history. Major restoration efforts got underway in Virginia's Williamsburg and in the early settlements of New England, and Dickeyville was one of the most notable examples of the trend in the mid-Atlantic region. For three-quarters of a century, the commitment to restoration and preservation has maintained the distinctive character of Dickeyville as a historic community. In 1972, it was placed on the National Register of Historic Places.

Trailhead 3: the trail spur to Dickeyville from Windsor Mill Road follows Wetheredsville Road (closed to motor traffic).

Roads and Bridges

TRAVERSING THE GWYNNS FALLS

"From the bridge over Gwynn's Falls [the old lower Baltimore Street Bridge] *can be seen the picturesque portion of that valley now visible only from the railroad bridge and from the old mill race."*

—*Report of the Olmsted Brothers, 1904*

Today's Gwynns Falls Trail threads through a valley that has served both as a conduit and an obstacle for transportation. Portions of the path follow the route of early wagon roads and turnpikes. When the stream needed to be crossed, some lower lands permitted fording, but the hillsides of other sections required bridging—especially in the stretches where the water cut a deep gorge.

Native Americans crossed the Gwynns Falls on their north–south journeys between today's Washington Boulevard and Wilkens Avenue, at the point where the stream became more shallow as it entered the coastal plain. From the early colonial period, European settlers used similar crossings. One roadway extended north to reach a fortified garrison in what was then the frontier of central Baltimore County. A second became the principal line for stagecoaches traveling between Baltimore and locales to the south—Alexandria and Georgetown (later, Washington, D.C.).

In the late 1780s, the Maryland legislature, recognizing the need to improve the crude, colonial-era roads, authorized the development of several turnpikes and named commissioners to plan them. When progress proved slow through these early public efforts, the legislature, in 1805, chartered private companies to build and maintain the turnpikes. Tollgates were established at intervals along the routes to collect money for use of the improved routes. One of the first of these roadways was the Baltimore and Fredericktown Turnpike (later, simply the Frederick Turnpike and today's Frederick Avenue), which extended west from the settled parts of the early city across the Gwynns Falls to Ellicott City and on to Frederick. Ellicott family members played an important role in the establishment of the road, which connected their flour milling operations in Ellicott City and their Three Mills on the Gwynns Falls with their wharf facilities at the Inner Harbor.

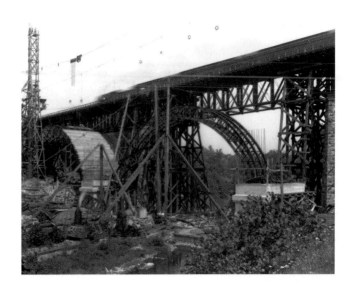

Construction of the Baltimore Street Bridge in 1932, with a train crossing the parallel railroad bridge. Baltimore Sun.

The Frederick Turnpike also became an important link with the National Road, which was authorized in 1806 by Congress at the urging of President Thomas Jefferson. This first federally financed roadway headed westward from Cumberland over the Appalachian Mountains to connect the Eastern United States with the developing frontier of the Ohio River Valley. A tollgate for the Frederick Turnpike stood near where it crossed the Gwynns Falls. The road's bridges over the Gwynns Falls and the Patapsco River (in Ellicott City) were badly damaged by the great flood of 1868.

Other turnpikes along today's Gwynns Falls Trail included the Washington and Baltimore Turnpike (Washington Boulevard), which was planned to provide improved connection between the two cities in the early years of the new nation. The Calverton Turnpike was developed by the owners of the five Calverton Mills in the Gwynns Falls Valley to ensure their access to city markets. The Franklin Turnpike extended beyond the Calverton Mills, along the Gwynns Falls and Dead Run Valleys and through the mill village of Franklintown as a transportation artery for wagons and livestock from northwestern Baltimore County traveling to Baltimore. Portions of the turnpike were considered to feature particularly lovely natural scenery. Historian William Hollifield notes that the heyday of the turnpikes was the 1820s and 1830s, a period of major growth for Baltimore as an urban center in the new nation. However, in the latter years of the century, the turnpikes fell into disrepair—investors no longer finding it profitable to provide the funds needed for their improvement. In response to complaints about the roads and their tolls, as well as calls for more modern highways to accommodate automobiles, in the early 1900s they were taken over by the State Roads Commission.

At the mouth of the Gwynns Falls, a long plank bridge—Harmon's—crossed the broad wetland formed by the meandering stream as it emptied into the Middle Branch. When the area was substantially filled in, Old Annapolis Road required a much shorter span. To connect South Baltimore and the settled sections south of the Middle Branch, a narrow frame bridge carried Light Street to provide a link with Brooklyn.

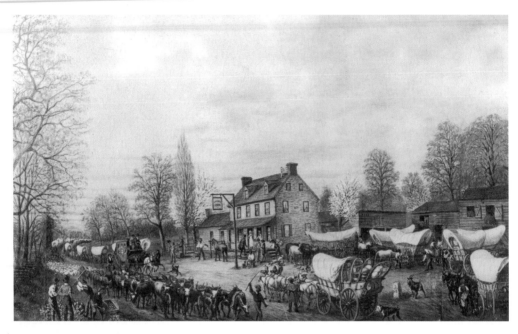

The Fairview Inn on the Frederick Turnpike, with wagons and livestock, from a painting. *Enoch Pratt Free Library.*

The tollgate keeper on Frederick Turnpike near Mount Olivet Cemetery, just west of the Gwynns Falls, circa 1908. *Enoch Pratt Free Library.*

The Edmondson Avenue Bridge, under construction in 1909, looking toward the hillside to the west. Baltimore Sun.

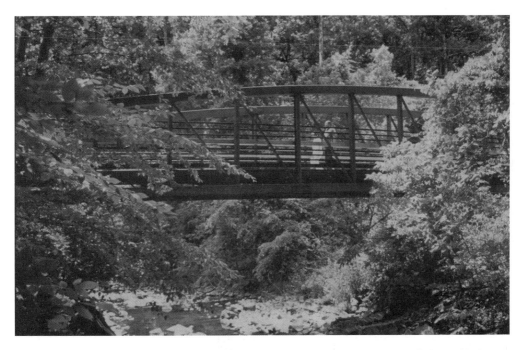

The first bridge constructed for the Gwynns Falls Trail crossed Dead Run near its confluence with the Gwynns Falls. *Trust for Public Land.*

As urban development reached and then passed the Gwynns Falls, the need for roadways connecting the central city with newly settled areas became apparent. When Baltimore City, in 1888 and 1918, annexed lands on the north and west sides that were formerly part of Baltimore County and northern sections of Anne Arundel County along the Middle Branch, improved transportation was one result. A series of grand bridges symbolized the sense of expansiveness and civic pride that accompanied the annexation era. Edmondson Avenue was extended west across the valley in 1879–80, and in 1910, it was provided with a broad, multispan, concrete bridge. In 1916, the Light Street span was replaced by the gracefully arched concrete Hanover Street Bridge (now officially named the Vietnam Veterans Memorial Bridge). The Depression era produced several impressive new structures. In 1932, the lofty arches of the Baltimore Street Bridge provided additional access to the rapidly growing west side, though the route did not become a major transportation artery. In the same decade, the need for a north–south roadway link, connecting the densely settled northwestern and western sections of the city across the Gwynns Falls Valley, was accomplished through federal public works funding with the construction of Hilton Parkway between North Avenue and Edmondson Avenue.

Trailhead 4: south of Trailhead 4, the route passes under the Edmondson Avenue Bridge.
Trailheads 5 and 6: early Native American and colonial American trails forded the Gwynns Falls in this section of the valley. Trailhead 5 is located near Frederick Avenue, originally the Frederick Turnpike. North of Trailhead 5, the trail crosses Baltimore Street, near the Baltimore Street Bridge. The concrete structures of I-95 are visible at Trailhead 6, as well as along Annapolis Road, near the mouth of the Gwynns Falls.
Trailheads 8 and 9: between these two trailheads is the Vietnam Veterans Memorial (Hanover Street) Bridge.

Railroads

MAKING TRACKS TO THE INTERIOR

"No adequate sketch of the growth of Baltimore City could be given that did not embody some account of the great railroad [the B&O] *which has probably contributed more to its commercial prosperity than all other agencies combined."*
—*J. Thomas Scharf,* History of Baltimore City and County *(1881)*

T wo major railroad lines cross the Gwynns Falls and a third runs through the lower valley. Together, they represent significant episodes in the history of American railroading.

THE BALTIMORE AND OHIO RAILROAD

If Baltimore's port gave it a commercial advantage in the era of tobacco cultivation and the early stages of flour production, the lack of navigable rivers to provide access to interior markets soon proved a liability. The plan to develop a rail line to link Baltimore with the fast-growing frontier of the Ohio River Valley across the Appalachian Mountains was a bold, but desperate move by Baltimore civic leaders. The name they chose for their enterprise, the Baltimore and Ohio Railroad (B&O), reflected their vision. Worried about the economic impact of competing canal enterprises in New York, Pennsylvania and along the Potomac River from Georgetown, they cast their lot with the untested technology of rail transportation. Loads drawn on rails promised more efficiency than cars and wagons conveyed over bumpy roads. Initially, rail carriages were pulled by horses, but early in the 1830s the B&O successfully introduced steam-powered locomotives, becoming the first long-distance, steam-driven rail line in America.

Landowner and investor James Maccubbin Carroll offered a site near the family's Mount Clare estate on the city's west side for the original terminus of the venture. Charles Carroll of Carrollton, signer of the Declaration of Independence and a prominent participant in the establishment of the B&O, laid the first stone for the new railroad on July 4, 1828.

A steam locomotive crossing the Carrollton Viaduct as part of the B&O centennial celebration in 1929. *Enoch Pratt Free Library.*

The B&O's founders determined that the Potomac River represented the most favorable route to the foot of the Appalachians—and, not incidentally, to Cumberland, the immediate goal of those planning to build the Chesapeake and Ohio Canal westward from Georgetown. They projected an alignment up the Patapsco River Valley to the stream's headwaters at Parrs Spring Ridge near Mount Airy, and then down to the Potomac River at a point south of Frederick. To reach the Patapsco, the first miles westward from the B&O's shops at Mount Clare on Pratt Street would follow the contour along the outer edge of the Piedmont plateau, making the crossing of the Gwynns Falls the first significant construction challenge. The Carrollton Viaduct, named for the venerable Charles Carroll, was the result. Completed in 1829, it is considered the oldest single-span, stone railroad bridge in continuous use in the United States. The structure, which established the viability of stone for spans in the early railroading era, measures approximately three hundred feet in length, with the principal arch approximately eighty feet wide by fifty feet high. A smaller arch on the west bank accommodated a wagon road. Today, the Gwynns Falls Trail passes through this historic opening. In 1971, the Carrollton Viaduct became a National Historical Landmark.

The line reached the Patapsco River at Relay—the settlement named to recognize the location for changing horse teams at a point roughly halfway between Baltimore and Ellicott City—and then turned northwest along the riverbank. This route required a major crossing at Ilchester, where, in 1829, the Patterson Viaduct was completed to span the river on a bridge supported by four stone arches. The B&O also extended a second mainline south to Washington, D.C., in 1835, crossing the Patapsco River at Elkridge on

the Thomas Viaduct, designed by Marylander Benjamin H. Latrobe Jr. The viaduct's eight arches and gentle curve still make it an architectural marvel, and it continues in use as a functioning railroad structure. It became a National Historic Landmark in 1966.

The rail line beat the canal company to Cumberland, reaching that gateway to the mountains in 1842, long before the canal, which arrived ten years later. Construction of the B&O then crossed the Appalachians, extending to the Ohio River at Wheeling in 1853. By then, it had surpassed both the earlier National Road and the rival Chesapeake and Ohio Canal to become the dominant mode of transportation westward, hauling vast amounts of coal from the mountains and grain from the developing Midwest. This artery to the interior helped make Baltimore the second largest port for grain and a major terminal for livestock and coal by 1880, economic patterns that persisted into the next century.

The B&O's pioneering technological innovations earned it the title as "the Railroad University of the United States." Peter Cooper, a New York businessman and inventor who brought his entrepreneurial energies and resources to Baltimore in the late 1820s to help establish the Canton Company, built the engine for the first steam-driven locomotive tried by the B&O. Its trial runs in 1830 gave rise to the legend of a contest between his Tom Thumb locomotive engine and a horse-drawn carriage—won by the horse. Regardless of the accuracy of the story, Cooper's device convinced the railroad's directors to place their bets on the new technology. Ross Winans, whom railroad historian John F. Stover calls "a farmer with a bent for invention," was one of several representatives sent by the B&O to England in 1828 to examine pioneering railroad developments there. Winans, who assisted Cooper in building the Tom Thumb, was integrally involved in the design and construction of the B&O's locomotives and rolling stock in the early years. Winans later established his own firm. Determined to design steam locomotives powerful enough for the challenges of heavy loads and mountainous terrain, Winans produced the Mud-digger and the Camel (the latter so called because its cab rested atop the hump of the boiler). Both were built for the B&O in the 1840s.

In 1884, the B&O completed the imposing Passenger Car Roundhouse adjacent to its principal shops at the Mount Clare Station on Pratt Street. Designed by E. Francis Baldwin, the massive circular structure accommodated twenty-two tracks, joined by a turntable in the middle. The Roundhouse and Mount Clare Station were placed on the National Register in 1966; the complex houses the B&O Railroad Museum. The roof of the Roundhouse suffered major damage from a snowstorm in 2003, but extensive renovation has restored it to its former glory.

In the 1840s and 1850s, the B&O expanded its operations in the southwest section of the city to provide improved port access and to create a principal passenger station closer to the city center. Originally, city officials had barred direct access to the harbor along busy municipal streets at the behest of west-side merchants who were worried about their impact. They subsequently permitted a track from Mount Clare to the harbor along Pratt Street, where the railroad established a terminal at the shallow Inner Harbor, but limits were placed on the use of locomotives along the line. Needing access that was more amenable to steam engines, as well as a deeper-water port, the B&O selected

This coal-burning "Camel" locomotive is similar to the two hundred to three hundred that Ross Winans built between 1848 and 1860 for slow freight service in mountainous terrain. *B&O Railroad Museum.*

a site on the north shore of the undeveloped Locust Point peninsula. The new line, completed in 1849, extended from a junction just east of the Carrollton Viaduct and skirted the downtown to the south. The Locust Point rail yards and terminal provided freight connections, especially for the important coal and grain trade. Following the Civil War, Locust Point also functioned as a terminal for ship passengers to and from Europe. Vast numbers of immigrants passed through its portals in the late nineteenth and early twentieth centuries. The Locust Point line also permitted rail cars to be ferried across the Northwest Branch of the harbor to Canton, establishing a connection for the B&O's tracks toward New York.

In 1851, B&O directors made the decision to replace the small Pratt Street depot west of the Inner Harbor with a more impressive passenger facility. The new Camden Station, built between 1857 and 1867, featured fashionable Italianate architecture, crowned by three towers. The rails to serve it connected to the Locust Point line, and over the following decades, the expansion of the Camden rail yards south of the station displaced substantial blocks housing working-class residents, both African American and those of European descent.

THE LIVES OF RAILROAD WORKERS

The development of the pioneering B&O Railroad required new labor pools—for construction of the rail line, and for the building and repair of locomotives and rolling stock. Initially, rail line construction was undertaken by contractors. Since much of the work was by hand, it required unskilled labor, largely performed by the newest immigrant group, the Irish. Construction crews lived in shanty camps along the route, and conditions were primitive. Periodically, violence occurred among laborers—sometimes Irish against Irish, sometimes Irish and Germans against one another and sometimes labor against management.

Construction and repair of locomotives and rolling stock, on the other hand, required a variety of skill levels, and in the early years these tasks were concentrated at the B&O's own Mount Clare Shops in Baltimore. Historian Sherry Olson has pointed out that the rapid and large-scale development of B&O-related construction represented a major era of industrial expansion in Baltimore, stimulating a variety of rail-related enterprises. She notes, for instance, that between 1848 and 1851, 190 locomotives were built at the Mount Clare Shops. When the B&O moved toward iron bridges, instead of the earlier stone structures,

The historic Mount Clare Station and Roundhouse now houses the B&O Railroad Museum at 501 West Pratt Street.

their parts also were fabricated at Mount Clare, under the direction of Wendel Bollman, whose name became attached to the distinctive "truss" design. As the rail line became operational, it also required specialized workers to serve as locomotive engineers, firemen, conductors and brakemen, many of whom were based out of the Mount Clare terminal.

This concentration of new labor demand spurred rapid residential development of the nearby streets of Southwest Baltimore—in a fan-shaped area from Pratt to Bayard and Bush Streets, the neighborhoods that became known as Mount Clare and Pigtown. Housing for working-class residents in Baltimore typically took the form of modest, single-family, brick rowhouses, and this section of the city became a densely settled residential area. The 1860 U.S. manuscript census registered railroad workers as heavily concentrated in the city's sixteenth and eighteenth wards, east and southwest of Mount Clare. Most were young, white, male, native born and renters; many had families, but some were single, sometimes living in households as boarders.

Periodically, conflict erupted between labor and management. As early as the 1840s, occasional strikes occurred to protest wages or conditions. James Dilts cites a strike at the Mount Clare Shops in 1853, when the company's directors refused a wage increase. The directors eventually reversed their decision and granted the wage raise, but strikers were fired. In the decades following the Civil War, labor-management tensions intensified. Typical worker grievances included the prevalence of accidents (especially in the dangerous work of coupling and uncoupling cars), lack of insurance to provide for workers injured on the job, lower wages than some other railroads, irregular work, lack of pay for overtime and changing policies regarding free rides on return trips. These circumstances—and the added problem of alcoholism that seemed endemic in railroad worker communities—often produced stress in family life.

In 1877, amidst a decade of protracted economic depression, these grievances bubbled up and erupted when the B&O announced a 10 percent wage cut at the same time that some investors were receiving a 10 percent dividend. Strikes broke out along the line at Martinsburg, West Virginia, and the protesters were joined by supporters at Cumberland and elsewhere. Powerful B&O president John Work Garrett drew upon his political relationship with the Maryland governor to persuade him to call out the National Guard for deployment to sites along the line where resistance had occurred. Railroad employees in Baltimore, joined their working-class comrades, forming crowds to block the guard's march from two armories to the Camden Street Station, and in the ensuing confrontation, violence occurred. Meanwhile, protesters sabotaged the tracks and the trains intended to convey the troops. In response, President Rutherford B. Hayes called up federal troops to quell what had become the nation's first industry-wide strike. Sylvia Gillett, writing in *The Baltimore Book*, has called it "one of the most significant strikes in U. S. history."

Order was restored along the rail lines, but the episode represented a major turning point in the conflict between capital and labor. In its wake, the B&O's Garrett, in the early 1880s, instituted the first insurance and pension plans in the industry, soon emulated by other rail lines. And labor, sobered by this confrontation, moved toward the eventual formation of modern trade unions to engage in collective bargaining to protect its interests.

RAILROAD COMPETITORS

The B&O's success bred competition. In the 1870s, the Baltimore and Potomac Railroad, with major funding from the Pennsylvania Railroad, established a north–south line through Baltimore from New York City to Washington, D.C. Its early frame trestle across the steep gorge of the Gwynns Falls near Baltimore Street was replaced in the early 1900s by the impressive, high, reinforced-concrete bridge in service today.

In the years following the Civil War, Baltimore officials became increasingly frustrated by the high freight prices of the B&O, which they feared would divert the Appalachian Mountain coal trade to other ports. In the late 1800s, municipal and private interests invested heavily in the smaller Western Maryland Railway (WMR) as a rival connection to western Maryland, West Virginia and Pennsylvania. In 1906, with new funding from railroad entrepreneur George Gould, WMR tracks reached Cumberland, where they then extended to Elkins, West Virginia, and Connellsville, Pennsylvania (for connections to Pittsburgh). The railroad also required adequate port facilities at its Baltimore terminus, and the Gwynns Falls seemed the only available route. Indeed, the Olmsted Brothers conceded as much in their 1904 report on Baltimore parks. Noting that the planned rail line would enter the valley near the broad meadow of Bloomingdale Oval north of Edmondson Avenue, an area they recommended for stream valley preservation as part of the newly established Gwynns Falls Park, the firm nevertheless concluded:

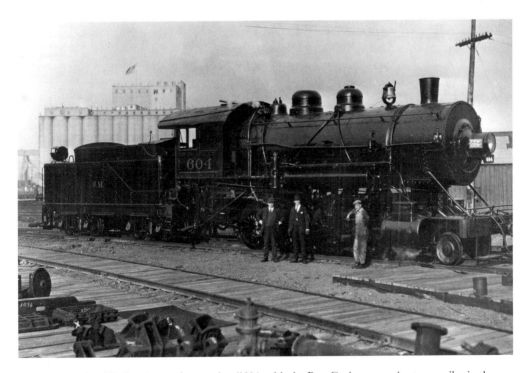

Western Maryland Railway steam locomotive #604, with the Port Covington grain storage silos in the background, 1922. *B&O Railroad Museum.*

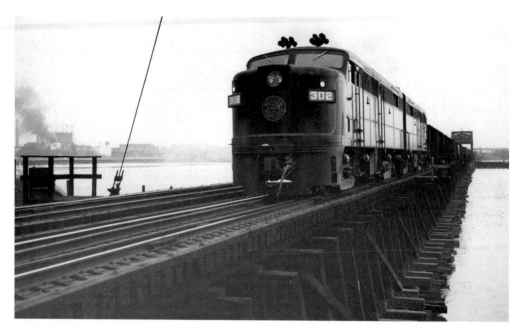

Western Maryland Railway diesel locomotive #302, crossing the bridge over the Middle Branch from Port Covington. *B&O Railroad Museum.*

> *Realizing the fundamental importance to the city of the economical connection of this [rail]road with tide water, we gave much thought to the joint problem from the city's point of view, of securing a first-class railroad line, without at the same time seriously impairing the great value for park purposes of the scenery now existing along Gwynn's Falls.*

The report recommended a slight realignment to reduce the impact on the meadow, though the railway's plans were well advanced and the mitigation not made.

In 1904, Port Covington, with its coal and grain facilities, was opened. To reach the new site, the railroad crossed the Middle Branch on a low timber trestle—at sixteen hundred feet, it was the longest span on the line—with a turntable bridge opening at the center. At its peak in the 1950s, Port Covington had track capacity for twenty-two hundred rail cars and wharf space for twenty-one ships. When the B&O acquired the WMR in the 1960s, it abandoned the operations at Port Covington in favor of its major, though aging, facilities nearby at Locust Point.

RAILROADS TODAY

Railroads continued their heyday for the first half of the twentieth century, but in the decades following World War II, motor vehicle and air transportation challenged their

An engineer fires a scale-model, live-steam locomotive to provide rides for a family in Leakin Park. *Chesapeake and Allegheny Steam Preservation Society.*

supremacy. Downscaling and mergers quickly followed. The B&O had taken steps toward absorbing the Western Maryland Railway as early as the 1920s. Even as it renewed those efforts in the 1960s, the Chesapeake and Ohio Railroad (C&O), a rival to the south, gained control of the B&O. As a result, the C&O and B&O (including the absorbed WMR) became components of the "Chessie" system, which in turn merged with the Seaboard Railroad in 1980 to become CSX Corporation.

North–south passenger trains of Amtrak and the Maryland Area Rail Commuter (MARC) service now travel along the former Pennsylvania Railroad tracks across the Gwynns Falls near Baltimore Street, and MARC trains also use the ex-B&O tracks south of Camden Station. CSX trains continue to carry cargo on the former B&O and WMR tracks through Southwest Baltimore.

Trailheads 4, 5 and 6: the original Western Maryland Railway tracks (now CSX) parallel the trail through this section of the valley. The Pennsylvania Railroad (now Amtrak) bridge crosses the Gwynns Falls beside the Baltimore Street span.

Trailhead 6: The trail passes through the reopened side arch of the B&O's historic Carrollton Viaduct, which carried the railway's original mainline and still operates as part of CSX.

The trail crosses the tracks of the B&O's Locust Point Branch at a number of points in the Carroll-Camden Industrial District: Washington Boulevard; and Bush, Bayard, Ridgely and Warner Streets. Along Bush and Bayard Streets are rowhouses of the type that housed railway and other industrial workers.

Industries on the Urban Periphery

"In every direction a once noble landscape is in the process of being engulfed by the relentless city."

—*William Marye, in the* Maryland Historical Magazine *(1921)*

For Baltimore's first century and a half, the lower Gwynns Falls, lying southwest of the developing town, served as the location for commercial, industrial and processing functions deemed more suitable for the periphery than the city center. In these early years, the stream often served as a conduit for waste from their operations. Gradually, residential districts for workers grew up in the vicinity of these industries.

As chapter four explains, the Baltimore Company was founded as an ironworks in the early 1730s, only a few years after the establishment of nearby Baltimore Town. Organized by investors who included several members of the prominent Carroll family, the company built forges and furnaces to process local iron deposits into nails, ship's anchors and iron implements. The insatiable demand for charcoal to fuel the operation took an immense toll on local forests. Near the site of the ironworks, Dr. Charles Carroll also established early gristmills.

In 1845, German-born William Wilkens founded the Wilkens Curled Hair Factory. It was located on the east side of the Gwynns Falls, between Frederick Avenue and Wilkens Avenue, the latter roadway built on land he donated to the city. The plant employed as many as one thousand workers, many of whom lived in the vicinity. The industrial operation processed animal hair for use in mattresses and upholstery, dumping its waste into Gwynns Run, which then flowed into the Gwynns Falls. The hair factory remained in business until the 1920s; today, the Westside Shopping Center occupies its former site.

In the nineteenth century, German butchers established their operations north of Frederick Avenue, high above the steep ravine on the east side of the Gwynns Falls. Their impressive residences were strung along Franklintown Road. Behind the houses were their butcher shops, the waste from which slid downhill into the millrace and stream below. The fouling of millraces led to lawsuits by gristmill owners against the butchers.

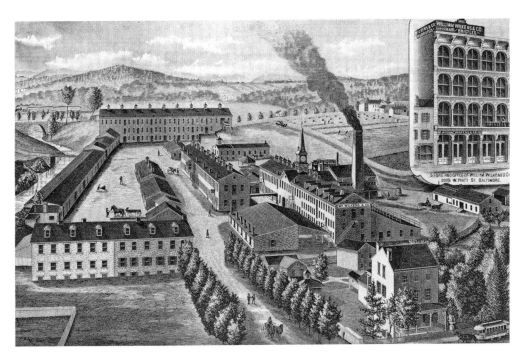

The William Wilkens Curled Hair Factory, from an 1881 engraving, with the company's W. Pratt Street office in the inset. *Enoch Pratt Free Library.*

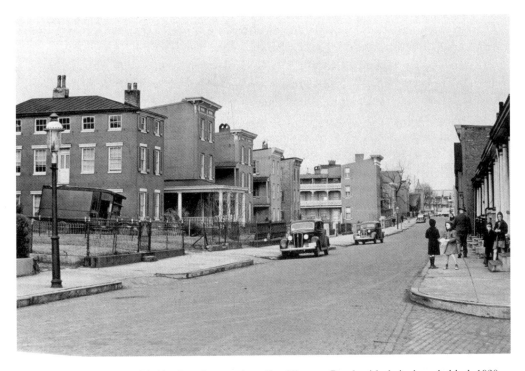

German butchers once resided in these houses along Franklintown Road, with their shops behind, 1930s. *Enoch Pratt Free Library.*

Ethnicity and race marked the history of the Franklintown Road area, as Roderick Ryon points out in his volume on West Baltimore's past. For example, St. John's Evangelical Church, established in 1867, was known locally as the "Butchers' Church" and conducted its services in German until the 1940s. In the 1960s, massive racial change from white to African American brought new residents to this neighborhood—in 1961, the former German congregation became the predominantly African American Shiloh Community Church.

Historically, Franklintown and Calverton Roads served as routes for driving livestock from rural areas of Baltimore County toward the city's markets. Livestock yards were established along these arteries on the east side of the Gwynns Falls Valley, and with the advent of the railroads, they were expanded. In 1891, the Union Stockyards became the largest of these operations. It was located on the west side of the Gwynns Falls, south of Wilkens Avenue, because of the proximity to major rail lines that converged there. For a time, the Union Stockyards claimed to be the largest operation east of Chicago and boasted that it brought "every hoof under one roof." The nearby Claremont Hotel accommodated farmers and other patrons, and a "jitney" streetcar ferried workers from Wilkens Avenue across the Brunswick Street Bridge to the yards. Changes in meat processing and transportation led to the closing of the stockyards in 1967.

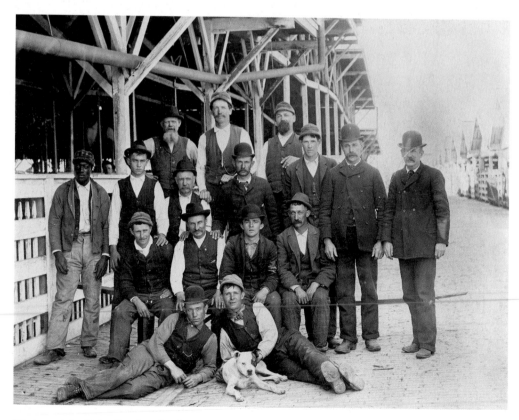

Workers at the Union Stockyards, circa 1890s. *Maryland Historical Society.*

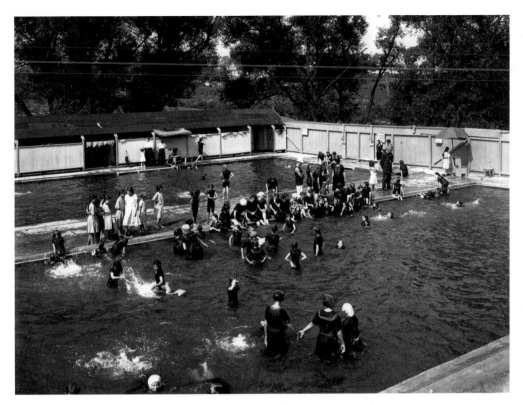

Public swimming pools at Gwynns Falls Park, 1915. *Albin O. Kuhn Library Special Collections, University of Maryland Baltimore County.*

Old Mill Hill grew up east of the Gwynns Falls as a rowhouse community for workers in nearby industrial and processing operations. In 1912, William Westphal erected brick houses along Wilkens Avenue—his 2600 block was said to be the city's longest uninterrupted row. West of the Gwynns Falls, Baltimore's Public Baths Commission opened two swimming pools in 1915 to serve the recreational needs of this densely developed urban district. Over the years, Mill Hill has maintained its heritage as a working-class neighborhood. However, when massive racial change occurred in the 1960s and 1970s in much of West Baltimore, Mill Hill remained predominantly white—a community of relatively high home ownership, but one also marked by poverty rates shared by nearby communities. Today, its population remains working class, though it has become more racially diverse.

Trailhead 5: uphill from the Ellicott Driveway portion of the trail, structures along Franklintown Road were once the homes and shops of butchers.

Trailheads 5 and 6: between Wilkens Avenue and the Carrollton Viaduct, the stone abutments of the old Brunswick Street Bridge used by trolleys to reach the Union Stockyards are visible.

Trailhead 6: the Baltimore Company's ironworks and the early gristmill of Dr. Charles Carroll were near this location.

The Industrial
Southwest

"It's all about location, location, location. It's a gateway location to and from the city."
—M.J. (Jay) Brodie, president of the Baltimore Development Corporation, 2003

Carroll-Camden, near the mouth of the Gwynns Falls and the Middle Branch, became an important industrial district in the second half of the nineteenth century. One hundred years ago, this area on the southern edge of the city hosted gas producers, breweries and manufacturers of dredging equipment and pianos. Today, some early buildings stand vacant, but other complexes take advantage of a location accessible to rail and road transport to house a variety of industrial and commercial operations.

The level landscape disguises the fact that, in the early years, an inlet on the northern side of the Middle Branch (called Ridgely's Cove) extended westward nearly as far as the later rail line, draining two streams that extended along the eventual route of streets like Bayard and Stockholm, with a third running as far as the western edge of the central business district. Indeed, the entire northern crescent of the Middle Branch was so watery that it was given the name "Spring Gardens." From colonial times, the area had been part of the Carroll family's vast Mount Clare estate, and James Maccubbin Carroll tried unsuccessfully to persuade fellow B&O Railroad investors to make Carroll's Point on the shore of Ridgely's Cove the principal port facility for the proposed railway. In the late 1840s, the B&O did construct a mainline through the area, providing access to extensive port facilities farther east at Locus Point and also serving its new Camden Station near the Inner Harbor. The line, operated now by CSX, remains very active. Over time, land east of the railway was filled in, extending the district some three to four blocks into the former cove area.

In the mid-nineteenth century, two of Baltimore's largest industrial employers were located just north of Carroll-Camden. The Mount Clare Shops of the B&O Railroad produced equipment for the railway, including locomotives and freight and passenger cars. Next door, the Bartlett-Hayward Company was a major manufacturer of cast-iron products. A compact residential district of rowhouses, serving industrial workers, extended to the edge of Carroll-Camden, its marshy land still nearly vacant. In the 1880s, two gas

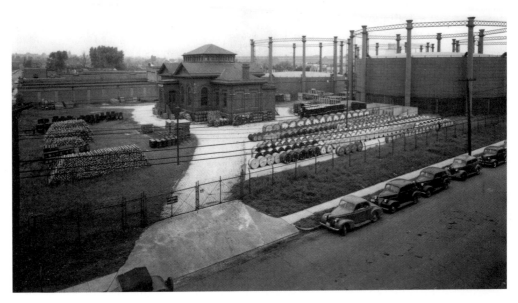

The Bayard Street Station, 1949, was once part of Chesapeake Gas Works. The Valve House structure still stands along the Bayard Street section of the Gwynns Falls Trail. *Enoch Pratt Free Library.*

manufacturing plants, their operations not compatible with residential districts, located in this fringe area.

GAS

Baltimore pioneered the use of gas, initially for streetlights, but later for other household and commercial uses. In 1816, Rembrandt Peale, who was always interested in technological innovation and ways to attract public attention, drew crowds to witness the use of gas lighting to illuminate one of his museum exhibits. That same year, he joined other investors to found the Baltimore Gas Light Company. The company obtained a charter to provide gas for streetlights in the city, eventually becoming the Consolidated Gas Company of Baltimore.

In the 1880s, two new entries, both located in Carroll-Camden, challenged the gas monopoly. They offered lower prices designed to undercut the current service. The Equitable Gas Company built a complex adjacent to the B&O railroad line on Severn Street, constructing five buildings between Bush and Bayard Streets from 1882 to 1885. Nearby, the Chesapeake Gas Works, chartered in 1885, established Bayard Station at Bayard and Hamburg Streets. The complex included an impressive stone structure facing Bayard, the Valve House, behind which were four round gas holding tanks (later razed), as well as a number of structures between Hamburg and Wicomico Streets.

The period of cut-rate competition proved short-lived. First, Chesapeake absorbed rival Equitable, and then in 1888 it in turn merged with Consolidated Gas, once more establishing a single gas producer for the city. The new, expanded company was the corporate predecessor of the Baltimore Gas and Electric Company, in recent years an entity of Constellation Energy. The era of competition brought episodes of lower prices, a temporary benefit to consumers, but it also created confusion, with streets torn up for the gas lines of rivals and uncertain service. One major consequence of the gas wars of the 1870s and 1880s was the introduction of public utility regulation.

The gas provided by these early Baltimore companies was "manufactured" in a process using byproducts of coal, and the B&O delivered carloads from the mountains to the west over its tracks in the district. Manufactured gas had the disadvantage that the process also produced toxic waste, and in recent years, many of the former sites have required extensive environmental remediation efforts. From the late nineteenth century onward, manufactured gas faced growing competition from electricity; moreover, the construction of pipelines bringing natural gas from distant fields provided a more desirable gas source. By World War II, manufactured gas production had virtually disappeared.

In the wake of consolidation, the Equitable and Chesapeake gas production complexes soon were turned to other functions. The Equitable site was acquired by the H.B. Davis Paint Company in 1914. It was listed on the National Register in 2003 and is being redeveloped as "Gaslight Square." Gas production soon was transferred from the former Chesapeake Gas complex at Bayard Station to Consolidated's larger operations at Spring Gardens. For many years, some of the buildings were used to produce stoves; today, the old Valve House shelters Housewerks, an architectural salvage firm.

DREDGING EQUIPMENT

A neighbor of the gas plants in the 1880s along Bush Street was the Ellicott Dredge Company, which produced equipment for the dredging of waterways. It was established by Charles Ellis Ellicott, a Philadelphia-born descendant of the Ellicott City family, whose extensive enterprises had included a wharf at the Inner Harbor that required experimentation with early dredging operations to keep it open for shipping. Ellicott Dredges, founded in 1885 and now a division of Baltimore Dredges LLD, is one of the largest international manufacturers of dredging equipment. Its machinery has been used to clear waterways around the world, including the Panama Canal and the St. Lawrence Seaway.

BREWERIES

Large-scale immigration from Germany in the mid-nineteenth century brought customs and skills from the old country, not the least of which was beer making. Southwest Baltimore was one of the areas of extensive German settlement, and a number of popular beer gardens

were located around the Middle Branch. In the 1870s, John Bauernschmidt established one of the city's largest breweries at 1510 Ridgely Street, providing for his own housing in the same complex. Brewing ended there in 1911. The structure (brick, painted white) is still evident along Ridgely Street and has since been used for a variety of other purposes. Along the trail route, at the corner of Warner and Ostend Streets, John Marr established a malt house for the preparation of this key beer ingredient. Acquiring the nearby Bauernschmidt brewery, he combined the two operations, as well as serving as a dealer of hops. Marr's business closed in 1907, and the building was later used for other purposes. In the 1990s, it was razed to provide parking for the Camden Yards sports complex.

PIANOS

Another German entrepreneur, William Knabe, established a major piano manufacturing business in 1853, one of sixteen such operations in Baltimore at the time. In the 1860s, his sons expanded the enterprise, erecting a large complex on South Eutaw Street. Knabe Company was one of Baltimore's largest manufacturing plants in the late nineteenth century, and—together with William Wilkens's hair factory—it was a major employer of German workers, many of whom lived in Southwest Baltimore. The principal building, constructed in 1869, occupied an entire city block, its cupola atop the five-story structure dominating the skyline on the southwestern side of the city. Knabe was sold in 1908, and its piano production moved to Rochester, New York, in 1929. In the 1930s, the factory building was bought by the Maryland Cup Corporation, which manufactured paper cups, straws and ice cream cones under the "Sweetheart" brand name. In 1990, the building was torn down to make way for the Camden Yards sports

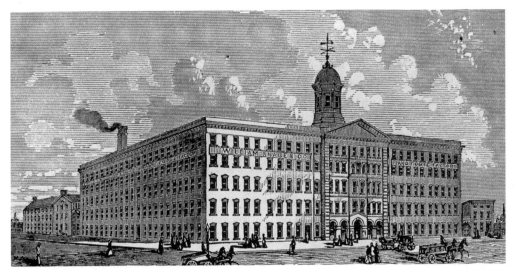

The William Knabe Piano Company was a major South Baltimore employer. Its site is now occupied by the Baltimore Ravens M&T Bank Stadium. *Enoch Pratt Free Library.*

complex, and in 1998, the cupola was moved to a site at the Baltimore Museum of Industry on Key Highway.

Retail Distribution

On the western edge of Carroll-Camden, the transformation of the massive eight-story former Montgomery Ward Warehouse and Retail Store represents an example of the kind of adaptive reuse that planners and officials hope will point to the future for the district. In 1924, the city sold land to Ward's on the west side of Monroe Street between the Mount Clare section of Carroll Park and the Carroll Park Golf Course, deeming the tract "unsuitable for park purposes." The national catalogue retailer built its facility as one of nine similar distribution centers erected around the country. The substantial reinforced concrete building was designed in simplified art deco style. Its two parallel sides permitted railroad cars to access it from the center for efficient loading. Closed by Ward's in 1985 and then sold, the facility was renovated and reopened in 2002 as Montgomery Park. The project incorporated energy and water conservation innovations, including a "green" roof over the old train shed, which earned it the federal Environmental Protection Agency's highest award for sustainable design in 2003. Today, it houses the Maryland Department of the Environment and other users. The building was added to the National Register of Historic Places in 2000.

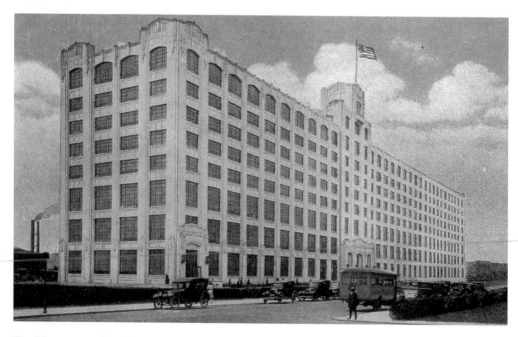

The Montgomery Ward Company distribution Center at Monroe Street and Washington Boulevard from a postcard. The structure, which adjoins the trail, has been renovated as Montgomery Park. *Enoch Pratt Free Library.*

CARROLL-CAMDEN AT A CROSSROADS

Over the past century, the Carroll-Camden industrial district has aged, as some of its technologies became obsolete. Some of its structures were adapted, with modern additions, but others stood vacant or were demolished. Over the years, many businesses moved to new locations. The Baltimore Development Corporation (BDC), which undertook a master plan for the area in 2002, identified among its problems poor vehicular access, functionally obsolete buildings and brownfield conditions. The master plan led to city council authority for the BDC to acquire portions of the land east of Russell Street for development of a new business park. Efforts to sustain and revive the district include designation as a state and federal empowerment zone. Planning officials envision Russell Street as a major gateway to the city, serving the Camden Yards sports stadiums and the downtown area's redeveloping west side, and they promote the possibilities for transit-oriented development, taking advantage of the MTA's double-tracking of the north–south Light Rail line, as well as the convenience to I-95 and to CSX railroad service.

One of the most striking modern industrial structures in this area houses the operations of Baltimore Refuse Energy Systems Company (BRESCO), located adjacent to the trail near the mouth of the Gwynns Falls, next to the pillars of I-95's elevated spans. Established in 1985, BRESCO disposes of some 2,250 tons of municipal solid waste each day, trucked in from the city and several surrounding counties. A furnace subjects the trash to high temperatures, producing high-pressure steam, which is used to make electricity as well as to provide heating and cooling for downtown buildings. BRESCO represents a new type of industrial function in a historic industrial district.

In Carroll-Camden the Gwynns Falls Trail passes the following sites of past and present industrial and commercial activity:
** Montgomery Park (former Montgomery Ward Warehouse and Retail Store), 1000 South Monroe Street.*
** Maryland Transit Authority Bus Maintenance Facility (former United Railways Car Barns), 1500–1600 blocks, Washington Boulevard.*
** Ellicott Dredges, 1611 Bush Street.*
** "Gaslight Square" (former Equitable Gas Works), 1401 Severn Street.*
** Housewerks (formerly Bayard Station Gas Works), 1415 Bayard Street.;*
** Spring Garden Brewery (Bauernschmidt's), 1510 Ridgely Street.*
** (Former site of) John Marr Malt House, 1411–1419 Warner Street, corner of Ostend Street.*
** (Former site of) William Knabe Piano Company, 100 South Eutaw Street.*
** CSX Locust Point/Camden Yards Rail line (former B&O), multiple trail crossings.*
** Baltimore RESCO, Old Annapolis Road at Russell Street.*

Rowhouses For the
Expanding City

"Here you will find delightful English-type daylight homes of the better sort, whose remarkably low prices will give you a pleasant surprise. These homes are artistically designed and sturdily constructed and contain eight large, well-lighted and ventilated rooms."
—*James Keelty Company ad for Edmondson Avenue–area rowhouses, 1928*

For the first century of Baltimore's history, the Gwynns Falls lay beyond the settled sections of the city, the site of agricultural, industrial and processing functions. By 1800, Baltimore had grown to 30,000, making it the new nation's third largest city. In 1817, the expanding municipality annexed lands that made the lower Gwynns Falls the city's western and southern boundaries, though most actual settlement lay east of that line. The first half of the nineteenth century produced further rapid increase, so that at the time of the Civil War, Baltimore's population stood at 212,418. By 1888, the city had become so fully developed that a new annexation was required, leapfrogging the valley on the west side, as well as adding land to the north.

The extension of street railways (horsecars, then electrified streetcars) spurred rowhouse builders in the development of the annexed area. In the early twentieth century, continued population growth (to 558,485 in 1910) and the addition of motor vehicles to the transportation options led to the city's final annexation in 1918. The new boundaries added another mile on the west side, extended below the Middle Branch to include Cherry Hill and Curtis Bay on the south and incorporated Highlandtown on the east—altogether adding fifty square miles formerly in Baltimore and Anne Arundel Counties. By 1950, when Baltimore reached its peak population of 949,708, the area within the city's boundaries had been nearly fully developed, except for tracts that had been retained as parkland. But the following decades brought population decline, as new development spread beyond the municipal limits to the surrounding suburbanizing areas. In 2000, Baltimore City's population had dropped to 651,154, while the Baltimore metropolitan region, consisting of the city and the six neighboring counties, was home to 2.5 million.

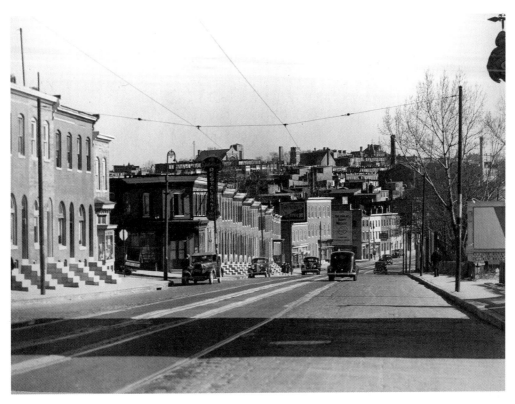

White marble steps in front of rowhouses became a trademark of Baltimore; looking east along Frederick Avenue in 1937, near today's Gwynns Falls Trail. *Enoch Pratt Free Library.*

Throughout these periods of urban growth, the housing type of choice was the rowhouse. Characteristically built of brick, rowhouses in a variety of sizes served the needs of all classes. In the early period of the city's history—when people needed to live near their places of work—typical blocks might feature a mix of housing types: elegantly designed structures facing the main street or square, providing housing for the wealthy; more modest versions on side streets, serving the needs of artisans, mid-level professionals and lesser merchants; and narrow houses on alleys, the residences of laborers, both white and black. The advent of the street railway and then motor vehicles enabled separation of place of residence and place of work, leading to a greater degree of separation by class, as well as forms of discrimination that led to division by race as well. Rowhouse developers, building on a larger scale, responded to growing demand by erecting whole neighborhoods with houses of a similar type and cost, producing sections much more socially and economically homogenized than in the earlier eras.

Rowhouses provided economies of scale, both for builders and for residents, producing affordable housing options. They made optimum use of urban land, could be economically constructed and minimized heating and upkeep costs, yet they permitted a degree of privacy—all at a price that fostered ownership by both middle- and working-class households. However, their density left little open space for public land.

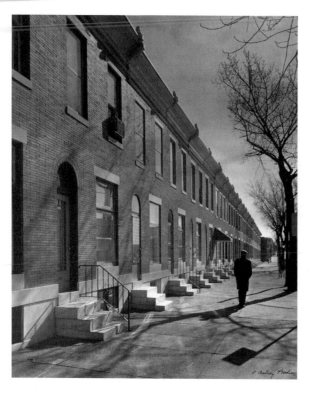

Left: Well-known Maryland photographer A. Aubrey Bodine took this photo of a long stretch of brick rowhouses, with marble steps and roofline cornices, in 1945. *A. Aubrey Bodine.*

Below: The rowhouse could be adapted to various sizes. Along alleys they were often narrow, like these in Federal Hill. *Guy Hager.*

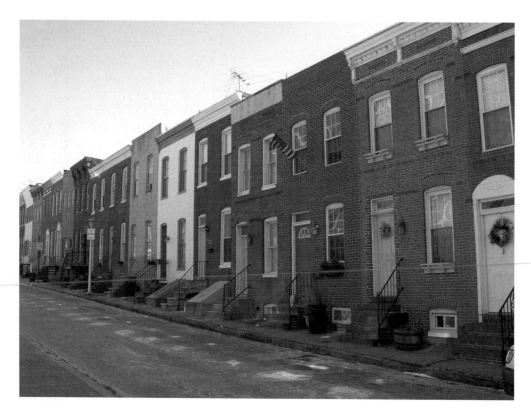

Presenting flat façades, rowhouses distinguished themselves from one another with modest decorative and design features in keeping with the architectural trends of the era. The oldest types, which survive in Otterbein, Federal Hill and parts of Sharp-Leadenhall, were those in the Federal style, recognizable by their gabled roofs and dormer windows, followed by the classical motifs of Greek revival. In the mid-nineteenth century, Italianate styles became the fashion, with flat or slightly sloping roofs to provide maximum space in two- and three-story versions. Technological innovation, enabling stone, metal and wood features to be mass-produced by machines, allowed for almost infinite variations on the essential housing box. Until the turn of the twentieth century, most rowhouses were narrow and deep, but concern for urban density and the desire for greater degrees of light and ventilation led to a number of innovations in rowhouse layout—most notably the "daylight" form, whose wider and shallower dimensions allowed configurations in which all rooms had a window. Similarly, later rowhouses were more likely to have front porches and façades set back from the street to afford small front yards, rather than the traditional stone or brick steps directly on the sidewalk, which had been a signature of earlier Baltimore neighborhoods.

In the early period, rowhouses often were built one at a time, with new dwellings simply attaching to those previously erected. Over the years, builders began to construct whole blocks, and eventually entire neighborhoods. As an example of the former, Walter Westpahl, in 1912, built the 2600 block of Wilkens Avenue for workers in the area that

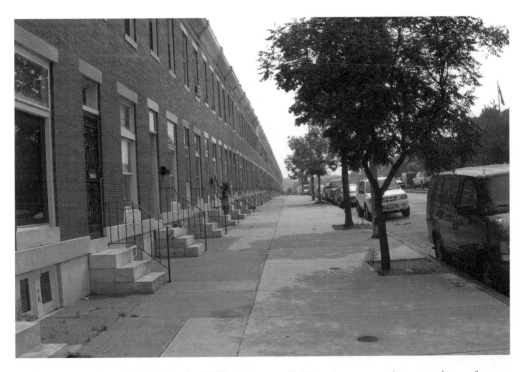

"The deck of cards"—the 2600 block of Wilkens Avenue, Baltimore's longest uninterrupted row of attached houses, built by William Westpahl in 1912. *Guy Hager.*

came to be known as Mill Hill. These Italianate houses, with light-colored brick and marble front steps, covered eighteen hundred feet of frontage, creating Baltimore's longest block, sometimes known as the "Deck of Cards." James Keelty, like Westpahl, began building blocks of houses on the west side. Between 1920 and 1950, his firm erected nearly the entire section along Edmondson Avenue west of the Gwynns Falls, providing housing for some twenty thousand residents. Keelty houses featured the popular "daylight" layout in styles ranging from English to colonial, most providing for porches facing small front yards.

Post–World War II suburbanization, which filled up the city's boundaries and then spread to the surrounding counties, featured detached housing in popular new single-story and split-level styles, often with larger yards, and rowhouses lost their appeal. In recent years, however, rowhouse options have experienced a revival, evident in the renovation of structures now considered "historic" in such early sections of the city as Federal Hill, Otterbein, Fells Point and Canton, all among the earliest settled areas around the Inner Harbor. The revival also can be seen in new construction of what now are often called "townhouses" in both urban and suburban areas, where more economical land use again calls for the denser development offered by the traditional housing type.

The lower Gwynns Falls became the southwest boundary of the city in 1817 (Trailhead 6). In 1888, the boundary reached the upper Gwynns Falls (Trailhead 3). The present boundary, established in 1918, is at Trailhead 1.

Examples of early rowhouses in Federal, Greek revival and Italianate styles can be seen along the Gwynns Falls Trail in Federal Hill, Otterbein, Sharp-Leadenhall and Carroll-Camden; William Westpahl's "longest row" is a short distance east of the trail, where it crosses Wilkens Avenue. James Keelty's "daylight" rowhouses are in the neighborhoods along Edmondson Avenue, up the hill to the west of the Trail.

Streetcars

CONVEYANCES FOR THE FIRST COMMUTERS

"A wide expanse of picturesque country, including the valley through which Gwynns Falls wends its meandering course, present[s]...a view of the city and bay, which seemingly lie at the foot of the beholder, though a number of miles away...[and]* a landscape in point of beauty seldom seen."*
—*Reporter for the* Baltimore Sun *on the new Baltimore, Calverton and Powhatan (Street) Railroad (July 7, 1871)*

In the mid-nineteenth century, horsecars—carriages drawn on tracks by teams of horses—provided transportation from the city across the Gwynns Falls Valley to the village and rural hinterlands. Early horsecars traveled along Frederick Avenue to Loudon Park Cemetery and then on to Catonsville, and from Walbrook along Windsor Mill Road to Lorraine Cemetery and the mill village of Powhatan (Woodlawn area). The city, realizing that its new Druid Hill Park was likely to be a popular and profitable street railway destination, in 1859 instituted a special tax (initially one cent on a nickel fare), the proceeds going to the budget for parks. The tax continued to benefit the park system until it was rescinded during the Great Depression.

Electrification of streetcars in the 1890s ushered in a new era of street railway transportation, making commuting from outlying residential areas more feasible. Principal electric trolley lines crossing the Gwynns Falls included those along Wilkens, Frederick and Edmondson Avenues, as well as Washington Boulevard. In the upper valley, a line ran from Windsor Hills through Dickeyville to Lorraine Cemetery. Nearby, a spur from Liberty Heights Avenue took passengers to Gwynn Oak Amusement Park, a popular, but racially segregated streetcar destination. In 1963, the park became the site of civil rights demonstrations protesting its exclusionary policies, and it closed soon after.

Areas south of the Middle Branch, not incorporated into the city until 1918, were served by a line to Westport. A second route across the early Light Street Bridge was shifted to the Hanover Street Bridge when it was completed in 1916. The United

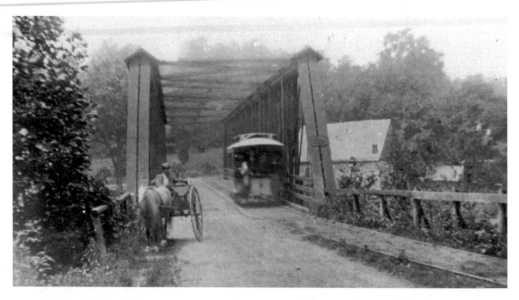

A streetcar and horse-drawn wagon share the Bollman Truss Bridge on Windsor Mill Road, circa 1900. *Enoch Pratt Free Library.*

Railways and Electric Company, which consolidated many of the early, competing streetcar companies in 1899, built an extensive set of car barns along Washington Boulevard in 1901. They were designed by architect E. Francis Baldwin, who was also responsible for the plan for the B&O Railroad's Mount Clare Roundhouse nearby. Today, the former streetcar barn complex, a prominent feature along the Gwynns Falls Trail as it passes through Carroll Park, serves as a maintenance and storage facility for Maryland Transit Authority buses.

In the early half of the twentieth century, streetcar transportation enabled residential development for urban commuters in the formerly rural sections west of the valley. But the increasing availability of automobiles and the greater flexibility afforded by buses led to the demise of the streetcar system. Beginning in the 1950s, diesel buses began to replace the streetcars, and in 1963, the no. 8 streetcar along Frederick Avenue made the system's last run.

Ownership had passed to the Baltimore Transit Company in 1935, following the bankruptcy of the United Railways and Electric Company, but in 1970 the state took over responsibility for mass transportation in the Baltimore area. Today, the Maryland Transit Administration presides over the metropolitan bus, light rail, subway (Metro) and commuter train (MARC) services. The MTA's Light Rail line, connecting downtown with BWI Thurgood Marshall International Airport, represents a modern version of earlier street railway transportation. In 2004, the MTA initiated a planning process for future mass transit needs, identifying the east–west corridor along Edmondson Avenue as the Red Line in a study considering alternative transportation options—bus rapid transit, light rail transit and enhanced bus service. As in the past, the impact upon neighborhoods and parks represented major concerns in the planning process.

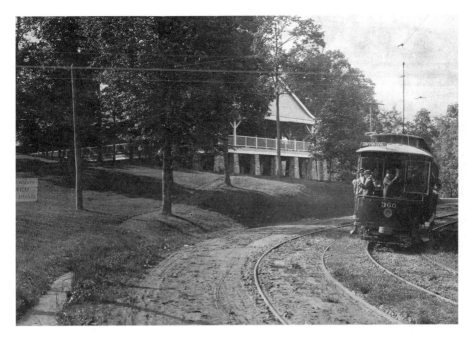

Visitors to the Gwynn Oak Amusement Park arrive by streetcar, circa 1900. *Enoch Pratt Free Library.*

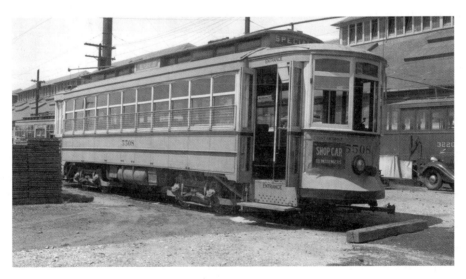

A streetcar in 1939 at the Carroll Park car barns. The structures now house bus maintenance facilities for the MTA. *Enoch Pratt Free Library.*

Streetcar lines crossed the route of the trail on the various streets listed above. The former streetcar barns, now serving MTA buses, are across Washington Boulevard from the Carroll Park portion of the trail.

The MTA Light Rail line has stations near the trail at Camden Yards, Hamburg Street, Westport and Cherry Hill.

The Park Era and the Olmsted Vision

"From the landscape point of view it frequently happens that a great deal of charming scenery is to be found along the stream; the water itself is interesting, the trees along the stream banks are apt to be numerous and well developed and the valley landscape is generally self contained and full of interest."

—*Report of the Olmsted Brothers, 1904*

Parks were not part of the urban agenda as American cities like Baltimore grew rapidly in their first century. Commerce, industry and residency were their principal functions, and green spaces, open areas or waterside locations were to be used for those purposes. Such environments, not intentionally preserved, typically were left untouched only when they proved unsuitable for development. Outside the built-up city, the wealthy often secured more scenic natural sites—open lands with rural charm and hilltops with picturesque views and cooling breezes. In the middle part of the nineteenth century, however, the urban park movement caught the imagination of civic leaders nationwide, and cities raced to secure park spaces, eventually developing comprehensive plans for parklands. The impetus for the park movement resulted from the convergence of two factors: first, the realization that unbridled urban growth had made cities unlivable—crowded, unsafe and unhealthy; and second, a romantic, perhaps nostalgic, conception of the esthetic and moral value of nature—even as "nature" was rapidly disappearing in the rush toward modernization.

Baltimore therefore was in step with the times when, in 1860, it opened its first large park, Druid Hill, on grounds formerly part of the estate of Nicholas Rogers, one mile beyond the city's northern boundary at the time. Prior to then, early park spaces in the city had consisted principally of public squares—like Union, Lafayette and Franklin on the city's west end—set aside by developers as they realized that provision for small green plots might enhance the value of more upscale rowhouses, especially those on the streets that faced them. In the early nineteenth century, the rural cemetery provided another kind of public green space, an escape from the city to settings where

A streetcar crosses the Edmondson Avenue Bridge above the waterfall of the Gwynns Falls near Ellicott Driveway, 1910. *Enoch Pratt Free Library.*

natural features were enhanced in keeping with romantic sensibilities, as in the case of Baltimore's Greenmount and Loudon Park Cemeteries. In contrast to either the squares or cemeteries, the spacious scenic grounds of the Druid Hill estate offered a mix of open fields, forests and water features on a spectacular hilltop setting. Already possessing many of the natural elements to fit the sensibilities of the romantic park movement, the landscape was enhanced by the provision for curving roadways and scenic vistas designed by Howard Daniels, an early prominent figure in park planning.

The creation of Druid Hill Park placed Baltimore in the forefront of the park movement in American cities at mid-century. It was the third such large, multipurpose park, only shortly following Central Park in New York and Fairmount Park in Philadelphia. In the mid-1850s, Frederick Law Olmsted (in partnership with Calvert Vaux) had won the competition to create Central Park in New York. Olmsted's design soon set the standard for the "naturalistic" park. The term made explicit the reality that the site had not been a spectacular example of preserving nature—the rectangle of its outer boundaries had been laid out amidst the straight lines of the planned grid of streets in the process of the development of upper Manhattan—but rather, it was a carefully crafted creation of features that combined to produce the appearance of nature. Trees around the circumference screened out the city, and cross-park roadways were hidden to reduce

their negative impact. Vast open meadows provided the serenity of "pastoral" nature, while craggy rocks and dense woodlands afforded a contrasting rugged or "picturesque" nature—both sensibilities so prized by romantics. Threaded throughout were curving roadways and walking paths, the two carefully separated in order not to interrupt the tranquil experience intended for a variety of park users. Essential for Olmsted was a democratic commitment to the park as a public space, available to people of all social classes, as much needed to relieve urban pressures for common workers as for the captains of industry.

The acquisition, development and maintenance of parks like Central or Druid Hill would be expensive, of course, and in Baltimore, Mayor Thomas Swann came up with an ingenious way to pay for them. As the city's various horsecar lines competed for customers, they sought routes that might increase ridership and, hence, profits. Swann, recognizing that Druid Hill Park—located outside the city's existing boundaries to the north—represented a desirable transportation destination, proposed and received approval for a street railway tax of one cent on a fare set at five cents. The proceeds provided an independent budget for Baltimore parks for the succeeding three-quarters of a century, until the streetcar system faced bankruptcy during the Great Depression of the 1930s. Administering the funds and supervising the parks of the city was the newly created Board of Park Commissioners. Parks had become an important element of the urban agenda.

During the second half of the nineteenth century, the framework of a park system began to take shape in Baltimore. As early as the 1820s, William Patterson had donated land on the eastern edge of the city for a walking park. As that section became more densely developed, the need to expand parklands there was recognized, and the park named for him was gradually enlarged. Beginning in 1890, the city began to acquire portions of Mount Clare, the former Carroll estate, to create Carroll Park, serving the needs of the congested and predominantly working-class southwest sector. Prior to that time, portions of the grounds had been leased to the West Baltimore Schuetzen Association as a recreational ground for the German-American organization. On the northwest side, Clifton, formerly the estate of Johns Hopkins, whose funds helped to establish a new university bearing his name, was purchased by the city in 1895 when the trustees decided against using the grounds for a new suburban campus. And in 1902, the Park Board recognized the needs of urbanized South Baltimore by acquiring land there for Swann and Latrobe Parks.

By 1900, Baltimore's civic leaders sought to position the city as a national leader, not only in size—it had become the nation's sixth largest—but also in civic amenities. Some of the area's most prominent citizens formed the Municipal Art Society (MAS), dedicated to the beautification of the city through both artistic embellishment and careful urban planning. Baltimore had tripled in size by annexing twenty-three square miles on its west and north sides in 1888, and the MAS made plans for these new sections a top priority, even as consideration was being given to further expansion of the municipal boundaries. Theodore Marburg, MAS president, arranged for the society to engage the firm founded by Frederick Law Olmsted to develop a comprehensive plan

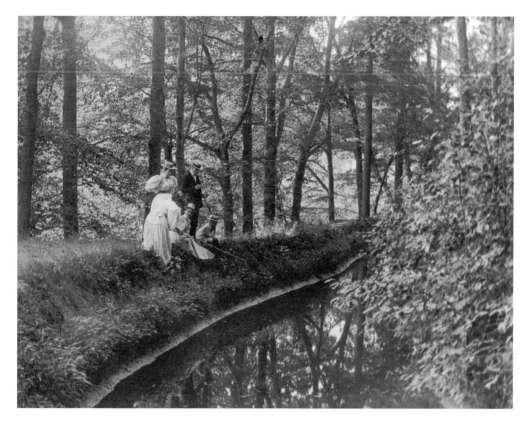

Four people fish in the Calverton millrace, 1899. *Enoch Pratt Free Library.*

for "greater Baltimore"—both the annex and beyond—especially addressing future park needs in advance of the development that was likely to come. Frederick Law Olmsted, whose plans for parks in New York, Boston, Buffalo and elsewhere, had become the gold standard for aspiring American cities, was in declining health (he died in 1903), but the firm continued as Olmsted Brothers Landscape Architects under the guidance of his stepson, John, and his son, Frederick Jr. (or Rick). Frederick Jr. had established ties with the Baltimore leaders during his recent work with the commission developing park plans for the District of Columbia, and he became the firm's principal in the Baltimore study. As an indication of the company's prominence, while Rick and a staff undertook the Baltimore work during 1903, another team, under the leadership of John, completed a comprehensive plan that same year for the newly booming northwest city of Seattle.

The resulting "Report Upon the Development of Public Grounds for Greater Baltimore," published in early 1904 by the Municipal Art Society and presented to the Board of Park Commissioners, was impressive in length (120 pages, plus maps), scope and ambition. Significantly, it made the case for Baltimore parklands in the context of what would have been considered world-class cities—London, Paris, New York and Boston. It took into account the condition and adequacy of the existing parks, as well as "the comprehensive development of a park system in the suburban zone of Baltimore."

Frederick Law Olmsted Jr. (1870–1957) in 1925. *National Park Service, Frederick Law Olmsted National Historic Site.*

Indeed, in consideration of this latter objective, it ranged beyond both existing and projected city limits to sketch out a plan truly metropolitan in scope. In clear and persuasive logic, the report laid out the types of parks a comprehensive system should contain. First were playgrounds and athletic fields—the former at the neighborhood level to serve young children and the latter at a larger district level to serve the sporting activities of older children and adults. Second were large, multipurpose parks. Here the report found Druid Hill and Clifton impressive, though in need of better planning, and it expressed the view that Patterson, serving residents unlikely to be able to travel readily to Druid Hill, should be expanded as an additional multipurpose park.

In terms of new park types, especially for the developing suburban zone, the report's most innovative and detailed recommendations were for stream valley parks and connecting parkways. The case for the former was both esthetic and practical. The principal stream valleys cutting through the uplands of the piedmont section of the developing metropolitan area offered "charming scenery," to this point relatively unspoiled because of their relative inaccessibility. For example, the report, describing the wooded gorge of the upper Gwynns Falls, observed, "The scenery is remarkably beautiful, of a picturesque and sylvan sort seldom possible to retain so near a great city." But, as if to win over the more businesslike mentality of civic leaders, it concentrated as

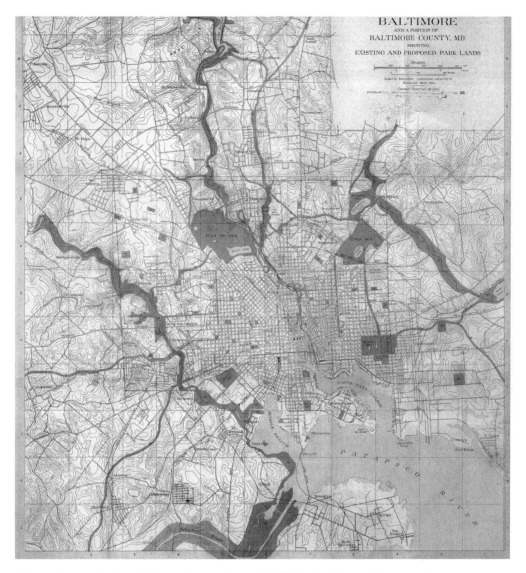

The map accompanying the Olmsted report in 1904 highlighted existing park areas and proposed expansions of the park system. The Gwynns Falls Valley stands out as a diagonal on the city's southwest side. *Friends of Maryland's Olmsted Parks and Landscapes.*

much on the efficiency of securing streams and their valleys in advance of development as on the preservation of scenic landscapes. Immediate acquisition could mean purchase of the land at a cheap price and avoidance of the high cost to remediate the erosion, flooding and other problems that likely would come in the wake of untrammeled urban growth. In addition to the Gwynns Falls on the west side, other stream valleys singled out for park acquisition included the Jones Falls and Stony Run on the north and Herring Run on the northeast. Beyond the city limits, the report also called for similar preservation of the Patapsco and Gunpowder River Valleys.

Winans Meadow and the Ben Cardin Pavilion on the Gwynns Falls Trail. *Guy Hager.*

Finally, parkways and "cross connections" should link the principal large parks and stream valley parks, knitting them together in a way that created the opportunity for park-like experiences throughout the entire metropolitan area. Parkways not only provided approaches to the city's parks, but also an alternative to "the petty annoyances and danger of ordinary street travel." While the report laid out an ambitious proposal for major parkways extending radially from the city to its surroundings, the recommendations that came closest to eventual implementation were for corridors linking the three major stream valleys, with Druid Hill Park as the centerpiece. The report called for connections from Druid Hill westward to Gwynns Falls and eastward across the Jones Falls and Stony Run (through Wyman Park) on to Clifton and Montebello Parks and the Herring Run Valley. Scaled down to less park-like dimensions and straightened, these became Gwynns Falls Parkway on the west and Thirty-third Street on the east.

No sooner had Baltimore received its world-class Olmsted vision than municipal tragedy struck. On February 7, 1904, fire swept through the heart of the downtown. The city now would have a major rebuilding challenge, even as it contemplated the sweeping proposals for park expansion. However, the Olmsted report had profound consequences for the Gwynns Falls Valley over the years to come.

Trailhead 6: to the east, the trail passes through Carroll Park. The section of the Gwynns Falls Valley between Trailheads 6 and 3 was addressed in detail in the Olmsted report, which also took into account the construction of the rail line.

The Gwynns Falls as a Stream Valley Park

STEPS TOWARD FULFILLING THE VISION

"North of Edmondson Avenue occurs the widest stretch of bottom land to be found for several miles along the Falls, a great meadow flanked by steep and attractive hills."
—*Report of the Olmsted Brothers, 1904*

The 1904 Olmsted report laid out an ambitious vision of a comprehensive park system for Baltimore, expanding existing parks, securing the stream valleys as natural corridors and knitting everything together with a system of parkways. Over the next ten years, the firm worked closely with city officials on the initial steps to implement these recommendations, and over the first four decades of the twentieth century, the Olmsteds continued to be retained periodically as the principal outside consultants for park matters. The first decades of the twentieth century equaled in significance the earlier initiatives toward creating a premier park system. By 1925, park acreage had doubled from the pre-report level. Yet, political considerations and financial realities circumscribed fulfillment of the vision, leaving a framework but an unrealized vision.

Part of the genius of the approach pioneered by Frederick Law Olmsted Sr., and carried on by his sons John and Frederick Jr., was the careful attention given to existing conditions in the cities where they undertook comprehensive planning. Their preliminary review involved considerable consultation with local authorities to assess the existing parks and to determine their ideas for the future. Additionally, it involved careful study of what the 1904 report called "local conditions"—both the natural and the built environment—based upon thorough study of such aids as topographical maps and careful field observation. As a result, though their park plans for different localities had common features, they did not simply mimic one another, imposing a one-size-fits-all imprint. For example, the 1903 planning for Seattle and Baltimore resulted in different schemes. The Seattle plan accepted the absence of a large, multipurpose park, instead proposing to knit together smaller parcels to maximize the scenic views and natural beauty of water features and mountain vistas, while the Baltimore plan was anchored by its larger parks, Druid Hill and Patterson, augmented by the addition of stream valley parks and connecting parkways.

Rustic furniture was provided along the millrace path in the 1920s. *Enoch Pratt Free Library.*

The early 1900s represented a critical juncture in the conception of parks for American cities. Frederick Law Olmsted Sr. had championed the "naturalistic" park, one that emphasized natural features, whether carefully crafted as in examples of his work in urban settings like New York's Central Park and Brooklyn's Prospect Park, or enhanced, as in the case of such spectacular sites as Yosemite and Niagara Falls. Both the Baltimore and Seattle plans continued to accord primacy to the value of naturalistic scenery, but the work of the firm began to take fuller account of the rapidly growing movement for active recreation. In its discussion of the functions of parks, the 1904 report first addressed the need for playgrounds for young children and athletic fields for older children and adults, and these kinds of facilities represented a full one-third of the park acres recommended for acquisition. Follow-up plans by Rick and his associates for Swann and Latrobe Parks in South Baltimore and for the eastern end of Carroll Park in Southwest Baltimore principally addressed the design of such active recreation features as playgrounds and athletic fields. A consistent principle of the Olmsted approach, however, was that whenever possible, active and passive recreational opportunities should be kept separate, as when Rick expressed concern that the playing fields in Druid Hill Park were "unfortunately located," creating problems of access and detracting from "the quiet rural landscape which it is the primary purpose of such a park to provide." Similarly, the plan for Carroll Park provided for more formal design in the Mount Clare mansion portion to the west of the athletic grounds.

During the decade following publication of the 1904 report, the Olmsted firm worked with the park board on extensive study of plans for the stream valleys, including detailed recommendations upon land acquisition in the Gwynns Falls Valley. The firm's

The Carroll Park playground in early 1900s. *Maryland Historical Society.*

P.R. Jones provided careful evaluation of expansion for Gwynns Falls Park, the initial portion of which had been established only a few years earlier in 1901 as a small parcel of land on the west side of the Edmondson Avenue Bridge between the stream and Hilton Street. The 1904 report urged acquisition of substantial portions of the valley north of Edmondson Avenue to preserve their natural qualities against the threat of development, which already was beginning to encroach in the vicinity. It was especially taken with the beauty of the area known locally as Bloomingdale Oval and detailed the case for a slight realignment of the Western Maryland Railway line (which even the Olmsteds acknowledged had no alternative but to use the lower valley for port access), though its recommendations fell on deaf ears.

In addition to attention to the lowlands, Jones worked with park officials to evaluate the lands that should be acquired on the hillside to the north, including the former Calverton millrace, which struck him as an area of particular natural beauty. Making the case for filling in the old water course to create a promenade, he wrote:

> *The mill race is largely fringed with valuable trees and commands a remarkably fine view of the valley over the adjacent lands on the slope,* [and openings along it] *form the frame and enclosure of the valley landscape.*

In 1913, park officials followed Jones's advice, creating a popular woodland walkway. Guided by Jones and the Olmsted team, 462 acres were added to Gwynns Falls Park during the 1905–16 period, approximately half of all acreage acquired in those years of the city's parkland expansion.

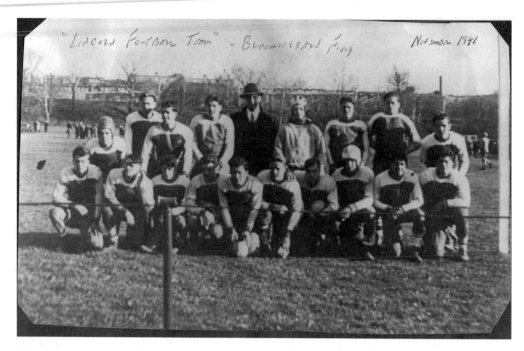

The Lincoln Football Team at Bloomingdale Field, 1941. *Darla Sando.*

Bicycle riders along today's Gwynns Falls Trail. *Guy Hager.*

The proposal in the 1904 report for parkways linking the stream valleys to Druid Hill Park were only partially fulfilled. The Olmsted Brothers recommended broad, winding, park-like routes, with trees and plantings on both sides. However, as eventually developed, Thirty-third Street on the east and Gwynns Falls Parkway on the west ended up more as boulevards, straight-line roadways with tree-lined medians, rather than Olmsted-style parkways. Similarly, the 1904 report argued that "the entrance of this connection into the proposed Gwynn's Falls Park would be through one of the most beautiful of the lateral valleys along the course of the stream." Considerable Olmsted design work on how Gwynns Falls Parkway might appropriately descend into the valley portions of Gwynns Falls Park went unfulfilled. Instead, the tree-lined portion of the main roadway ended abruptly at the park boundary, where through traffic follows the historic course of Windsor Mill Road, descending into the valley and crossing the stream.

Between Edmondson and Frederick Avenues the valley narrows. The 1904 report noted that this was "a very beautiful portion of the valley" and argued that it "should unquestionably be set aside as a park," especially the east side between the stream and the millrace that formerly had served the Ellicott Three Mills complex. On the other hand, the west side had less value as a park because it was "[s]o occupied by quarries as to be both unattractive and costly to interfere with at the present time." It also had been selected for the tracks of the new Western Maryland Railway line.

Not only was the east side added to the acreage of Gwynns Falls Park, but in the 1910s, as motor car advocates increasingly looked to create scenic drives, momentum built for filling in the old millrace (its stagnant water a health and safety hazard) and creating a parkway along its course. At the point where the stream flowed over a durable rock formation, the operators of the Ellicott Mills had added additional height with a diversion dam to channel water to their mill complex at Frederick Avenue. The resulting cataract was considered especially picturesque, known locally as "Baltimore's Niagara Falls." In 1917, Ellicott Driveway (named for the original mill owners) was constructed atop the former millrace. The gently curving scenic parkway linked three west-side arteries—passing beneath Edmondson Avenue, it reached Baltimore Street and Frederick Avenue at grade level. Eric Holcomb, of Baltimore's Commission for Historical and Architectural Preservation, notes that Ellicott Driveway conformed so well to the design principles of the Olmsted Brothers that it was singled out in their 1926 report on Baltimore parks, with an accompanying photograph, in making the case for scenic parkways that provide

opportunity for pleasant driving to and from work, or from neighborhood to neighborhood, or entirely for pleasure, relieved at least partly from the sight of crowded buildings.

Over time, portions were closed to motor traffic and they suffered from neglect. In 2000, Ellicott Driveway became the route for the Gwynns Falls Trail.

South of Frederick Avenue to the Middle Branch, the 1904 report recommended acquisition of property on both sides of the Gwynns Falls, noting that the land was

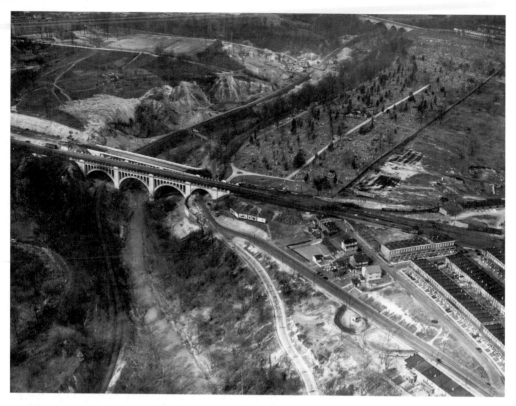

Multiple transportation modes along the Gwynns Falls Valley, 1932. Ellicott Driveway and the Western Maryland Railway followed the valley, while Baltimore Street and the Pennsylvania Railroad bridged it. *Enoch Pratt Free Library.*

"free from costly improvements and can be cheaply acquired." A portion west of the Gwynns Falls, between Frederick and Wilkens Avenues, was added to Gwynns Falls Park, and in 1915 public swimming pools were built there, replacing older swimming facilities maintained on the Gwynns Falls itself and serving the needs of the populous urban district. But acquisition to secure uninterrupted control of the stream side in the lower valley, long impacted by commercial and industrial uses, did not occur until the Trust for Public Land assisted the city in adding portions of property to provide for connecting the route of the Gwynns Falls Trail.

In 1926, the Olmsted Brothers landscape firm was again retained to provide a master plan for Baltimore's parks. Just as the 1904 report took into account the special needs occasioned by Baltimore's annexed area, even anticipating the further round of expansion that occurred with the 1918 annex, the 1926 report sought to project the city's park requirements to the year 1950. Arguing that continued urban growth seemed inevitable for the city, the report reasoned:

> *What the present generation can do and all that it can do, is to endeavor intelligently to guide this growth and development into efficient and healthful and beautiful ways.*

Ellicott Driveway under construction, about 1917. *Enoch Pratt Free Library.*

The report, like its predecessor, made the case for a balanced park system, but especially concentrated upon those areas of the outer city where population was increasing, urging further extension of the stream valley parks on the urban periphery. For the Gwynns Falls, the report recommended acquisition of land northwest of Windsor Mill Road through Dickeyville toward the streetcar-run Gwynn Oak Park just outside the new city limits, noting that this would include "some of the parts of the Gwynns Falls Valley which are the finest because of the beauty of their great trees and striking ground formation." It also urged acquisition of the valley of the Dead Run, a westerly tributary of the Gwynns Falls.

The Great Depression put great stress on the park system and any plans for expansion, though New Deal economic relief programs provided some assistance—the WPA (Works Progress Administration) for civilian labor projects and the PWA (Public Works Administration) for capital improvements (like the building of Hilton Parkway). As the Depression began to ease, Baltimore park politics became embroiled in the question of where funds from the Leakin bequest should be expended to create a significant new park, and the Olmsted recommendations regarding the natural advantages of the Dead Run Valley took center stage.

Above: Young people installing arbor identification signs on the millrace section of the Gwynns Falls Trail. *Guy Hager.*

Left: The Hilton Parkway Bridge, built in the 1930s, to cross the Gwynns Falls near Bloomingdale Oval. *Enoch Pratt Free Library.*

Trailhead 3: users of the unpaved millrace portion of the Gwynns Falls Trail between Windsor Mill Road and Morris Drive will appreciate P.R. Jones's evaluation of this scenic pathway high above the valley floor. Windsor Mill Road connects with Gwynns Falls Parkway up the hill to the east of this trailhead.

Trailhead 4: the Olmsteds urged securing as parkland the meadows of Bloomingdale Oval, now the playing fields of Leon Day Park. Hilton Parkway crosses the valley upstream on the bridge constructed with public works funds in the 1930s.

Trailheads 4 and 5: this section of trail makes use of Ellicott Driveway (closed to motor traffic).

Trailhead 5: the small portion of Gwynns Falls Park between Frederick and Wilkens Avenues once was the site of municipal swimming pools.

African Americans and the Struggle for Equality

"The only thing different between the South and Baltimore was trolley cars."
—*Thurgood Marshall, quoted by Juan Williams in* Thurgood Marshall:
American Revolutionary *(1998)*

Just as slavery, segregation and racial discrimination have had profound impact upon the African American experience in Baltimore, so has the struggle for equality provided its defining theme. Housing, jobs, education and civil and political rights have been the principal arenas in a historical legacy often exposing the contradictions between democratic ideals and actual social practices.

Maryland, like Virginia to the south, introduced African slavery early in the colonial period, and the slave system became closely tied to the tobacco cultivation economy of the tidewater regions. In the lower Gwynns Falls, Mount Clare, the large Carroll plantation, employed slave labor, as did the ironworks of the Baltimore Company. However, slavery was less prevalent on the farms and in the small settlements of the upper Gwynns Falls, and those districts had only modest African American residency. For example, the U.S. manuscript census for 1860 reveals that in the settlements known as Franklintown, Wetheredsville, Calverton and their vicinity (all then in Baltimore County), only William H. Freeman of Franklintown and Reverdy Johnson on his Lyndhurst estate had slaves, the former owning three and the latter, one. In these same districts, the census generally found only a few, scattered free black residents, most of them listed as laborers or servants.

At the outbreak of the Civil War, Baltimore had more free blacks than any other city in America. Its free black population in 1860 stood at 25,680, compared to a slave population of only 2,218. Urban conditions in the first half of the nineteenth century proved not to be conducive to slavery. However, the actual social and political status of those considered free blacks fell far short of freedom—they often lived and worked in conditions not very different from the city's slaves. At a time when proximity to work was the principal determinant of residency, African Americans lived scattered

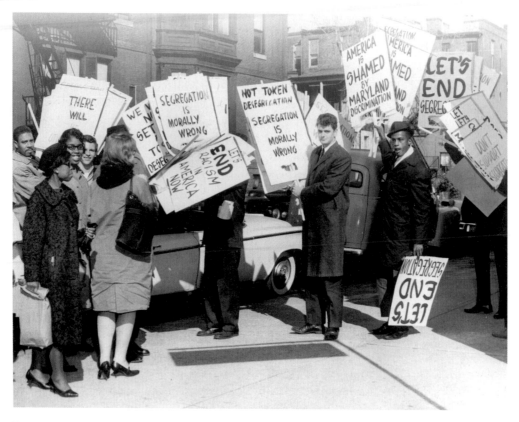

Demonstrations against segregation in Baltimore restaurants, 1961. Baltimore News–*American Collection,*
University of Maryland, College Park.

throughout the city, not residentially segregated. For example, in 1860, African
Americans resided in all of the city's wards, but nowhere were they more than one-
third of the total population. In the city's two west-side wards, they constituted 7.6
percent of the population. However, African Americans often were forced to live in
substandard housing, frequently inhabiting the smaller and more crowded residences of
the alleys, and few owned their own homes. Most were limited to jobs as domestics or
laborers, but in the 1840s and 1850s competition even for those jobs became intense as
Baltimore's European immigrant population grew rapidly, especially with newcomers
from Germany and Ireland. In 1860, the foreign-born population was nearly twice as
large as the African American population. Circumscribed by these conditions, African
Americans established early institutions, including churches, as important places of
refuge and autonomy. One reminder of this heritage is the Mount Auburn Cemetery,
located along Waterview Avenue just west of the Gwynns Falls Trail. Dedicated in 1872
and known as the "City of the Dead for Colored People," Mount Auburn was owned
and operated by African Americans. It was listed on the National Register in 2001.

By the turn of the twentieth century, a number of factors converged to produce
a greater degree of residential segregation in the city. Baltimore's population grew

substantially, fueled both by African Americans from rural areas of Maryland and nearby Southern states and by new waves of European immigrants. The newcomers crowded into older sections of the city, greatly increasing the pressure upon the available housing stock. Meanwhile, transportation innovations—first the horsecar and then the electrified streetcar—made it possible for people of greater financial means to move farther from the city center to new housing on the urban periphery. As the city's population began to separate by class, it also began to separate by race. With the new housing on the city's expanding urban edge available to whites only, and with blacks experiencing resistance to residency in other parts of the city, concentrated areas of black settlement emerged on the near west and east sides of the city center.

In an era when Jim Crow segregation laws were being instituted to govern race relations, Baltimore's city government went so far as to pass a series of housing segregation ordinances in the 1910s. Though declared unconstitutional by the Supreme Court in 1917, these regulations (dubbed "Apartheid—Baltimore Style" by legal historian Garrett Power) epitomized a racial climate in which both social and spatial separation prevailed. But such restrictions were not without resistance. For example, African Americans had to fight for public schooling (introduced on a segregated basis in the late 1860s), for black teachers (finally appointed in the late 1880s) and for high school grades (also instituted in the 1880s). In 1925, Douglass High School occupied a new building in the heart of the segregated Upton area. Though it was the city's only high school for black young people, it became a source of pride, producing a number of notable graduates, including Thurgood Marshall.

Residential segregation confined Baltimore's growing African American population to limited housing space, but it also fostered a strong sense of black community and provided the base for a growing tradition of civil rights activism. Beginning in the 1930s, Lillie Mae Jackson led the Baltimore chapter of the NAACP (National Association for the Advancement of Colored People) in a campaign against racial discrimination and injustice, publicized by Carl Murphy, editor of the Baltimore *Afro-American* newspaper. Initial targets were lynching (still occurring in rural Maryland and elsewhere), jobs (fought with a "Don't Buy Where You Can't Work" picketing campaign) and education. On the latter front, an important breakthrough came in 1935, when NAACP lawyers— including the young attorney Thurgood Marshall—successfully sued to gain admission for Donald Murray to the University of Maryland Law School. During and after World War II, the campaign for equal rights made advances in ending segregation in downtown hotels, restaurants, entertainment and department stores, as well as in parks and municipal government employment. When the Supreme Court delivered its landmark *Brown v. Board of Education* decision in 1954, Baltimore became the first officially segregated big city school system to initiate a policy of desegregation, though the initial steps were limited.

Housing, however, remained highly segregated. Baltimore's population, black and white, surged during and after World War II, fueled by the large numbers coming to the city to work in war industries. Between 1930 and 1950, the African American population increased from 142,106 to 225,099, but the walls of segregation remained

Baltimore NAACP chapter president Juanita Jackson Mitchell responds to criticisms made of African American leaders by Governor Spiro Agnew in the aftermath of the 1968 riots following the assassination of Martin Luther King Jr. *Baltimore News–American Collection, University of Maryland, College Park.*

virtually unchanged. During those years, the racial divide roughly ran along Fulton and Monroe Streets, approximately a mile east of the Gwynns Falls Valley. In the postwar period, middle-class whites could take advantage of new housing opportunities in the suburbs of the city and beyond. However, such housing was restricted in a subtle but complex pattern of discrimination, underwritten by custom as well as by the practices of the real estate industry and financial institutions (both private and governmental).

Beginning in the 1950s, the old walls of housing discrimination rapidly began to crumble, as growing protest against traditional forms of segregation combined with African American housing needs to create intense demand for new housing opportunities. Old-line civil rights organizations like the NAACP were joined by new activist groups like CORE (Congress of Racial Equality) to press the demand for fair housing opportunity. As African Americans sought residency in formerly all-white neighborhoods, many whites moved rather than integrate. Sometimes white fears were fanned by real estate operatives, called "blockbusters," who bought low from fleeing whites, then sold high to incoming blacks. The result was a period of rapid racial turnover, as substantial sections of the city changed racially from white to black.

The area of African American settlement expanded considerably, though often on a resegregated basis. By the 1950s, the Greater Rosemont community, due east of the Gwynns Falls Valley, had become predominantly African American. In the period from 1955 to 1965, a similar pattern of racial change occurred on the west side of the valley

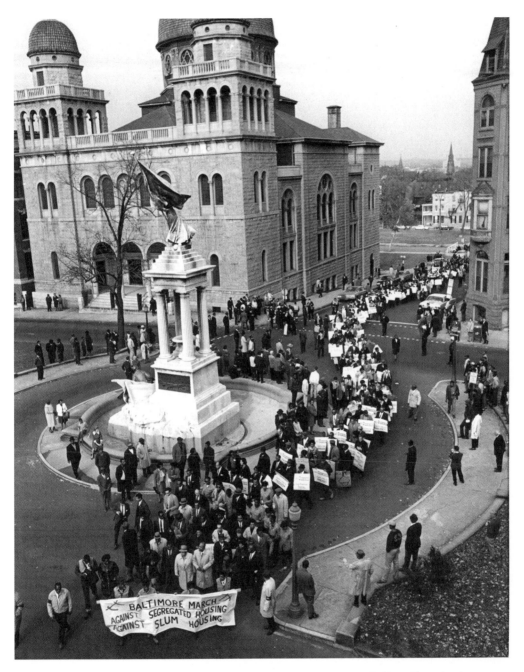

A Baltimore rally protesting segregated housing and slum conditions, 1965. *Baltimore News–American Collection, University of Maryland, College Park.*

along Edmondson Avenue. In that section, virtually an entire population of twenty thousand changed places in a period of less than ten years. One of the few notable efforts to accept racial integration and work toward a pattern of stable integration occurred in the neighborhood of Windsor Hills, to the east of the Gwynns Falls. In 1968, the federal Fair Housing Act outlawed discrimination in housing rentals, sales and loans, and prohibited a number of unfair real estate practices, including steering and blockbusting. By that time, Baltimore's west-side area of predominant African American residency extended to the city line, approximately three miles farther than in the 1930s.

Reginald F. Lewis: Rosemont's Native Son
By David Terry

Born in East Baltimore, on December 7, 1942, a young Reginald Francis Lewis dreamed of all life's possibilities. He spent his early years at 1022 Dallas Street, part of a working-class family in a working-class neighborhood. Like others in a part of the city burdened with racial segregation and material neglect (the street was not even paved), Lewis benefited from the nurture of kinfolk and community.

Players and coaches from the Leon Day Little League baseball team in Rosemont, where Reginald Lewis once played sports. *Leon Day Foundation.*

In 1951, his family moved to a rowhouse at 2802 Mosher Street in West Baltimore's Rosemont neighborhood. From an early point in his life, it was clear that Lewis had a mind for business. Indeed, he began his entrepreneurial career at the age of ten by delivering the Baltimore *Afro-American* newspaper—a business venture he reportedly later sold at a profit. His parents and grandparents taught him the importance of saving some of everything he earned.

During his high school years at Paul Lawrence Dunbar High School, Lewis excelled academically and athletically. A quarterback in football, shortstop in baseball and forward in basketball, he served as captain on all three teams while at Dunbar. He was also elected vice-president of the student body. His friend and classmate, Robert M. Bell (who went on to become chief judge of the Maryland Court of Appeals), served as president. During his high school years, Lewis also worked nights and weekends at jobs with his grandfather, a headwaiter and maitre d'.

In 1961, Lewis entered Virginia State College (now Virginia State University) in Petersburg, Virginia, on a football scholarship and majored in economics. After losing the scholarship to injury, he persevered, working in a bowling alley and as a photographer's assistant to help pay his expenses. He graduated on the dean's list. During Lewis's senior year, he participated in a Rockefeller Foundation program at Harvard Law School, where he so impressed his hosts that, at the conclusion of the program, he was invited to attend Harvard Law School. During his third year there, Lewis discovered the direction for his future career in a course on securities law. He graduated from Harvard Law School in 1968 and was recruited to work for the prestigious New York law firm Paul, Weiss, Rifkind, Wharton and Garrison. Within two years, he was ready to go out on his own, establishing the first African American–owned law firm on Wall Street.

In 1983, Reginald F. Lewis formed a venture capital company, the TLC Group, LP. His first major deal involved the $22.5 million leveraged buyout of the McCall Pattern Company. Lewis nursed the struggling company back to profitability, leading it to enjoy the two most prosperous years in its history. In the summer of 1987, he sold McCall Pattern for $90 million.

In October 1987, Lewis purchased the international division of Beatrice Foods, with holdings in thirty-one countries. At $985 million, the deal was the largest leveraged buyout of overseas assets by an American company at the time. As chairman and CEO, Lewis moved quickly to reposition the company—known thenceforth as TLC Beatrice International—paying down debt and vastly increasing its worth. By 1992, the company had sales of over $1.6 million annually.

With all of his success, Lewis did not forget others—giving back was part of his life. In 1987, he established the Reginald F. Lewis Foundation, which funded grants totaling approximately $10 million to various nonprofit programs and institutions. His first major grant was an unsolicited $1 million in 1988 to Howard University—a school he never attended. In 1992, Lewis donated $3 million to Harvard Law School—the largest grant in the history of the school at the time. The Reginald F. Lewis International Law Center was named in gratitude for this gift.

The Charm City Buccaneers football team at Leon Day Park, 2007. *Leon Day Foundation.*

In January 1993, after a short illness, Lewis's remarkable career was cut short by his untimely death at the age of fifty. Yet, his philanthropic spirit lives on through his foundation. Before his passing, Lewis made known his desire to support a museum of African American culture. In 2002, with remarkable serendipity, trustees of the Reginald F. Lewis Foundation learned of an effort to build a museum of Maryland African American history and culture in Lewis's hometown, Baltimore. In support of the proposed museum's education programs, the foundation made its largest grant ever: $5 million. In recognition, the Reginald F. Lewis Museum of Maryland African American History and Culture now stands five-stories tall at the corner of Pratt and President Streets, mere blocks from where its namesake spent his early years and first dreamed of all life's possibilities.

The Rosemont neighborhood in which Reginald Lewis grew up is adjacent to Trailhead 4.

The Middle Branch's Southern Shore

"Shad, herring, rock fish and yellow perch were plentiful [in the Middle Branch]. *During flood tide there was an abundance of soft crabs. The place was thick with snapping turtles."*

—*Lee McCardell,* Baltimore Sun *(1940)*

The southern shore of the Middle Branch lay beyond the Baltimore City limits before the annexation of 1918. Until well into the nineteenth century, the land between the mouths of the Gwynns Falls and the Patapsco River was thinly settled, its uplands a mix of farming and mining operations, its shore the location for a popular fish house for those willing to make the trek from the city.

When the site to establish Baltimore Town was being considered in the 1700s, landowner John Moale refused selection of his property south of the Middle Branch because of its potential for iron ore mining, so the Inner Harbor location at the mouth of the Jones Falls was chosen instead. In the nineteenth century, a long plank bridge—Harmon's—crossed the broad, shallow mouth of the Gwynns Falls to provide road connections between Baltimore and Annapolis. Later, fill shortened the span on Old Annapolis Road. Fletcher's Fish House on Waterview Avenue invited "sportsmen and others" to fishing outings, followed by evenings with "the choicest liquors, the best fish and also those superior delicacies, soft crafts and mackerel, in season."

The natural resources that Moale prized led railroad inventor and entrepreneur Ross Winans to establish mining operations and a town for workers at Mount Winans in the mid-nineteenth century. Since the hills had been left bare by the earlier Baltimore Company's quest for timber to produce charcoal for its iron furnace, Winans proceeded to plant orchards and erect greenhouses. In the 1880s, the Carr Lowrey Glass Company brought glass production to the shores of the Middle Branch. Glassmaking had a long history in Baltimore, dating to early manufacture in the vicinity of Federal Hill. For the next century, Carr Lowrey produced glass products, specializing in containers for perfumes and pharmaceuticals and employing workers who settled nearby in

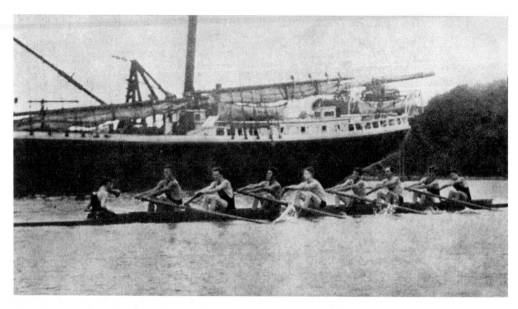

A rowing crew on the Middle Branch in the early 1900s. *Enoch Pratt Free Library.*

Westport. In the early 1900s, the massive Westport powerhouse was constructed on the adjoining shoreline, providing electric power for Baltimore's growing energy demands. Westport, with nearby employment and a station on the rail line, took on the character of an urban neighborhood.

The isolation of southern sections of the Middle Branch began to change with annexation by Baltimore City in 1918. In anticipation, the city constructed the impressive Hanover Street Bridge in 1916, its graceful arches a monumental tribute to an area long separate from the city and seemingly bypassed.

In the early 1940s, the Housing Authority of Baltimore City selected Cherry Hill as the site for new housing to meet the needs of African Americans drawn to the city to work in war-related industries. The project involved the erection of public rental units as well as the construction of houses by private developers for sale to homeowners. These origins in an era of segregation led to the establishment of a substantial new African American community, though one that was physically isolated from other parts of the city.

The 1904 Olmsted report paid little attention to the southern shore of the Middle Branch. The area was outside the city limits, although the report did make recommendations regarding other outer city locations. In 1920, the city established Broening Park along the waterfront southeast of the Hanover Street Bridge as the first park in the new annex area. The Maryland Yacht Club leased land there to erect a clubhouse, and hydroplane boat races on this portion of the Middle Branch became popular events. In 1977, additional parcels on the northern and southern shores were incorporated to form Middle Branch Park, and ten years later the Baltimore Rowing and Resource Center was erected on the waterfront west of the Hanover Street Bridge, with fishing piers and ramps for rowing

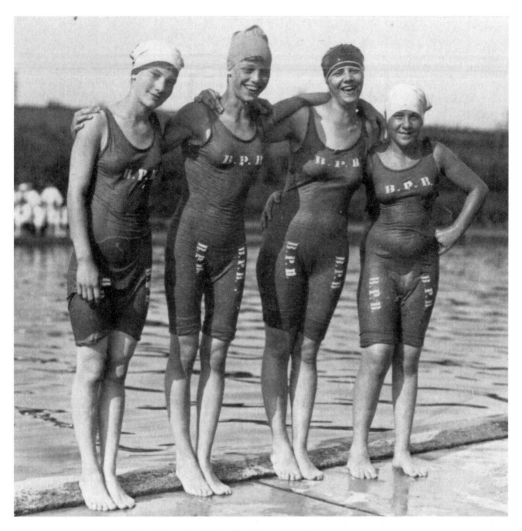

Swimmers at the Middle Branch, early 1900s. *Enoch Pratt Free Library.*

clubs. In 1989, the granite Maryland Vietnam Veterans Memorial, listing the names of Marylanders who lost their lives in that war, was dedicated at its site southeast of the span, renamed the Vietnam Veterans Memorial Bridge.

When South Baltimore General Hospital relocated in 1968, eventually taking the name Harbor Hospital, its modern structure dominated the shoreline east of the Hanover Street Bridge. To the west, a thin band of parkland gave way to a marina and then to the warehouses and industries of Westport. When the Baltimore Gas and Electric Company decommissioned its steam-generating power plant, and the Carr Lowrey Glass Company, no longer able to compete with specialized glass products in an era of plastic, closed up in 2003 after 114 years of operation, the industrial era had passed by Westport and its nearby neighborhoods, and abandoned structures lined the shoreline.

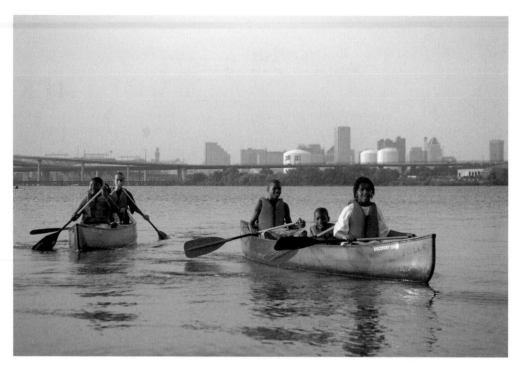

Contemporary young people canoeing on the Middle Branch water trail. *Baltimore Department of Recreation and Parks.*

The establishment of a station for the new Light Rail in Westport and the inauguration of the Gwynns Falls Trail along the shoreline provided glimmers of change for the southern shore of the Middle Branch, but few would have predicted that the long-neglected area would attract ambitious plans for high-end waterside development that some would compare to the Inner Harbor as the twenty-first century dawned. On the hillside opposite the marina on Waterview Avenue, the condominium units of Waterview Overlook promise to afford impressive views across the Middle Branch to the downtown skyline, the Carr Lowrey Glass Company buildings have been razed to make way for mixed-use development and plans are underway to redevelop the old steam-powered electric plant. Developers talk of the southern shore of the Middle Branch becoming "a little Canton or Harbor East in Harbor West." The proposed changes have brought mixed response from residents of Mount Winans, Westport and Cherry Hill, who welcome prospects for economic revitalization, but worry that redevelopment may result in gentrification and displacement. In response to this concern, the developers have made commitments to work toward sustaining affordable housing options as well as upgrading the quality of life in the community.

Trailheads 8 and 9 are situated on the Middle Branch.

Leakin Park

A NAME BEFORE A PLACE

"This valley [Dead Run], *of all those discussed, has been freer from defacement by man's activities. It is considered by all who view it as one of the very best bits of scenery near Baltimore."*
—*Olmsted Brothers,* Report and Recommendations on Park Extension for Baltimore, *1926*

Leakin Park had a name before it had a place. The former Crimea estate was acquired by the city in 1941 and 1948 with money left as a bequest by Baltimore attorney J. Wilson Leakin in 1922 to purchase land for a park. The site belonged to the Hutton family, heirs of Thomas Winans, who had established the country estate in the late 1850s. The park would serve to honor Leakin's grandfather, Sheppard Church Leakin, who had served as Baltimore's mayor from 1838 to 1840.

The money would come from the sale of several downtown properties. However, by the time the existing leases for the structures had expired, the stock market crash and the subsequent Great Depression led the city to defer action. When prices rebounded in the late 1930s, the city moved to sell the properties. But questions remained: What kind of park, and where?

The ensuing controversy demonstrated just how diverse the park needs of the city were and how politically divisive park policies could be, as various sections of the city competed for the park funds. In 1939, Mayor Howard Jackson appointed a selection committee to review potential sites and to make recommendations. In the process, over one hundred locations were considered, many with strong local advocates. But the choice boiled down to two types: One was a "utilitarian" park in an underserved inner city neighborhood; such a site would necessarily be small due to the high costs of acquisition. The second type was an "esthetic park" in a place of natural beauty, where a large tract of land might be secured from the available funds. The leading contender for the former was a site along the Fallsway (near where the Jones Falls emptied into Baltimore's Inner Harbor) in an impoverished section of the old city. For the latter, the

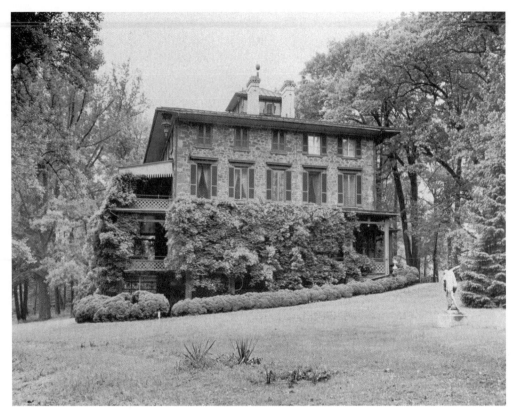

Orianda, the home of the Winans family on the Crimea estate, 1948. Baltimore Sun.

Crimea estate in the valley of the Dead Run (a northwestern branch of the Gwynns Falls) on the city's growing northwest side—only annexed by the city twenty years earlier—had strong appeal.

With the matter at an impasse, municipal officials requested the opinion of Frederick Law Olmsted Jr., the nationally prominent landscape architect whose firm had completed major park planning studies for Baltimore in 1904 and 1926. Olmsted acknowledged the value of both kinds of parks and the ways they addressed different, but important needs. He recognized that Baltimore's inner city areas required more satisfactory park spaces, calling the necessity "real" and "urgent" (and noting that some cities, like Chicago, had begun to establish new types of parks to serve older urban sections). However, he questioned whether the available funds would be sufficient to accomplish the goal. On the other hand, he concluded that the Crimea estate offered the greatest advantages in terms of size, natural beauty and value. Part of the logic of this site was that it required little alteration to make it park-like. Olmsted wrote that it was

> *so nearly in condition, just as it now is, to be a very beautiful and valuable park…a type of park which is notable for its exceptional natural landscape beauty, of a sort very keenly enjoyable, in a quiet, leisurely way, by many kinds of people.*

J. Wilson Leakin (1857–1922), from a
portrait in the Peabody Institute's Leakin
Hall. Baltimore Sun.

Olmsted's recommendation was supported by planning officials, who concluded that it
was consistent with the goal of securing the major stream valleys as natural spaces, in
this case expanding the land already secured for adjacent Gwynns Falls Park.

Mayor Howard Jackson signed the ordinance authorizing the purchase of the valley
portion of the Crimea estate in June 1940, and in January 1941, the city completed the
transaction. But the story was not over. Mayor Jackson was succeeded by former city
councilman Thomas D'Alesandro Jr., who had supported an inner city site. D'Alesandro
contended that the Crimea land was inaccessible, underutilized and unknown to many
city residents. He objected to the proposal to purchase the remaining portion of the
estate, instead proposing the sale of the first section, with the proceeds to acquire a
waterfront park closer to the city center. Despite the mayor's opposition, the remainder
of the Crimea estate, including the old summer mansion house and associated structures,
was purchased in 1948. Over twenty years after Leakin's provision to establish a park to
bear his family name, Baltimore had finally found the right place.

The 1941 and 1948 acquisitions created a 309-acre park. While much of the Crimea
tract was woodland, which could remain in its natural state, the upland area along
Windsor Mill Road lent itself to more active recreation. In 1950, the Slomann Memorial
Playfield was dedicated on that portion. Ten years later, Leakin Park was expanded on

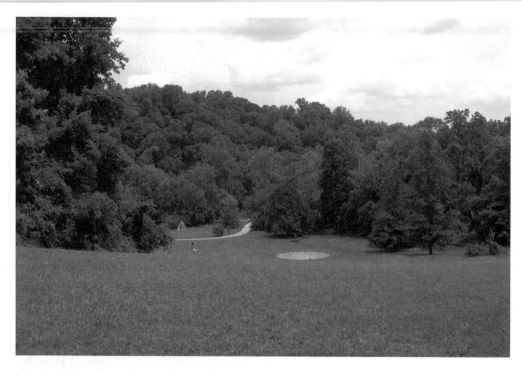

Winans Meadow and the Gwynns Falls Trail near Trailhead 2. *Guy Hager.*

the northeast side by the acquisition of 100 acres from the former Windsor estate, along Windsor Mill Road. The addition was to replace land to be taken for the east–west expressway (I-70) because of its proposed route through the park, but the fight to prevent the road's intrusion is another story in the politics of parkland.

Overall, Baltimore's park system never fully recovered from the loss of its dedicated funding stream with the termination of the streetcar tax in the 1930s. In the half century following World War II, as the Department of Recreation and Parks became principally dependent upon the vagaries of the city's budget, its operations were not always high among urban priorities. A 2000 comparison of Baltimore to other cities with high-density populations by Peter Harnik of the Trust for Public Land placed Baltimore in a middling position, much lower than Chicago, Boston and San Francisco and on a par with Philadelphia and New York in terms of expenditure per resident. Parks like Leakin and Gwynns Falls felt the budgetary pinch.

Today, Leakin and Gwynns Falls Parks together, augmented by the additional purchase of 209 acres in 1969, comprise 1,200 acres, representing one of the largest natural woodland parks in an eastern U.S. city. However, considered as a type of park not requiring a great deal of development, the tract received scant resources or attention. Dumping became a perennial problem along the roadways crossing through parkland. And further tarnishing the image of these parks were occasional crimes—even, on several occasions, the dumping of dead bodies in places far from public sight. Local lore and popular culture picked up on this reputation—as when the popular locally filmed

Leakin Park offers area children an opportunity to learn in a natural setting. *Heide Grundmann.*

NBC television series *Homicide* and local mystery writer Laura Lippman based stories around the theme. Portions of the parks along the Gwynns Falls and Dead Run suffered major damage from flooding as a result of Hurricane Agnes in 1972, and initially, little was done to repair the damage.

The period saw positive developments as well, however. In 1986, the Outward Bound program, known internationally for its outdoor education programs, established its first urban-based location in Baltimore. The Baltimore–Chesapeake Bay Center, which particularly addresses its programs to young people in the Baltimore and Maryland area, leased space in buildings in the Crimea section of Leakin Park. The Parks and People Foundation raised an endowment for Outward Bound youth programs and contributed substantial funds to restore the Crimea estate buildings for Outward Bound's use. Also in the late 1980s, the Carrie Murray Nature Center was built in Leakin Park to provide nature programs and activities, especially to Baltimore City schoolchildren. Former Baltimore Oriole great Eddie Murray, a member of the Baseball Hall of Fame, contributed funds to establish the facility, and it was named to honor his mother. An annual event in Leakin Park was born in 1987, with the first Baltimore Herb Festival. Local Dickeyville resident Mary Lou Wolfe conceived of it as a way to promote the use of herbs, as well as to instill an appreciation for the park. As it became increasingly popular, funds from admission and the fees assessed to vendors were used to restore the

Climbers test their skills in the Baltimore-Chesapeake Outward Bound program in Leakin Park. *Baltimore-Chesapeake Outward Bound.*

old wooden chapel. And a further activity was created in the open meadowland near the Windsor Mill Road entrance when the Chesapeake and Allegheny Steam Preservation Society received permission to install tracks for its scale-model, coal-burning, live-steam locomotives, which provide free rides for children and adult passengers on the second Sunday of each month.

Surprisingly, in spite of these developments, the large natural tracts of Gwynns Falls and Leakin Parks remained relatively unknown to many Baltimore-area residents and only lightly used. Planners of the Gwynns Falls Trail recognized the largely untapped resource this parkland represented and envisioned the trail as a way to make it more visible, accessible and appreciated.

Trailhead 2: the Winans Meadow Trailhead is located in the stream valley of the former Crimea estate, now Leakin Park; footpaths ascend to the former Winans mansion (Orianda) and the upland grounds of the park.

THOMAS WINANS AND THE CRIMEA

The Crimea, which became Leakin Park in the 1940s, was a reminder of the heyday of Baltimore's leading role in railroad technology in the first half of the nineteenth century.

It was the country estate of Thomas Winans, son of B&O locomotive and rolling stock designer Ross Winans. When Czar Nicholas sought a contract with the senior Winans for construction of equipment for the Moscow to St. Petersburg railroad, a high-priority project for his goal to modernize Russia, Ross Winans sent his sons Thomas deKay and William Louis—both only in their twenties—to work with his former associate George Washington Whistler to carry out the task. There they operated out of the railroad shops at Alexandroffsky, near St. Petersburg. The railway opened successfully in the early 1850s, and Thomas—now only thirty—returned to Baltimore a wealthy man. He made use of his new fortune to purchase a mansion on Hollins Street, near the B&O railroad shops at Mount Clare. Expanding the existing structure to create an opulent villa in the fashionable Italianate style, and filling the landscaped grounds with statuary, Winans named it Alexandroffsky—a tribute to the origin of his fortune.

Later in the 1850s, he acquired land along the Dead Run and the heights above for a country estate. Work began on the mansion house in 1856 and it was completed in 1857. Winans named the house Orianda for a resort town in the Crimea—another Russian connection. The house was built of stone in rustic, Italianate style on the edge of a hill with commanding views of the meadow in the stream valley below. Nearby, he constructed other estate buildings, including a wooden chapel, erected in Carpenter's Gothic style for his Russian-born wife Celeste Revillon, who died just a few years later in 1861.

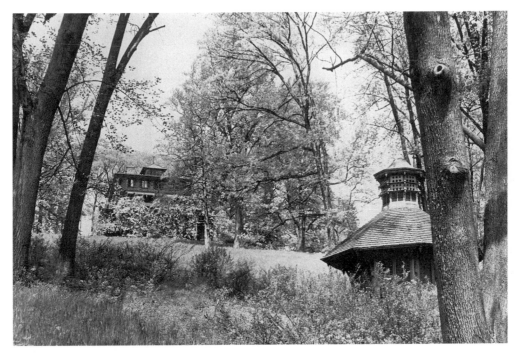

The city's second purchase of land from the Crimea estate in 1948 included Orianda, the country home of the Winans family, and uplands portions of the former Winans property. Baltimore Sun.

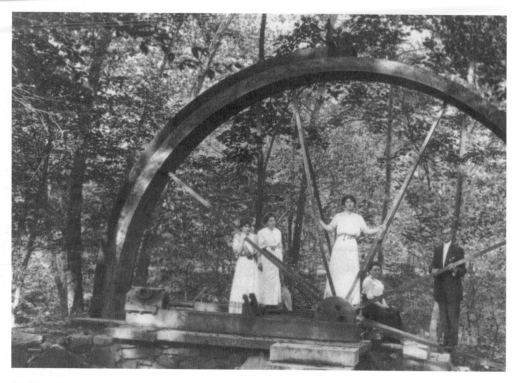

The Hoddinott wedding party pose in 1915 at the old iron wheel on the Winanses' Crimea estate. *Rick Smith and the Hoddinott Family.*

Originally, the main entrance to the Crimea was from Franklintown Road, near today's Winans Meadow Trailhead. Visitors passed through gates, crossed the stream on an iron bridge and then wound up the hill on a stone roadway. Near the Dead Run stream in the valley, an iron wheel pumped water to the hilltop structures. The wheel still stands, though it had fallen into disuse by the late nineteenth century. At the foot of the hill, remnants of other estate structures include a barn, silo, smokehouse and root cellar. At an overlook midway up the curving walkway to the mansion house, a mock battlement long has piqued curiosity. Though local legend often ascribed it as a way to ward off Federal troops during the Civil War due to the family's anti-Union reputation, local historian John McGrain and others have found documentation dating the battlement to 1857. The site evoked the scene at the Battle of Balaklava during the Crimean War (1853–56), a tribute to the stand made there by the Russians against the British in the military engagement immortalized by Tennyson's poem, "The Charge of the Light Brigade"—further evidence of the Russian proclivities with which Winans returned home to America.

The death of his wife left Thomas a widower at age forty-one. From that point on, he apparently spent very little time at the Crimea. With his Russian wealth, he had also acquired an estate at fashionable Newport, Rhode Island, and there he died, seventeen years later in 1878. Crimea passed down to his heirs, and it was from his granddaughter Celeste Winans Hutton that the city acquired the estate for Leakin Park in the 1940s.

Cherry Hill

African American Community on the Southside

BY JOHN BREIHAN

*"Cherry Hill for us was an oasis…There was grass, a swimming pool, a playground.
We felt like the Jeffersons, "Movin' on up." It was a wonderful experience for us."*
—Barry C. Black, U.S. Senate chaplain, on his family's move to Cherry Hill from an older
part of the city in the late 1950s, quoted in the Baltimore Sun, *February 18, 2008*

Cherry Hill is a unique example of an African American planned community, established to provide housing for those who had migrated to the city to work in industries during World War II. In an era when housing opportunities for black citizens outside the city's historic core were severely limited, this was a rare case in which new housing was created in what was then deemed a semirural or suburban area. Baltimore housing planners, hewing to principles of residential segregation as public policy, considered several sites before choosing a largely vacant south-side location on a hill overlooking the Middle Branch. Before 1944, Cherry Hill had been home to a few small farms, the potter's field burial ground and a city incinerator.

Designers of Cherry Hill planned a whole new suburb laid out along streets that curved around the hill. They set aside sites for churches, parks, schools and a shopping center. Cherry Hill was intended to be about half public and half privately owned housing. In 1944 and 1945, three private builders constructed 541 rowhouses; most were conventional brick construction, though they included two groups boasting modern steel-and-glass "Venti-Lights" windows. The Housing Authority's Cherry Hill Homes added 600 apartments and a community building.

The war was over by the time Cherry Hill was completed in late 1945. Before then, Baltimore's African Americans usually had lived in older buildings originally constructed for some other group, but now Cherry Hill offered an opportunity to live in newly built houses, surrounded by grass and trees. The new residents set to work organizing a new community, with fourteen new churches, as well as clubs and associations of all kinds. They agitated for more schools, recreation and health centers, parks and playgrounds, bus service and a library. Eventually, they succeeded in closing down the incinerator along the Patapsco River.

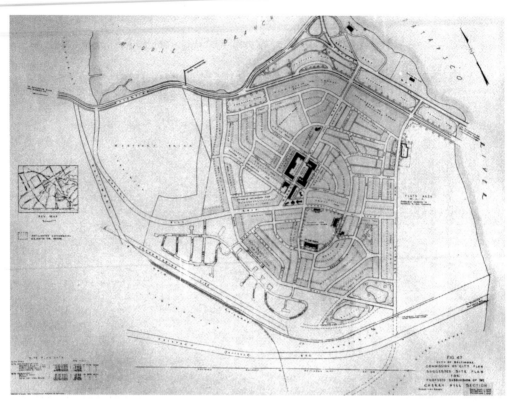

Site plan for Cherry Hill, showing curving streets and a town center, just south of the Middle Branch and Patapsco River, 1945. *Langsdale Library, University of Baltimore.*

Cherry Hill rowhouses under construction, 1945. *Maryland Historical Society.*

Pupils attend a Cherry Hill school in new classrooms, 1947. *Maryland Historical Society.*

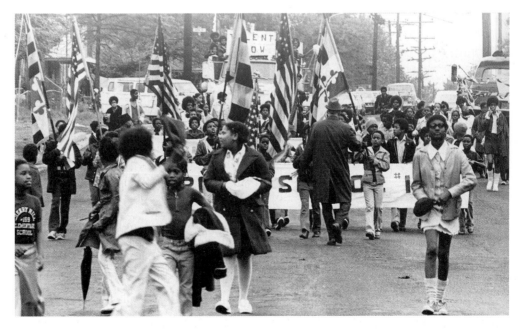

The Fourth of July parade in Cherry Hill, 1973. *Baltimore News–American Collection, University of Maryland, College Park.*

The new community grew rapidly in the 1950s. Cherry Hill Homes Extensions 1 and 2 added a thousand more units, and private builders constructed still more apartments and rowhouses. By the 1970 census, the population exceeded fourteen thousand people. Cherry Hill supplied an extraordinary number of Maryland's African American teachers, writers, lawyers, judges and other professionals.

In the 1960s, the original ratio of approximately 30 percent homeowners and 70 percent renters began to slip. Unfortunately, poverty and crime rates began to rise. Beginning in the 1990s, hundreds of public housing units were demolished, and more private ownership was encouraged. Although these measures brought the homeownership rate back up, the total population of Cherry Hill fell sharply, and questions remained about what to do with the vacant land in the center of the community.

Civic leaders have organized to address some of the major issues facing the community. For more than seven years, the Cherry Hill Trust has sponsored the Hotspot/C-SAFE program as a community-based approach to crime. Changes in police administration paid off with reduction in the number of violent offenses. In the town center, Catholic Charities renovated the original 1940s-era shopping center, and a new health facility and public library branch were opened. Southside Academy and New Era Academy became the community's first high schools, and Towson University partnered with all the local schools to form the Cherry Hill Learning Zone.

Looking to the future, city planners have put forward a number of ideas for extensive new development around the Middle Branch. These include possibilities for making more use of Cherry Hill's valuable waterfront and light rail station. While these prospects may hold some promise for Cherry Hill's future, local residents believe that it should remain a distinctive African American planned community—part of the city, but green as a suburb.

Trailheads 8 and 9, along the Middle Branch shoreline, are adjacent to Cherry Hill.

Baltimore's Expressway Controversy

> *"Open space is not the left-over land, or the vacant land, the unused land or the waste land. It is of an equal order of consideration with any kind of development."*
> —*Robert H. Giles, "An Ecological Study of the Influence of a Highway on Leakin Park and Vicinity," 1969*

> *"To adopt a hard-line attitude and oppose the expressway through Leakin Park would disregard the city's need for a balanced transportation system to enable the city to continue to flourish."*
> —*Douglas S. Tawney, director, Baltimore City Department of Recreation and Parks, 1976*

> *"It is tragic and sad that one generation of politicians and contractors should be able to destroy an irreplaceable resource that was centuries in the making. It would be arrogant enough if collectively we Baltimoreans should dictate that our descendants shall not have the privilege of experiencing the pageant of the seasons, the procession of wildflowers and bird life. But how much more arrogant when this destruction is undertaken without the consent of the citizens."*
> —*George Scheper, Volunteers Opposing Leakin Park Expressway, 1976*

For nearly forty years, Baltimoreans were engaged in a protracted controversy that pitted transportation needs against the needs of neighborhoods and parks. For highway planners, the challenge was how to link north–south and east–west roadways where they converged in Baltimore to benefit both interstate and local interests. But the imposition of multilane corridors upon a landscape already occupied by residential and park uses produced inevitable conflict. Indeed, the controversy heated up to the point that it was referred to as "Baltimore's Vietnam" or "a Gettysburg in concrete."

Plans for the east–west expressway originated in the early 1940s. Proposals were put forth to solve the city's transportation needs, but their potential impact on older sections

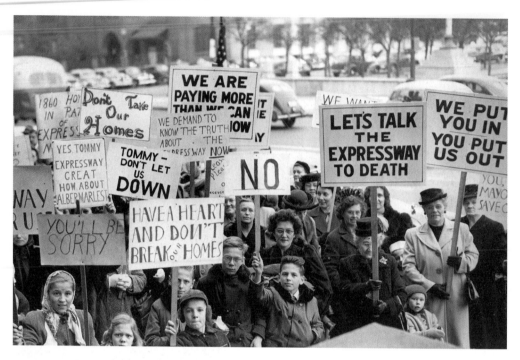

Residents of East Baltimore protest plans for the expressway route through their neighborhoods, 1947. *Baltimore News–American Collection, University of Maryland, College Park.*

of the city's west side were also justified as eliminating slums. The establishment of the federal Interstate Highway System in 1956 provided new impetus to expressway planning in Baltimore. In 1960, the City Department of Planning advanced a proposal to link three envisioned interstate routes—I-70 from the west, I-83 from the north and I-95, the major north–south route. The Baltimore Beltway, under construction at that time (and later designated I-695), promised to serve the suburban belt around the city, but municipal officials worried that it represented a Baltimore bypass, which could have adverse effects on the economy of the older urban area.

The plan, as modified by engineering consultants, stirred up fierce opposition by those concerned about its effects on parklands and neighborhoods. These apprehensions were heightened as the city began to acquire properties along some of the potential routes— most notably the Franklin-Mulberry corridor in West Baltimore, the Sharp-Leadenhall and Otterbein areas in South Baltimore and Fells Point in East Baltimore. Concern also mounted about the impact upon Leakin and Gwynns Falls Parks, slated to be bisected by the highway. Their cause was taken up by Volunteers Opposing Leakin Park Expressway (the VOLPE acronym a play on the name of Nixon administration transportation secretary, John Volpe). Responding to these threats, a biracial coalition of neighborhood and citywide groups joined together as the Movement Against Destruction (MAD) to fight the expressway plans.

African American residents of Rosemont, west of the Franklin-Mulberry corridor and adjacent to the Gwynns Falls, organized the Relocation Action Movement (RAM) to fight

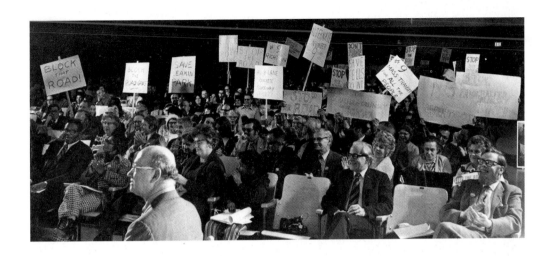

Above: Protest signs fill the hall at a public meeting on the proposed expressway route through Leakin Park, 1972. *Baltimore News–American Collection, University of Maryland, College Park.*

Right: Norman Reeves, a member of the city council in the 1970s, was an active opponent of the expressway. A trail in Leakin Park is named in his memory. *Baltimore News– American Collection, University of Maryland, College Park.*

the planned route of the expressway through their neighborhood. Already, demolition along Franklin and Mulberry Streets was displacing eight hundred households. The Rosemont group, active participants in MAD, won a partial victory in 1968 when Mayor Thomas D'Alesandro III, endorsed modifications to shift the route south of the community. However, the altered plan—now given the designation 3A—kept many of the controversial features of the earlier versions, including the route through the west-side parks.

The year 1972 marked a watershed year in the battle of the road. In May, recently elected Mayor William Donald Schaefer vowed to move ahead with the full 3A plan, and in July the city council voted to support the decision, despite the objections of a vigorous minority. However, MAD and expressway opponents won a partial victory that same summer when federal judge James R. Miller Jr. ruled that earlier hearings on the plans through Leakin and Gwynns Falls Parks had been "legally insufficient" and ordered new ones to address fully the economic, social and environmental impacts of the highways, as required under federal law. When planners responded by offering alternatives to the park route that targeted many of the surrounding neighborhoods, they only served to heighten the growing opposition to the road. In confirmation, the outcry at a packed public meeting in December was intense. Commenting on the meeting, a *Baltimore Sun* editorial observed that the battle involved more than the immediate threat to the parks, but rather raised a fundamental question of how to accommodate transportation needs in an urban society: "Must a city destroy parks, dwellings and businesses in order to accommodate the automobile?"

Not all affected residents joined the chorus, however. Schaefer and the interstate officials proposed compensation for lost parkland and provision for new playgrounds and other recreation facilities, promising as much as $4 to $5 million to address these needs. Planning Commission chair George Jude also made the case that the expressway could mean jobs to economically depressed neighborhoods. A community leader in Carroll-Hilton, one of the affected neighborhoods, told an interviewer that she felt that, given the relative neglect of the parks, the promised improvements might have brought some needed funds for park improvements: "What's more important—the use of that park or the birds and the bees and the trees? The City of Baltimore doesn't have enough money to maintain that park," and the city "talked about tennis courts, swimming pools, even an amphitheater."

MAD continued its tactic of challenging particular aspects of the 3A plan in court. Though these suits were costly, and rulings often went against the group, the appeal process had the effect of delaying implementation. Facing a 1975 deadline to use or lose the federal funds, city and interstate highway officials eventually made the decision to divert them to portions of the road plans that had the highest priority. A short stretch of I-170 was constructed from downtown westward along the Franklin-Mulberry corridor in the 1970s, but it stops abruptly just beyond Monroe Street and is popularly known as "the highway to nowhere." In the early 1980s, the plan to extend it farther west to connect with I-70 through Leakin and Gwynns Falls Parks was withdrawn. Consequently, interstate I-70 terminates at the park boundary on the city line, from which it proceeds westward some two thousand miles to Cove Fort, Utah (where it links to I-15, connecting

Concrete pillars support Interstates 95 and 395 above the Middle Branch. *Guy Hager.*

Los Angeles and Salt Lake City). The terminus now serves as the northwestern gateway for the Gwynns Falls Trail.

As a result of the opposition to the plans for the I-95 route near Federal Hill and across the Inner Harbor, a more southern alignment was chosen, crossing the Gwynns Falls near its mouth—its sky ramps high above the Gwynns Falls Trail there—and then proceeding along the lower edge of South Baltimore to the Fort McHenry Tunnel. And I-83, the Jones Falls Expressway, empties onto the boulevard-like President Street. Where its route was blocked along the eastern waterfront, Fells Point—whose historic district designation played a strategic role in halting the road—and nearby Canton have experienced considerable urban revitalization in recent years.

Trailhead 1: the Park and Ride lot at the end of I-70 provides convenient parking for those accessing the Gwynns Falls Trail at its northwestern gateway.
Alignment of the expressway targeted Leakin and Gwynns Falls Parks, including the grounds of the Crimea and sections of the valley between Trailheads 2 and 4. The Rosemont neighborhood also adjoins Trailhead 4. West of Trailhead 7, the trail passes through the Otterbein and Sharp-Leadenhall neighborhoods, also threatened by the expressway plans.

Baseball Legends of the Gwynns Falls

BABE RUTH, LEON DAY AND AL KALINE

Gwynns Falls area neighborhoods can boast three members of baseball's elite Hall of Fame: Babe Ruth, Leon Day and Al Kaline. The three grew up and began their baseball play within two miles of each other—and all three participated in recreational and sandlot baseball in locales along the Gwynns Falls, but time and race separated them, making it unlikely that their paths ever crossed.

Famous as the player whose feats helped to build a New York baseball dynasty—and create the need for legendary Yankee Stadium—Babe Ruth was born to a family residing on Camden Street, the present site of Oriole Park at Camden Yards, in the mid-1890s (most likely in 1895, though birth records and family legend conflict on this point). The son of struggling parents—his father at times tended bar and eventually owned a tavern—Ruth, at age seven in 1902, was taken by his father on a trolley ride to enroll as a resident student at St. Mary's Industrial School for Boys. Located west of the Gwynns Falls on Wilkens Avenue, St. Mary's had been founded in 1866, and from the 1880s, it was run by the Xaverian brothers, its full name offering a more complete statement of its mission: "St. Mary's Industrial School for Orphan, Delinquent, Incorrigible, and Wayward Boys." There Ruth spent the majority of the following twelve years, learning the trade of tailoring. But, more importantly, he also learned the art of baseball under the tutelage of Brother Matthias, the school's disciplinarian and also its baseball coach. At times, he played catcher—using the only available mitt, which was for right-handed throwers, even though he was left-handed. Remarkable as a hitter, he also got his first chance to pitch at St. Mary's, and his reputation spread. In February 1914, Jack Dunn, owner of the International League Baltimore Orioles, signed Ruth to a $600 contract. In July of that same year, Dunn, facing financial troubles, sold Ruth's contract to the Boston Red Sox. Ruth quickly made a mark as both a pitcher and a hitter. At bat, he displayed a powerful swing that produced home runs in an era when hitting for the fences was more rare.

In 1920, the Red Sox made the fateful decision to trade Ruth to the New York Yankees. The new club featured Ruth principally as a hitter, and during the 1920s his

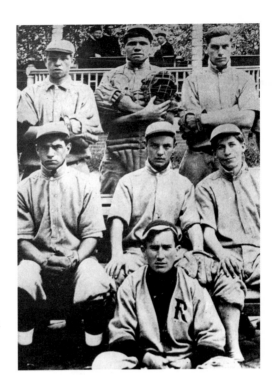

At St. Mary's, Babe Ruth (upper row, center) often had to play with a catcher's mitt on his left hand, even though it was his throwing hand. *Babe Ruth Museum.*

accomplishments with the Yankees established him as a national celebrity. Over his twenty-two-year career, Ruth amassed a prodigious record: 714 home runs and 2,873 hits. He played his final game in 1935, and the following year he was elected to the Baseball Hall of Fame. Babe Ruth died in 1948.

As Ruth was making his mark with the Red Sox, Leon Day was born in Alexandria, Virginia, in 1916. At age six, his parents moved to Pierpont Street in Baltimore's Mount Winans neighborhood. Day's parents, like Ruth's, were people of modest economic means (his father a glassworker), and as an African American growing up in an era of rigid segregation, his opportunities were circumscribed by racial discrimination. Day played on local sandlots and then for the Mount Winans Athletic Club before entering Frederick Douglass High School. After two years there, in 1935, he signed to play semiprofessional baseball with the Silver Moons—a decision opposed by his mother but supported by his father, according to family lore. At age seventeen, Day moved on to the Baltimore Black Sox. When that team was disbanded, he was signed by the Brooklyn Eagles, which later became the Newark Eagles. When African Americans had been closed out of the developing major league systems at the turn of the century, a series of associations known collectively as the Negro Leagues were formed, and in the 1930s and 1940s Day was one of their most prominent stars. In Baltimore, teams of the Negro Leagues at various times played at Bugle Park on the east side, at Westport Park and, later, at Maryland Park along the Russell Street streetcar line near Westport.

By all accounts, Day was a dominating pitcher. In 1995, Congressman Kwesi Mfume quoted an admirer who said that he had "a curve ball that dropped off the table." Over

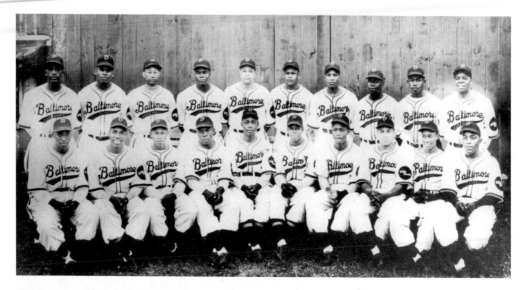

The Baltimore Elite Giants, 1949 National Negro League Champions. Leon Day is seated in the front row at the far right. *Babe Ruth Museum.*

his twenty-two-year career, Day amassed a remarkable 70 percent winning mark as a pitcher and appeared in seven East–West All-Star Games, a Negro Leagues record. With great all-round baseball skills, he also played every other position on the field except catcher. In 1942, facing the hometown Baltimore Elite Giants, Day set the unbroken Negro Leagues record by striking out eighteen. During World War II, Day served in the segregated U.S. Army, participating in the invasion of Normandy. Continuing his career upon his return from service, his last Negro Leagues seasons were stints with the Baltimore Elite Giants in 1949–50.

In 1995, Leon Day became the twelfth Negro Leagues player elected to the Baseball Hall of Fame in Cooperstown, New York. Recognition—and rectification—had been slow in coming for Negro Leagues stars like Day. Receiving news of his selection in March of that year, Day died a week later. In August 1997, Leon Day Park, the site of traditional baseball games for decades—which soon would have new, upgraded playing fields—was named in his honor. The Gwynns Falls Trail passes through Leon Day Park, where the sports traditions of Bloomingdale Oval continue.

Only a few blocks from Leon Day's Mount Winans home, and several decades later, Al Kaline grew up in a home on Cedley Street in Westport adjacent to the three smokestacks of the Baltimore Gas and Electric (BGE) power plant. Born in 1934, Kaline, like Ruth and Day, came from a family of modest means—his father worked nearby as a broom maker. But his father and his uncles also had been semiprofessional baseball players on Maryland's Eastern Shore, and the young Kaline grew up playing baseball on neighborhood sandlots, with recreation leagues and for the Westport American League Post team. At Southern High School, Kaline's accomplishments as a hitter and in the field were so spectacular that they drew attention from scouts of all of the major league

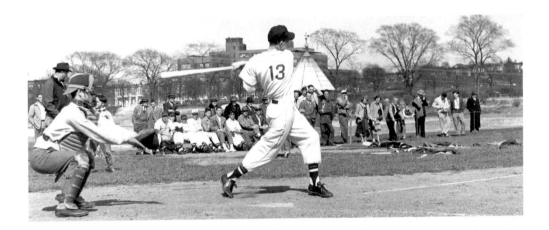

Above: Al Kaline at bat as a high school player in Baltimore, 1952. *Babe Ruth Museum.*

Right: A Little League player delivers his pitch at Leon Day Park. *Guy Hager.*

teams. Upon graduation in 1953, he was signed to a bonus contract by the Detroit Tigers and went straight from high school to the big leagues—a rare feat.

In 1955, his third season with the Tigers, Kaline's career blossomed. That year he hit .340 and won the American League batting title, the youngest player ever to do so. Over his twenty-two-year career with the same club, as a batter he recorded over 3,000 hits and 399 home runs, and his skill as a fielder was recognized with the award of ten Gold Gloves. Upon retirement in 1974, Kaline served as broadcaster for Tiger baseball for twenty-five years. In 1980, Al Kaline joined Babe Ruth and Leon Day in the Baseball Hall of Fame.

Both Leon Day and Al Kaline grew up in houses near the Kloman Street section of the trail in Mount Winans and Westport.

Babe Ruth was born and grew up near the present Camden Yards baseball stadium, west of Trailhead 7. He played baseball at St. Mary's (now Cardinal Gibbons) on Wilkens Avenue west of the trail.

The Inner Harbor and Camden Yards

"A festival marketplace…can become a billboard for new life downtown."
—*James Rouse, developer of Harborplace, quoted in Joshua Olsen,*
Better Places, Better Lives *(2003)*

By the mid-twentieth century, Baltimore's Inner Harbor, known historically as the Basin, had fallen upon hard times—ringed by decaying docks, warehouses and industries dating from the steamship era. In the 1960s, civic leaders and city officials launched a bold plan to revitalize the nearby aging downtown, creating the modern Charles Center complex, and in the following decade they began to focus on a new vision for the Inner Harbor. As demolition freed up open space along the waterfront, a series of city fairs brought thousands of Baltimoreans back to parts of the city most had long abandoned. Under the leadership of Mayor William Donald Schaefer, the plan that emerged for Inner Harbor redevelopment included amenities for residents and tourists alike—a waterfront promenade, open public spaces, cultural institutions and commercial services (hotels, restaurants and shops). The Maryland Science Center, which opened in 1976, anchored the southwest corner of the Inner Harbor, and it was joined in 1981 by the strikingly modern, pyramid-shaped National Aquarium in Baltimore on the north side.

As the centerpiece of Inner Harbor development, the Rouse Company's Harborplace Pavilions opened in 1980. Harborplace was the brainchild of Marylander James Rouse, who contended that "festival marketplaces" could restore the vibrant public life that historically had characterized cities, combining both commercial and civic activity. Building on the success of his company's restored Faneuil Hall and Quincy Market enterprises in downtown Boston, but lacking suitable historic structures on the Baltimore waterfront to provide the urban texture he preferred, Rouse turned to the celebratory architecture of the Tivoli Gardens of Copenhagen as the pattern for the new Harborplace structures. Only a few buildings remained along the waterfront as reminders of an earlier era: the power plant, whose black stacks once belched smoke from

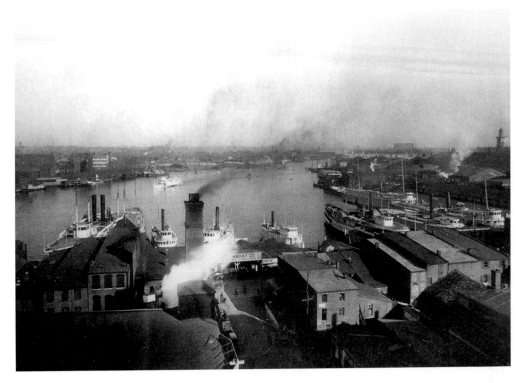

Baltimore Harbor from Light Street in 1895. *Enoch Pratt Free Library.*

steam engines used to power the city's street railways, now turned to commercial uses; and the sewage pumping station, its pumps long converted from steam to electricity, now the Public Works Museum. Joined by office buildings, hotels, marinas and restaurants, the Inner Harbor has become the new signature center of the city.

The decision to build a new stadium for the Baltimore Orioles in a downtown location transformed the old Camden rail yards of the B&O Railroad into Baltimore's venue for professional sports. The baseball stadium, which opened in 1992, set a new standard nationally with its central city location and its design, winning accolades for the way it blended with the urban context. Its playing field, sunk below grade level so that the outer walls would not overwhelm neighborhood surroundings; its brick exterior and traditional architecture evoking nearby structures; and its preservation of the century-old railroad warehouse as an outer wall along the Eutaw Street promenade all combined to make Oriole Park at Camden Yards a model to emulate for new ballparks. Baseball afficionados would also appreciate the connection of the site to baseball legend Babe Ruth. The saloon his father once owned stood on part of the grounds, and his birthplace, which in recent years has housed the Babe Ruth Museum, is located nearby. Subsequently, the museum's collections have expanded to become the Maryland Sports Legends Museum in the renovated historic Camden Station at the edge of the stadium complex. In 1996, Baltimore football fans, long suffering from the loss of the Colts to Indianapolis, welcomed the return of the city to the National Football League with the

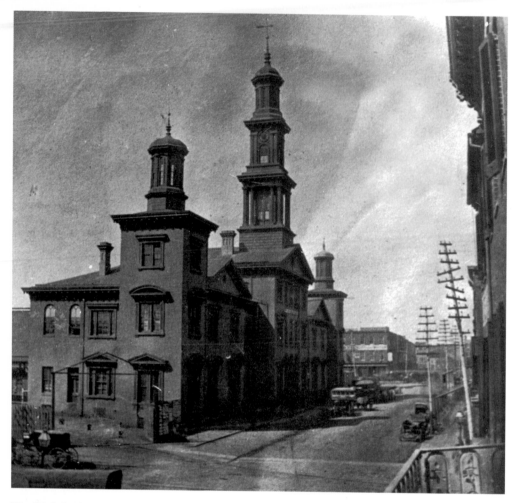

The B&O Railroad's Camden Station, circa 1900. *Enoch Pratt Free Library.*

advent of the Ravens, and in 1998, the team opened its new facility, now named M&T Bank Stadium, in the southern portion of Camden Yards. Both stadium sites are served by Light Rail connections and surrounded by parking.

Trailhead 7 is the Inner Harbor gateway to the trail. West of Trailhead 7, the trail passes near Oriole Park at Camden Yards and M&T Bank Stadium, home of the Ravens, along Sharp Street.

Baltimore's Parks
for a New Century

THE GWYNNS FALLS TRAIL

"Imagine kids from the neighborhoods being able to bike down to the Inner Harbor without even having to cross traffic, or tourists being able to discover a trail that will lead them to a forest in the middle of the city...If we can do this sort of thing in the Gwynns Falls, we can do it all over the city."
—*Chris Rogers, quoted in the Trust For Public Land report, 1993*

In 1991, Chris Rogers, working as a graduate school intern in Baltimore, came across the 1904 Olmsted report and recognized that its recommendations for stream valley parks had relevance for the contemporary challenges facing the urban area. Even though the proposals had been partially implemented over the years, their full potential had not been realized. Rogers believed that a new and expanded vision of stream valley parks might not only complete the job of land acquisition along these corridors, but also provide access to park spaces for underserved communities, foster environmental stewardship for the urbanized watersheds and serve as an agent of community revitalization. He wrote up his report—but it didn't stay on a shelf. Over the following years, a remarkable coalition brought together major players in a public-private partnership to work toward turning the vision into reality by creating the Gwynns Falls Trail, a hiker-biker pathway connecting park spaces large and small along the entire length of the city's stream valley corridor.

Rogers's presence in Baltimore resulted from an initiative championed by William (Bill) Burch of the Yale School of Forestry and Environmental Studies to redirect the skills and insights of environmental professionals in training toward the special challenges of urban settings. In 1988, he and Ralph Jones, director of Recreation and Parks for Baltimore, teamed up on a program to use Yale summer interns to help develop a plan for Baltimore parks and open spaces as spurs to community revitalization. Burch, an enthusiast for the concept that environmental programs must be based on community involvement, established the Urban Resources Initiative, and over successive years, the program brought dozens of youthful interns to Baltimore to work on projects with the staff of Recreation and Parks and other partners.

The Gwynns Falls Trail
bridge over Dead Run
near Winans Meadow.
Guy Hager.

By the early 1990s, the concept of greenway corridors and linear parks had been gaining substantial momentum nationally. Its seeds lay in the park planning of the previous century and a half. One of the noted accomplishments of Frederick Law Olmsted Sr. had been the design of the Boston park system's "emerald necklace," linking a series of wetlands on the city's west side, and the park plans of the partnership continued by his sons as the Olmsted Brothers had included greenway connectors in plans for Baltimore, Seattle and elsewhere. Notable twentieth-century precedents had been the establishment of the Appalachian Trail, extending along ridgelines from Georgia to Maine, and the Chesapeake and Ohio Canal National Park, which secured the former water course and path from Georgetown to Cumberland, Maryland. But the idea took on new energy in the second half of the century as increasing population and development in major metropolitan areas led to the realization that the kind of open space traditionally secured for parkland and public use was fast disappearing and becoming prohibitively expensive.

William H. Whyte, a prominent national voice among planners, spoke of the public value of this "last landscape" and urged "linkages" connecting green spaces and natural corridors. In 1985, the movement to secure abandoned rail lines as routes for hiker-biker trails became formalized with the organization of the Rails to Trails Association. Two years later, the American Greenways Program was founded to provide a broad coalition championing linear parks nationally. Many states, including Maryland, followed suit, establishing greenway commissions. During the decade of the 1980s, rail to trail projects were initiated in the Baltimore area: the B&A Trail in Anne Arundel County and the North Central Trail as an extension of Gunpowder Falls State Park in northern Baltimore County. Both received some initial local resistance, but soon became immensely popular. In Baltimore, the promenade around the Inner Harbor had begun to provide public access to waterfront areas, but the city lacked a significant hiker-biker trail.

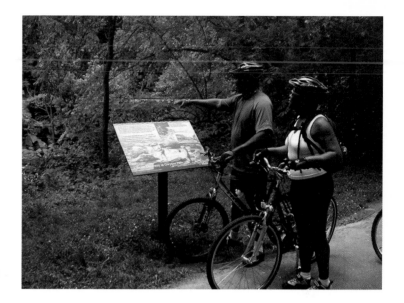

A couple on bikes examine an interpretive panel along the Gwynns Falls Trail. *Guy Hager.*

Historically, major environmental advocacy and land preservation groups often had directed their attention to rural and wilderness areas, placing priority on what might be considered pristine natural lands. But in the early 1990s, one of the major players, the Trust for Public Land (TPL), recognized the need to balance its traditional focus by developing an urban initiative. TPL's 1993 report stated its commitment to address the needs of urban areas:

> *This means restoring green space, parks, and playgrounds in inner-city neighborhoods. It also means conserving natural and recreational lands, connecting our urban neighborhoods to our deserts, mountains, rivers, forests, and seashores. Each place depends upon the other for our cities' livability, our nation's security, and our planet's health.*

Rogers turned to TPL to support the Baltimore project and found a willing partner. Rose Harvey, director for the mid-Atlantic region, hired Rogers to set up a Baltimore office, and over succeeding years, the national organization brought its impressive expertise, contacts and resources to the table in support of the Gwynns Falls Trail.

Rogers's youthful enthusiasm and political savvy led to the development of a dynamic coalition of other like-minded people—young in age, at an early stage in their careers, energetic and committed to urban revitalization and environmental restoration. Laura Perry, who became a mentor to the group in her role as chair of Mayor Kurt Schmoke's task force on greenways for Baltimore, described them as "young staffers nipping at the heels of their seniors." Among them were Jackie Carrera, who organized Maryland's Save Our Streams efforts in Baltimore before joining the staff and eventually becoming executive director of the Baltimore Parks and People Foundation, and Chris Ryer and Beth Ann Strommen, both in the Department of Planning.

Together with others who were persuaded by their enthusiasm, they forged a partnership with key organizations and agencies to turn the dream into reality. TPL provided its national expertise in land acquisition and preservation, as well as its record of working closely with local and state governments. Baltimore City's Department of Planning already had begun studies of waterfronts and waterways and worked to get funds for the project into the municipal budget. The Department of Recreation and Parks would supervise design and construction through its capital projects division, headed by Gennady Schwartz. The Parks and People Foundation, a nonprofit organization established in 1984 under the leadership of Sally Michel to enhance the care and programming of the city's parks and recreation facilities, would promote the idea with public officials and develop outreach programs for community input and support. The mayor's Gwynns Falls Greenway Task Force, chaired by Laura Perry, included a range of civic leaders—citizens, public officials, businesspeople—as advocates of the project, and worked with Parks and People to foster neighborhood participation. Aiding the process at important steps along the way in terms of federal funding were the efforts of Maryland's congressional delegation, especially Senator Paul Sarbanes and Congressman Ben Cardin.

But the idea still faced major obstacles, not the least of which was funding. The prospect became much brighter when trail advocates realized that a major portion of construction expenses might be tapped from new federal transportation sources. The Intermodal Surface and Transportation Act (ISTEA—or "iced tea," as it came to be called), passed in 1991, set aside as much as 10 percent of federal highway funding for states to use for scenic easements, historic preservation and the creation of greenways. Maryland State Department of Transportation officials proved supportive of securing early ISTEA expenditures for the Gwynns Falls Trail, and this source provided the major portion of construction costs. Principal funding for land acquisition came from Maryland's Project Open Space, the program that set aside a percentage of the property sales tax for public space initiatives. The Trust for Public Land lent its expertise in working with local property owners to negotiate land transactions for the eventual purchase of several parcels needed for connecting the trail along the stream corridor, and state Department of Natural Resources officials secured MPOS funds to acquire them for the city.

Nonprofits also made a major commitment. In addition to TPL, a substantial infusion came from the Lila Wallace–Reader's Digest Fund (now the Wallace Fund), which recently had initiated an urban parks initiative. The fund stepped forward with grants to TPL for its Baltimore office and land acquisition efforts and to Parks and People for the community component, with the goal of involving citizens of west-side neighborhoods fully in the planning, design, construction and maintenance steps of the process. Major funding also came from Baltimore's France-Merrick Foundation, supporting TPL's trail project efforts, and from the Merck Family Fund, enabling Parks and People to provide grants to communities for projects along the trail route.

Laying the groundwork for support that such an undertaking was worthwhile represented a second challenge. In 1992, the mayor's task force convened a broad-based

Kids working on the garden at Leon Day Park. *Heide Grundmann.*

convocation of stakeholders from all segments of the Baltimore community to address and advance the project's vision, identify and take steps to secure funding and plan for design and maintenance—the three subcommittees dubbed the Eurekas, Greenbacks and Hardhats. In the following years, a series of cleanups, walks and festivals promoted the project. To heighten visibility and to take steps toward design and construction, the Municipal Art Society, sponsor of the earlier Olmsted reports, was persuaded to contribute funding for a master plan, conducted by a multidisciplinary design team and headed by nationally prominent landscape architect Diana Balmori. The process included forty meetings with various constituent groups, and the completed report was presented to the mayor and public at a special event at the Baltimore Museum of Art in June 1995. By that point, the project was receiving important endorsement from influential quarters, such as the *Baltimore Sun*, which editorialized that its "fervent supporters" had created a climate for "believing in the Gwynns Falls Trail," and concluded, "Residents and city and state officials need to build support for the trail to make the entire project a reality."

It would take even harder work, however, to persuade underserved neighborhoods, where the Gwynns Falls corridor had not been viewed as a positive asset, to welcome the idea of the trail and to believe that the land along it could provide important recreational purposes and access to nature. It would take even more to ensure that they had a voice in the design and planning and that they felt ownership when the project was completed. The trail and the parklands to which it provided points of entry needed to be understood as something that had benefit to the citizens of local neighborhoods, not simply to outsiders who might use it to pass through. Put another way, they would need to see it not only as the necklace, but for the pearls it offered along the way. Dolly Jefferson, president of the Edgewood Neighborhood Association, was quoted in an article by Tom Chalkley in TPL's 1993 annual report, voicing concern that in the past, parks near her neighborhood had a negative reputation: "'Woods' meant a deserted area…you grew up thinking of it as off-limits." In hopes that the trail project could help

turn that reputation around, Jefferson became an active member of the mayor's Gwynns Falls Task Force, telling Chalkley:

> I'd like to see more people and their children get involved and make the park family oriented. I'd like to give parents a chance to be parents. Maybe this park can bring a little togetherness.

A number of efforts were made to promote the idea that the trail could help foster a more positive connection between parks and neighborhoods. Outdoor education programs for local schools provided one way to do so, and links were forged with educators and area schools. On the Middle Branch shoreline, the Waterview West boardwalk was constructed to provide opportunities for schoolchildren to study a critical wetlands area. High school students from nearby Cherry Hill and Westport received summer employment for construction under the supervision of the Living Classrooms Foundation. Recognizing the critical need for playing fields in the predominantly

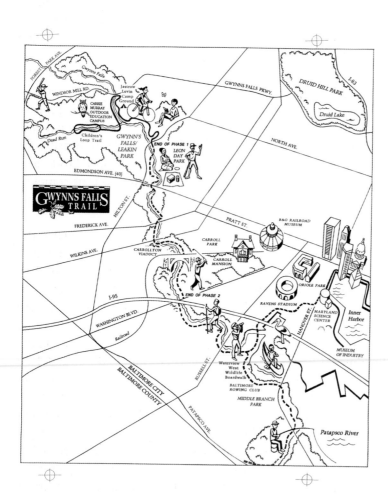

A cartoon map promoted sites connected by the Gwynns Falls Trail. *Parks and People Foundation.*

African American Rosemont community, trail planners worked with the neighborhood to develop a master plan for major improvements to the playing fields at Bloomingdale Oval. Developed with assistance from the Trust for Public Land, the upgraded park included new basketball courts, football fields and baseball diamonds (the latter with funding contributed by the Baltimore Orioles), with a section of the trail extending along the outer edge. Dedicated in August 1997, and opened in 2000, it was given the name Leon Day Park in honor of the Baltimore Negro Leagues great, who had been elected to the Baseball Hall of Fame in 1995, only a week before his death. Trail safety was a major concern both for community residents and planners, and commitment by the Baltimore City Police Department remained a high priority.

The attention brought to the Gwynns Falls corridor by the trail project also complemented the efforts of neighborhood activists concerned about environmental threats. Concerted protest thwarted a plan to fill the quarry on the west side of the stream with debris from the demolition of public housing projects and brought pressure to bear for remediation of a scrap metal processing plant. To serve as stewards of the trail project and to encourage community participation, the Gwynns Falls Trail Council was established and continues to function as a public-private partnership to oversee the maintenance, management and programming of the trail with the support of Parks and People.

With momentum building on all fronts in 1995, the project suddenly slowed down. Questions about the renewal of the federal ISTEA program led to some uncertainty. Securing a place for trail funding in the city budget would typically be a slow process. Developing detailed engineering plans required time as well. And at this critical juncture the capital projects division of the Department of Recreation and Parks, responsible for trail design and construction, was transferred to the Department of Public Works as a cost-cutting administrative efficiency measure. While the hope had been to complete the whole trail by 1998, trail partners began to face the reality that a longer timetable would be required.

The plan called for undertaking construction in phases. Phase I was designated as the section from what came to be called Winans Meadow in Leakin Park to Bloomingdale Oval (soon to become Leon Day Park). This portion included some of the loveliest natural scenery along the Gwynns Falls. From the point of view of construction, it appeared to require the least complexity and cost. The trail alignment made partial use of Wetheredsville Road, which became closed to motor traffic, as well as the existing millrace path. And it needed only one major bridge—bridges typically representing the costliest ingredient in building trails. Sacrifice of an immediate link to the end of I-70 was also a cost factor, though it meant that Phase I would suffer from being somewhat tucked away from public view. Construction got under way in 1997. Jacques Kelly of the *Baltimore Sun*, reporting that work was about to begin on the trail, noted that it would provide much-needed access to Leakin and Gwynns Falls Parks, whose assets as natural areas had long been neglected. And the *Sun*'s editorial writers chimed in, welcoming this first installment of what it said could become "West Baltimore's Appalachian Trail." Groundbreaking occurred in December 1997, and, after delay due in part to

complications with underground water and utility lines, grand opening occurred with a public ceremony on June 5, 1999.

Phase II was designated as the section from Leon Day Park at Bloomingdale Oval to Carroll Park. The route would make use of the old Ellicott Driveway, with necessary improvements made to the road surface and provision for closing the roadway from Baltimore Street to Frederick Avenue to motor traffic. The portion below Wilkens Avenue included several of the properties only recently acquired to complete the corridor connection. It proved particularly challenging, due to the narrowness of the valley at that point, the necessity to follow a route partially on the flood plain and the complications posed by the rail line. The resulting series of ramps and bridges in this section were among the costliest on the trail. But planners were pleased that they succeeded in reopening the small arch that once had provided for a wagon road on the western side of the historic B&O Railroad's Carrollton Viaduct. Phase II formally opened with a celebration featuring Mayor Martin O'Malley on September 12, 2003.

Still, the trail lacked its final connection to the Middle Branch and the Inner Harbor. The initial hope that Phase III would follow the Gwynns Falls to its mouth posed major problems. I-95's concrete ramps and columns represented formidable obstacles, both aesthetically and in terms of cost, and land along the stream was quite inhospitable as a trail route. So, the decision was made to direct the trail on a path along Washington Boulevard to Carroll Park, thus connecting the park to the trail system, and then to make use of surface streets through the Carroll-Camden Industrial District. From the junction at Warner and Stockholm Streets, one leg continues along streets and through Solo Gibbs Park to the Inner Harbor. The other leg alternates between on-street lanes and separate waterfront pathways to its terminus on the Middle Branch south of Harbor Hospital. Along the way are areas heavily impacted by industrial use and urban neglect, as well as occasional spectacular views across the water to the city center. Through Westport, where historic industries forced the trail to follow Kloman Street, plans for redevelopment hold out the prospect of an eventual waterside route. On June 4, 2005, Mayor O'Malley presided over ceremonies at Solo Gibbs Park in the historic Sharp-Leadenhall neighborhood to celebrate the completion of Phase III of the Gwynns Falls Trail. *Baltimore Sun* reporter Jill Rosen, writing of the occasion, noted that the trail provided a route along a distinctive urban type of greenway, following a stream that "slices Baltimore's west side indiscriminately, rushing through villages and slums, past playgrounds and factories, forests and railroad tracks."

Completion of the trail to its western gateway at the terminus of I-70 was celebrated with ceremonies on June 7, 2008 (National Trails Day). The 2.7-mile route extends through the forested western edge of Leakin Park, proceeds along Franklintown Road and then skirts the ramps to the I-70 trailhead—the point where advocates of park and neighborhood preservation stopped the interstate highway years earlier. Over a decade and a half after the inception of the idea and at a cost of $14 million, the 15-mile Gwynns Falls Trail now threads through this distinctive urban watershed.

Recently, the Gwynns Falls Trail has become a part of the National Park Service's Chesapeake Bay Gateways Network program as one of the designated entry points to

Mounted on bicycles, police assigned to the Gwynns Falls Trail greet trail users. *Guy Hager.*

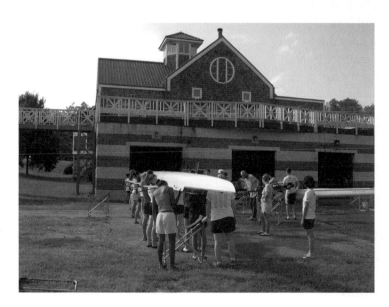

Rowers carry their boats from the Baltimore Rowing Center for use on the Middle Branch. *Guy Hager.*

the bay, and Park Service grants have helped to fund trail-side panels and other projects to interpret the natural and human history of the watershed area. Portions also have been incorporated into the East Coast Greenway, a route planned to link cities and towns along the eastern seaboard between Calais, Maine (on the Canadian border), and Key West, Florida. At the Inner Harbor, the Gwynns Falls Trail not only connects to the promenade, which extends from Locust Point to Canton, but also to the Jones Falls Trail, developed by the city's Department of Planning and Department of Recreation and Parks as Baltimore's second trail along a major stream valley. Staff members supervising the planning and construction of the Jones Falls Trail assert that lessons

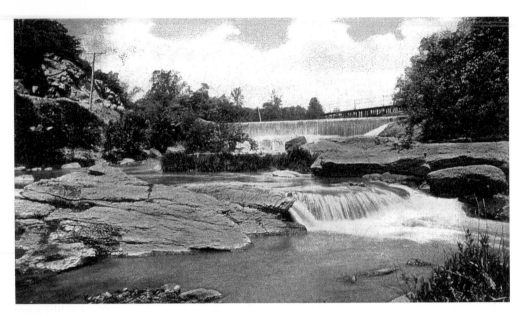

An undated postcard of the Gwynns Falls. *Enoch Pratt Free Library.*

learned on the Gwynns Falls, the city's first greenway trail, have facilitated the process for this subsequent undertaking. Consideration of expanded local connections include exploration of the potential for a loop trail around the Middle Branch, crossing from Westport to Port Covington on the old Western Maryland Railway trestle and back to the southern shore on the Hanover Street Bridge, as well as links to the south, including the BWI Trail and the trails of Patapsco Valley State Park. The Parks and People Foundation has drawn upon its experience with the trail and related efforts to advocate for a citywide concept of "One Park," a network of parks and open spaces throughout Baltimore to enhance green spaces, improve the quality of urban life and act as an agent of revitalization.

The Gwynns Falls Trail has been built, but many of the challenges envisioned by the coalition that conceived it remain: recreational use, environmental stewardship, maintenance, citizen ownership and community revitalization. As the history of the Gwynns Falls Valley illustrates so well, these very questions are rooted in the way in which the complex relationship between nature and human experience has unfolded in this complex slice of urban America. Perhaps the hopes for what difference the Gwynns Falls Trail might make in the lives of West Baltimoreans were epitomized by Rosemont resident Betty Hawkins, who was involved from early stages in the planning process, when she was quoted in the newsletter *Trail Talk* in 1998 as saying that "traveling along the Trail will be like 'going back to God's Earth' and gaining a sense of inner peace, getting in touch with yourself away from all the hustle and bustle of the City."

Selected Bibliography

The sources for the topics and themes related to the history of the Gwynns Falls Valley included in this book are drawn from a wide variety of documents, both primary and secondary. Local newspaper accounts and—increasingly in recent years—Internet sites often provide critical pieces of information. These are too numerous to list here in detail, but some are noted in the text accounts. The Maryland Department of the Enoch Pratt Free Library provided essential services through its clipping files and photo collections. Cited below are selected principal published studies, especially those that are relatively recent and generally available in print or in area libraries.

Arnold, Joseph L. "Suburban Growth and Municipal Annexation in Baltimore, 1745–1918." *Maryland Historical Magazine* 73, no. 2 (June 1978): 109–28.

Arnold, Joseph L., and Anirban Basu. *Maryland: Old Line to New Prosperity.* Sun Valley, CA: American Historical Press, 2003.

Balmori, Diana, et al. "The Gwynns Falls Master Plan." Report commissioned by the Trust for Public Land, 1995.

Baltimore, City of, Department of Planning. *A Master Plan for Carroll Park in Baltimore, Maryland.* February 2001.

Barbour, Philip L., ed. *The Complete Works of Captain John Smith. 1580–1631.* Chapel Hill: University of North Carolina Press, 1986.

Bready, James H. *Baseball in Baltimore.* Baltimore: Johns Hopkins University Press, 1998.

Brooks, Neal A., and Eric G. Rockel. *A History of Baltimore County.* Towson, MD: Friends of the Towson Library, 1979.

Brown, George T. *The Gas Light Company of Baltimore: A Study of a Natural Monopoly.* Baltimore: Johns Hopkins University, 1936.

Browne, Gary. *Baltimore in the Nation, 1789–1861.* Chapel Hill: University of North Carolina Press, 1980.

Brugger, Robert J. *Maryland: A Middle Temperament, 1634–1980.* Baltimore: Johns Hopkins University Press in association with the Maryland Historical Society, 1988.

Dilts, James D. *The Great Road: The Building of the Baltimore & Ohio, The Nation's First Railroad, 1828–1855.* Stanford, CA: Stanford University Press, 1993.

Fee, Elizabeth, Linda Shopes, and Linda Zeidman, eds. *The Baltimore Book: New Views of Local History.* Philadelphia: Temple University Press, 1991.

Ferrell, Michael R. *The History of Baltimore's Streetcars.* Sykesville, MD: Greenberg Publishing Co., 1992.

Garonzik, Joseph. "The Racial and Ethnic Make-Up of Baltimore Neighborhoods, 1850–1870." *Maryland Historical Magazine* 71, no. 3 (Fall 1976): 392–402.

Graham, Leroy. *Baltimore: The Nineteenth Century Black Capital.* Washington, D.C.: University Press of America, 1982.

Harnik, Peter. *Inside City Parks.* Washington, D.C.: Urban Land Institute, 2000.

Harwood, Herbert, Jr. *Baltimore and Its Streetcars: A Pictorial View of the Postwar Years.* New York: Quadrant Press, 1984.

———. *Impossible Challenge: The Baltimore and Ohio Railroad in Maryland.* Baltimore: Barnard, Roberts and Co., 1979.

Hayward, Mary Ellen, and Charles Balfoure. *The Baltimore Rowhouse.* New York: Princeton Architectural Press, 1999.

Hayward, Mary Ellen, and Frank R. Shivers Jr., eds. *The Architecture of Baltimore: An Illustrated History.* Baltimore: Johns Hopkins University Press, 2004.

Hollifield, William. *Difficulties Made Easy: History of the Turnpikes of Baltimore County and City.* Cockeysville, MD: Baltimore County Historical Society, 1978.

Keith, Robert C. *Baltimore Harbor: A Pictorial History.* Baltimore: Johns Hopkins University Press, 2005.

Kessler, Barry, and David Zang. *The Play Life of a City: Baltimore's Recreation and Parks, 1900–1955.* Baltimore: Baltimore City Life Museums and the Baltimore City Department of Recreation and Parks, 1989.

Korth, Cassandra, and Geoffrey L. Buckley. "Frederick Law Olmsted, Jr., and the Leakin Park Controversy." *Olmstedian* 16, no. 1 (Winter, 2006).

Lewis, Reginald F., and Blair S. Walker. *"Why Should White Guys Have All the Fun?" How Reginald Lewis Created a Billion-Dollar Business Empire.* New York: John Wiley & Sons, 1995.

Licht, Walter. *Working for the Railroad: The Organization of Work in the Nineteenth Century.* Princeton, NJ: Princeton University Press, 1983.

Little, Charles E. *Greenways for America.* Baltimore: Johns Hopkins University Press, 1990.

McCarthy, Michael P. "Baltimore's Highway Wars Revisited." *Maryland Historical Magazine* 93, no. 2 (Summer 1998): 136–57.

———. "Park Visions in Conflict: Baltimore's Debate Over the Leakin Bequest." *Maryland Historical Magazine* 98, no. 2 (Summer 2003): 187–203.

McGrain, John. "Calverton Mills." *Baltimore County History Trails* 34, no. 3 & 4 (2001): 1–8.

———. *From Pig Iron to Cotton Duck: A History of Manufacturing Villages in Baltimore County,* vol. 1. Towson, MD: Baltimore County Public Library, 1885.

————. *Grist Mills in Baltimore County, Maryland.* Towson, MD: Baltimore County Public Library, 1980.

McDougall, Harold A. *Black Baltimore: A New Theory of Community.* Philadelphia: Temple University Press, 1993.

Mohl, Raymond. "Stop the Road: Freeway Revolts in American Cities." *Journal of Urban History* 30, no. 5 (2004): 674–706.

Neverdon-Morton, Cynthia. "Black Housing Patterns in Baltimore City, 1885–1953." *Maryland Historian* 16 (Spring/Summer 1985): 25–39.

Olmsted Brothers. *Report and Recommendations on Park Extension for Baltimore.* Baltimore, 1926. Reprint, Friends of Maryland's Olmsted Parks & Landscapes, 2001.

————. *Report Upon the Development of Public Grounds for Greater Baltimore.* Baltimore: Municipal Art Society of Baltimore City, 1904. Reprint, Friends of Maryland's Olmsted Parks & Landscapes, 1987.

Olsen, Joshua. *Better Places, Better Lives: A Biography of James Rouse.* Washington, D.C.: Urban Land Institute, 2003.

Olson, Sherry H. *Baltimore: The Building of an American City.* Baltimore: Johns Hopkins University Press, 1980.

Orser, W. Edward. *Blockbusting in Baltimore: The Edmondson Village Story.* Lexington: University Press of Kentucky, 1994.

————. "A Tale of Two Park Plans: The Olmsted Vision for Baltimore and Seattle, 1903." *Maryland Historical Magazine* 98, no. 4 (Winter 2003): 466–83.

Orser, W. Edward, and the UMBC Community Studies Project. *A Natural Legacy: Gwynns Falls and Leakin Parks.* Baltimore: UMBC, 1986.

Phillips, Christopher. *Freedom's Port: The African American Community of Baltimore, 1790–1860.* Urbana: University of Illinois Press, 1997.

Power, Garrett. "Apartheid–Baltimore Style: The Residential Segregation Ordinances of 1910–1913." *Maryland Law Review* 42, no. 2 (1983): 289–328.

Raitz, Karl, ed. *The National Road.* Baltimore: Johns Hopkins University Press, 1996.

Rountree, Helen C., Wayne E. Clark, and Kent Mountford. *John Smith's Chesapeake Voyages, 1607–1609.* Charlottesville: University Press of Virginia, 2007.

Ryon, Roderick N. *West Baltimore Neighborhoods: Sketches of Their History, 1840–1960.* Baltimore: Institute for Publications Design at the University of Baltimore, 1993.

Scharf, J. Thomas. *History of Baltimore City and County.* Philadelphia: Louis H. Evarts, 1881. Reprint, 1971.

Sharp, Henry K. *The Patapsco River Valley: Cradle of the Industrial Revolution in Maryland.* Baltimore: Maryland Historical Society, 2001.

Shultheis, William C. "The Wethered Brothers: Innovators in Steam Navigation." *Maryland Historical Magazine* 102, no. 2 (Summer 2007): 58–71.

Stover, John F. *History of the Baltimore and Ohio Railroad.* West Lafayette, IN: Purdue University Press, 1987.

Thomas, Bettye C. "Public Education and Black Protest in Baltimore, 1865–1900." *Maryland Historical Magazine* 71, no. 3 (Fall 1976): 381–91.

Travers, Paul. *The Patapsco: Baltimore's River of History.* Centreville, MD: Tidewater Publishers, 1990.

Trostel, Michael. *Mount Clare: Being an Account of the Seat Built by Charles Carroll, Barrister, Upon His Lands at Patapsco.* Baltimore: National Society of Colonial Dames of America in the State of Maryland, 1981.

Whitman, T. Stephen. *Challenging Slavery in the Chesapeake: Black and White Resistance to Human Bondage, 1775–1865.* Baltimore: Maryland Historical Society, 2007.

Whyte, William. *The Last Landscape.* Garden City, NJ: Doubleday, 1968.

Zembala, Dennis M., ed. [Benjamin Latrobe Jr. Chapter of the Society for Industrial Archaeology]. *Baltimore: Industrial Gateway on the Chesapeake Bay.* Baltimore: Baltimore Museum of Industry, 1995.

Zucker, Kevin. "Falls and Stream Valleys: Frederick Law Olmsted and the Parks of Baltimore." *Maryland Historical Magazine* 90, no. 1 (Spring 1995): 73–96.

About the Authors

W. Edward Orser, professor of American Studies at the University of Maryland Baltimore County (UMBC) served as the principal author. His other works include *Blockbusting in Baltimore: The Edmondson Village Story* and numerous articles on the social and cultural history of the Baltimore area. He and his wife live in the Hunting Ridge neighborhood and are frequent users of the Gwynns Falls Trail.

CONTRIBUTORS

Daniel Bain is assistant professor in the Department of Geology and Planetary Science at the University of Pittsburgh. His research focuses on the impacts of historical land use changes on contemporary water quality and biogeochemical function, and his dissertation at Johns Hopkins University was on the Gwynns Falls watershed.

Since 1977, *Jack Breihan* has been a member of the History Department at Loyola College, where his courses include Historic Preservation and the Architecture of Baltimore. He has served as a member of the Commission for Historical and Architectural Preservation (CHAP) and on the board of Baltimore Heritage, Inc.

Guy W. Hager of Baltimore's Parks and People Foundation, working cooperatively with the Gwynns Falls Trail Council, has provided leadership for a variety of initiatives to interpret the human and natural history of the area along the trail. He helped to secure funding from the National Parks Service through its Chesapeake Bay Gateways Network program for background research, design and installation of interpretive panels along the trail, and he has provided essential leadership and support to help make this book possible.

Eric Holcomb works for the Baltimore City Planning Department in the Historical and Architectural Preservation Division. He is the author of the recent book, *The City as Suburb: A History of Northeast Baltimore Since 1660*, and lives in northeast Baltimore with his wife and two sons.

David Terry is executive director of the Reginald F. Lewis Museum of Maryland African American History and Culture. He formerly was on the staff of the Maryland State Archives, where he initiated the research program, "Beneath the Underground: The Flight to Freedom and Communities in Antebellum Maryland."

Special appreciation for serving as readers and lending their expertise for portions of the book is due to Guy Hager, John Maranto, John McGrain and Courtney Wilson.